W9-DGF-617

furnishing forward

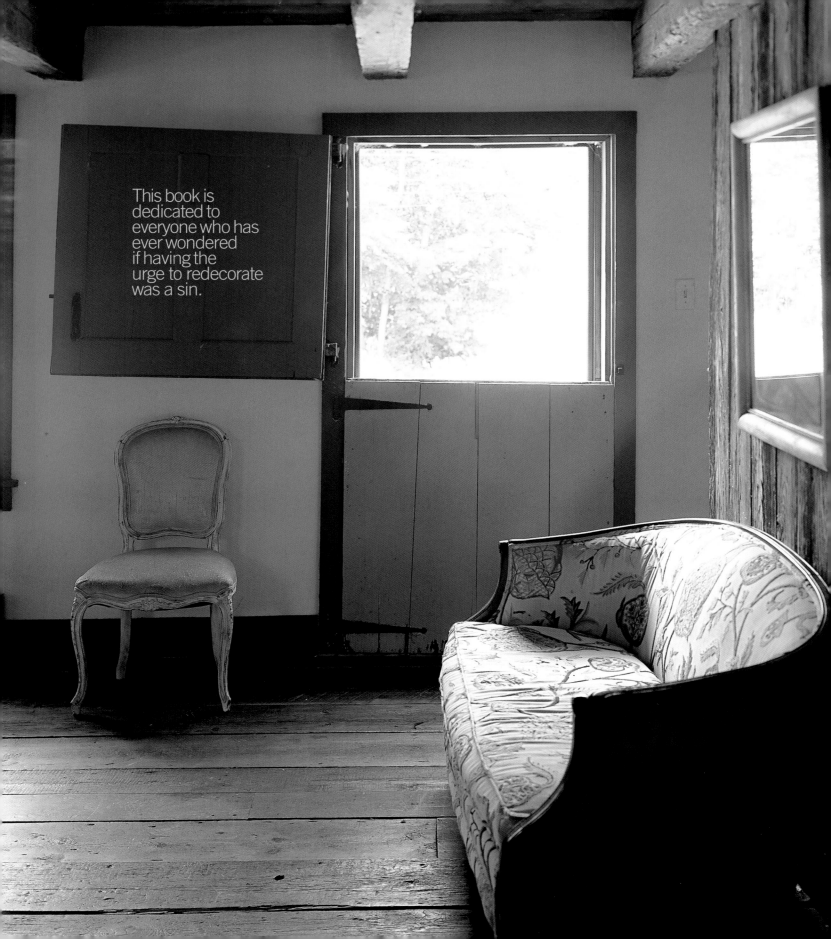

This book is
dedicated to
everyone who has
ever wondered
if having the
urge to redecorate
was a sin.

furnishing forward

a practical guide to furnishing for a lifetime

Sheila Bridges

with photographs by Anna Williams

A BULFINCH PRESS BOOK · LITTLE, BROWN AND COMPANY

BOSTON NEW YORK LONDON

Text copyright © 2002 by
Sheila Bridges
Photographs copyright © 2002 by
Anna Williams

Additional photography credits
as follows:
Fernando Bengoechea: 15, 44, 62,
63, 72, 85R, 122, 132, 160; George
Chinsee: 58, 78; Pieter Estersohn:
7, 22, 40, 55, 90, 108R, 109,
23, 136, 144, 152, 166, 168;
Richard Mandelkorn: 133; Toshi
Otsuki: 47; Laura Resen: 84, 115,
18, 131, 147, 150

First edition

Library of Congress Cataloging-in-
 Publication Data
Bridges, Sheila.
Furnishing forward : a practical guide
o furnishing for a lifetime / Sheila
Bridges.
p. cm.
ISBN 0-8212-2699-1
1. Interior decoration — United
States — History — 20th century.
I. Title.
NK2004 .B75 2001
747.213'09'04 — dc21
2001016480

DESIGN BY JENNIFER NAPIER

Bulfinch Press is an imprint and
trademark of Little, Brown and
Company (Inc.)

PRINTED IN SINGAPORE

contents

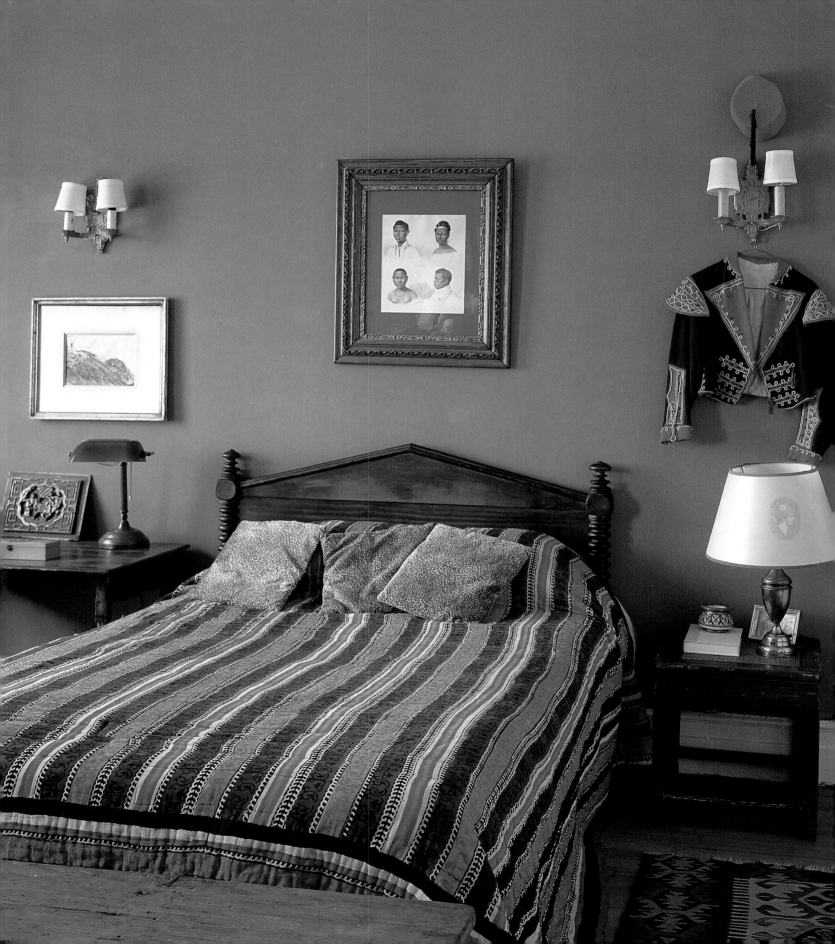

"There's no place like home, there's no place like home, there's no place like home."

—DOROTHY, in *The Wizard of Oz*

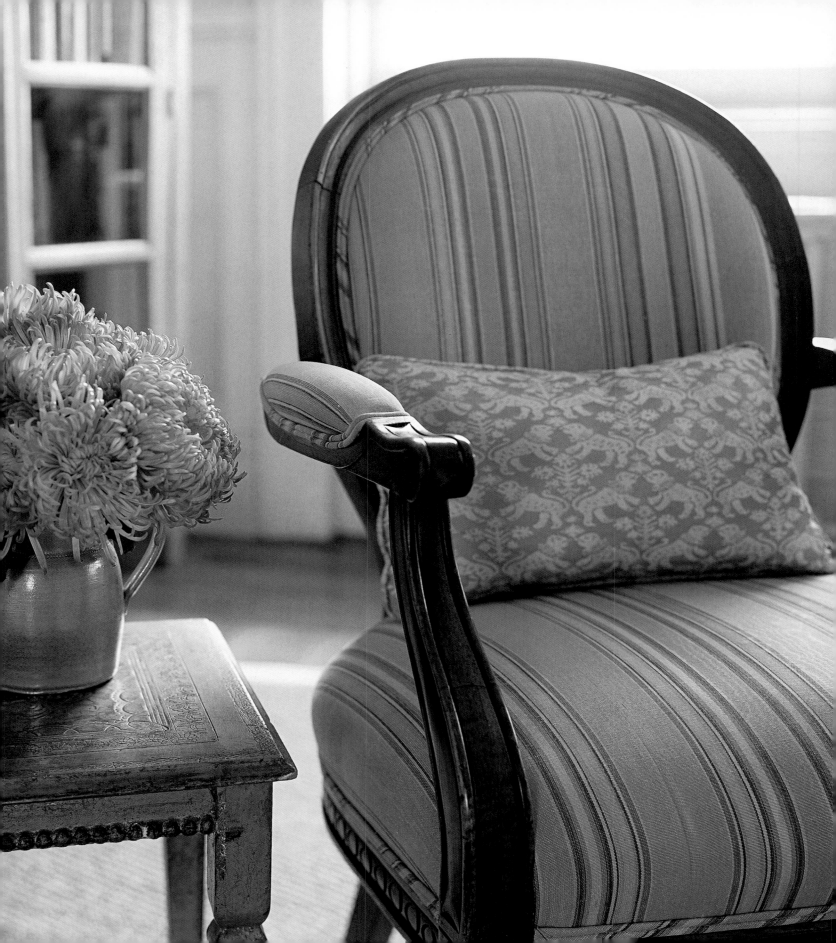

introduction
THE HUMBLE MAKINGS OF AN INTERIOR DESIGNER

When I was a child, I always thought that I would grow up to be either a veterinarian or a marine biologist. I certainly never envisioned becoming an interior designer. I'm not even sure if I knew what an interior designer did until I was in high school. I had never heard of fabric swatches, paint chips, or memo samples and definitely knew nothing about toile fabrics or Aubusson rugs. While I do vaguely remember being dragged into the dining room by my parents and asked my opinion about the fabrics that they were being shown by their interior decorator, the rest is pretty much a blur.

Obviously, something happened on my way to adulthood that drastically changed my career path from talking to the animals like Dr. Dolittle to talking to clients about fabrics and furniture. I can't pinpoint what set me sailing on a course to spend my days searching for antiques, art, and architectural salvage instead of searching for aquatic adventures on uncharted waters with Jacques Cousteau. Even though my close friends will tell you that I still have

a childlike fascination with animals and the ocean, I am very happy with my choice to become an interior designer. I am content with this choice even though it was unplanned, unanticipated, and most highly unlikely. Like every other profession, there are moments of frustration and moments when I wish the frenetic pace would slow down long enough for me to spend quality time in my own home. But I can't think of another career that would be as continually challenging, eye-opening, and visually stimulating to me as the one I have chosen. I also can't think of another profession that would have allowed me to play so many roles without an audition first. I have become a walking, talking, fabric-wielding designer-decorator-stylist-psychologist-florist-accountant-collection agent publicist-attorney-trucker-analyst with a Stanley Powerlock twenty-five-foot tape measure. It is as exhausting as it is rewarding, but I wouldn't want to trade places with anyone else in the world.

So who are you anyway, and how do you know whether this book is for you? You woke up this morning and suddenly realized that whether you like it or not, you are an adult. You have a career rather than a job. You pay bills and balance your checkbook regularly. You own a dog or a cat, or maybe both. You are married with one small child and are seriously thinking about having another. You are single with a demanding career that takes up most of your time. Or maybe you are a single parent with a demanding child that takes up most of your time. Either way, you probably own or lease a car and use a computer daily. You have an answering machine, a fax machine, voice mail, e-mail, a cell phone, a car phone, a pager. You have more than one type of insurance, including health, disability, home, auto, life, or pet insurance. You no longer have a roommate (unless you choose to) or live with your parents. You just purchased and moved into your first "real" apartment or house, or maybe you're still a renter if you live in an expensive city like New York, Chicago, Boston, L.A., or San Francisco. You have a real life with real responsibilities and realize that it's time to own some "real" furniture. *But* you're not quite sure where to begin. How do you upgrade from Conran's to classicism without becoming completely overwhelmed? How do you make that transition from IKEA to inspirational without having a nervous breakdown? What do you do with the stuff you already own that you think is too good to throw out but don't want to live with anymore? Where do you buy stylish, quality furniture without the qual-

PAGE 8: Bold stripes always look nice on tightly upholstered chairs. OPPOSITE: Even my Jack Russell terrier Dolby can appreciate a mantel with an eclectic mix of accessories including a Moroccan tile, sconces, a painting, and some small topiaries.

ity price? And once you find furniture you love, how do you put it together or arrange it in a way that will make the room look great? How can you make your home look terrific without spending all your money?

Do you need professional help? Do you want to enlist the services of a professional interior decorator or designer? And if so, can you afford one? Even if you can afford a design professional, what should you know before hiring one? If you choose not to work with a designer or decorator, how do you buy furniture that you won't hate or outgrow in three years? Is it really possible to buy furniture for today and tomorrow that you will love ten years from now?

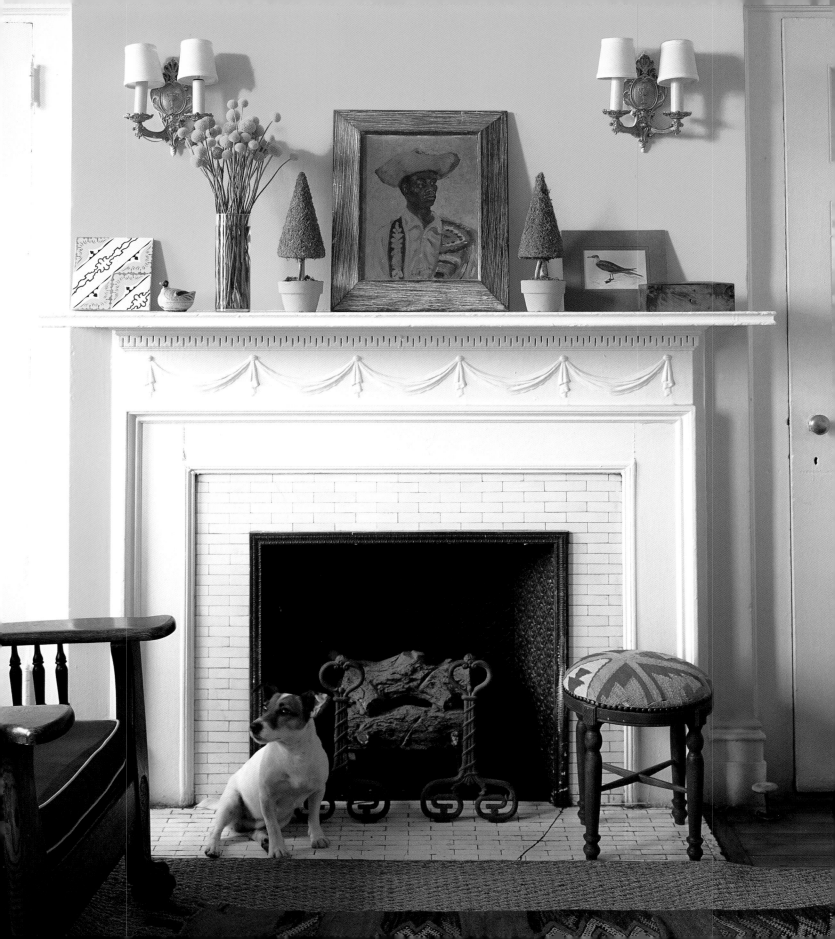

There really is a psychology to decorating, which exists for everyone who has ever tried to part with a rocking chair that belonged to a relative or a blanket that belongs to a child. Decorating is, and should always be, a very personal, intuitive, and enjoyable process. When it isn't, the results are glaringly obvious. My hope is that this book will address many of those apprehensions in a practical and reasonable way. My desire is that by discovering the basic anxieties and emotional

stumbling blocks that we trip over while decorating our homes, we will learn how to avoid them in the future. The goal is to help you to get past these impasses so that you can eventually create an affordable and comfortable home environment that reflects who you are or who you would like to be.

In the following chapters, I explain how the concept of "Furnishing Forward" will help you make logical and practical decisions so that you do not waste money on impractical items that you will need to replace in a couple of years. This concept will also help you approach decorating in a way that is straightforward, down-to-earth, and hopefully less overwhelming. Since so many people are intimidated by the mere notion of decorating, I was inspired to write a book that would take some of the mystery out of interior design and put some of the humor back in. I also wanted people to be able to refer to a practical guide and visual map when trying to create the kind of spaces they wanted to live in. The first step toward demystifying the world of interior design and decora-

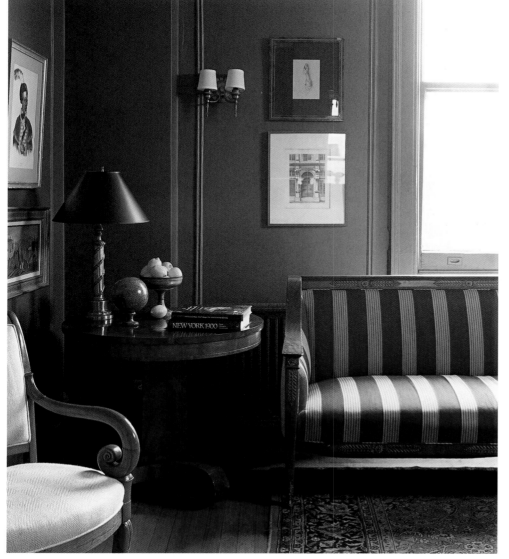

LEFT: Striped fabrics can liven up serious pieces of furniture, giving them more personality. OPPOSITE: Hallways should lead to interesting places with stimulating colors and touchable textures.

tion is to understand what it is exactly that interior decorators and designers do.

Good design is far from arbitrary, although it may seem that way to some. Design is a well-thought-out process that is as much about furniture, color, and lighting as it is about mood and atmosphere. It is as much about materials and fabrics as it is about function, scale, and proportion. There is a certain exactitude inherent in the process of design, partly because every design is based on a specific point of view. Interior design is also about spatial relationships and visual perceptions. It is one of the few professions that are truly reliant upon our senses. Without them we are profoundly lost in the world of design. Since our senses create a commonality we all innately share and are attuned to, I genuinely believe that we all have the creative potential and capacity to design and decorate our own homes.

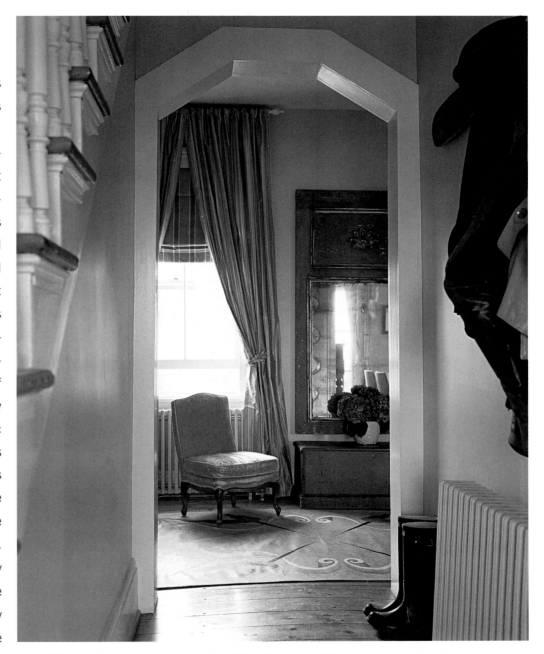

It is important to understand that creating a comfortable and elegant interior involves a lot more than just shopping for a great sofa or an interesting floor lamp. All the things we surround ourselves with in our homes certainly have an effect on our emotional well-being. Once we recognize this, the more likely we are to develop an appreciation for good design. Finally, the easier and more enjoyable the design process becomes for us, the better the results.

Thirteen years of working in the interior design profession has taught me a great deal about what it takes to successfully furnish people's homes. While much of my experience has come from working with clients, a lot of it

has also come from working on my own homes. During the past decade I have begun to understand the importance of having a design philosophy that you are willing to adhere to throughout the furnishing process. My own philosophy revolves around what I call the art and psychology of Furnishing Forward — a concept that suggests furnishing or buying furniture with the future in mind. Furnishing Forward has to do with furnishing for the long haul. Though I have too much of an appreciation for history to ever suggest that you completely turn your back on the past, I do suggest that you look at your past with a critical eye. Learn from both your mistakes and your triumphs as they pertain to the way you have approached furnishing your home. Be willing to interrogate yourself a little bit. Administer a polygraph if you have to. While it can be challenging to be completely honest with yourself about what has and hasn't worked in

the past, it is an essential component of Furnishing Forward to identify the potential mistakes before they become decorating disasters of *Titanic* proportions.

Whenever I'm in the process of helping someone furnish his or her home, friends always ask me when the project will be finished. The answer is always pretty much the same: *never.* Good design is an ongoing and ever-evolving process. Well-decorated homes are never completely finished, simply because the people living in them are never finished dreaming about the future. As our lives change, so do the spaces we live in. We all know that life is a series of both expected and unanticipated events. You get a new job instead of that promotion you were counting on. You have triplets instead of

twins. You elope to Vegas instead of getting married in your local church. We continuously move forward, bringing new experiences and attitudes with us along the way. We need to design and decorate our homes so that they are completely in sync with these life changes, no matter how difficult or provocative they may be. By the time we reach adulthood, we should know that most things in life are beyond our control. What we choose to put in our homes is not. One of the goals of *Furnishing Forward* is to motivate you to become an active participant in the furnishing process rather than a spectator watching from the sidelines. The reason for this is simple. The more involved you are in the process, the greater the likelihood that you will be happy with the results.

The most common excuse that I hear from people about why they can't focus on decorating their homes has to do with money. Although this excuse sounds good on paper, in reality it doesn't fly. I know plenty of people who do not have a lot of money but who live stylishly yet within their specific financial boundaries. You do not have to be a Wall Street banker, music mogul, or movie star in order to live comfortably, elegantly, and smartly. Whether you live in Tennessee or Timbuktu, we can all live in homes and with furniture that is long-lasting and low maintenance even if our lives are changeable and high maintenance.

I am continually amazed that people approach the design and

decoration of their homes in ways that are completely contradictory to how they manage the other aspects of their lives. Whether you choose to live in a tepee or a Tuscan villa, you have to *think* a little before you bulldoze into the design and decoration process. Like every other challenge that we face in our lives, we make better decisions when they are reality-based, educated, and well informed. This doesn't mean that there isn't room for fantasy. In fact, fantasy and curiosity should be encouraged. Design without these components is about as exciting as doing your income tax return. All of us want to live better and in ways that are more gracious and flattering to us and to our loved ones. The key is in the *balance*. Creating living spaces that are as beautiful as they are comfortable. Defining spaces and home environments that are as stylish as they are functional. Our homes should be as much about celebrating where we came from as they are about where we are going.

We should think about creating personal refuges that shelter us from the harsh realities we sometimes experience. As we get older, most of us come to realize that life is not always easy. On a daily basis, we face personal crises that come

OPPOSITE: **If you buy furniture that has great lines or a classic shape, it is unlikely that you will ever tire of it. LEFT: Colored glassware can be interestingly reflective when displayed in a place that catches the sun's natural rays.**

in many different colors, shapes, and sizes. Our children get sick, our company goes bankrupt, we get divorced, our parents pass away. Challenges arise in the forms of terrorism, sexism, racism, cancer, AIDS, etc. The list goes on, ad infinitum. We begin to realize that none of us, no matter how successful we are, are immune. While I am hardly suggesting that these things can be avoided or prevented because we have lovely homes, I am suggesting that our homes become places for self-contemplation, reflection, and healing, places where we can comfortably shed the armor that is necessary for the daily battle called *life.* Our homes should be places where we can truly relax and be ourselves. Finding comfort and humor in the physical walls surrounding us might help dismantle some of the emotional ones that we have built over the years. Our homes are where we should feel grounded and most centered. If this is so, then our hearts and souls have a place to retreat when things are truly difficult.

It is not uncommon for people to have love affairs with their furniture. Even the most unromantic of men have been known to fall in love with a La-Z-Boy chair now and again. Maybe we think we love our dining-room table. Is it because it is made of beautifully weathered pine and looks great in the space? Yes. But we also love it because of what it symbolizes. What we associate with it is part of what gives it such great significance. Maybe your dining table reminds you of Christmas dinner or your daughter's first birthday celebration. Whether we serve sushi or salami, getting together with friends and family to break bread is important to our overall well-being. Sitting down together at your dining table is as much about ritual and tradition as it is quite simply a place to sit and eat.

Whatever the memory or recollection attached to the rituals and routines that take place in our homes, we subconsciously keep them in our inner framework, always reaffirming what is most important in our lives.

There is a certain authenticity to our homes that can't be disguised in the same way that we do other aspects of our existence. We can hide that extra five pounds we gained during the holidays with a pair of control tops. We can disguise that premature gray hair with the help of a little Grecian Formula. We can paint the most flattering self-portrait for the rest of the world to see, but no matter how hard we try, we can't hide how we live. Our homes are honest in ways that we can't necessarily be. I find it truly discouraging that people so often become complacent when it comes time to decorate their homes. It's as if the cheesy particleboard table disguised as mahogany simply knocked on your door and invited itself into your living room. We make conscious choices about the way we choose to live and furnish our homes, whether we want to admit it or not.

The right accessories (candles, bath oils, and a fluffy robe) can make bathing a truly relaxing and sensual experience.

Home. Dorothy and Toto wanted desperately to get there, and E.T. wanted to phone there. We all have dreams about what our homes can and should be. Having a nice home is part of the American Dream. And the last time I checked, even Barbie had a dream house. For the three little pigs, home meant safety from the big, bad wolf. For me, home is shelter, sanctity, and sanity with a roof overhead. Whatever your home is to you, take great care in surrounding yourself with things and people you love.

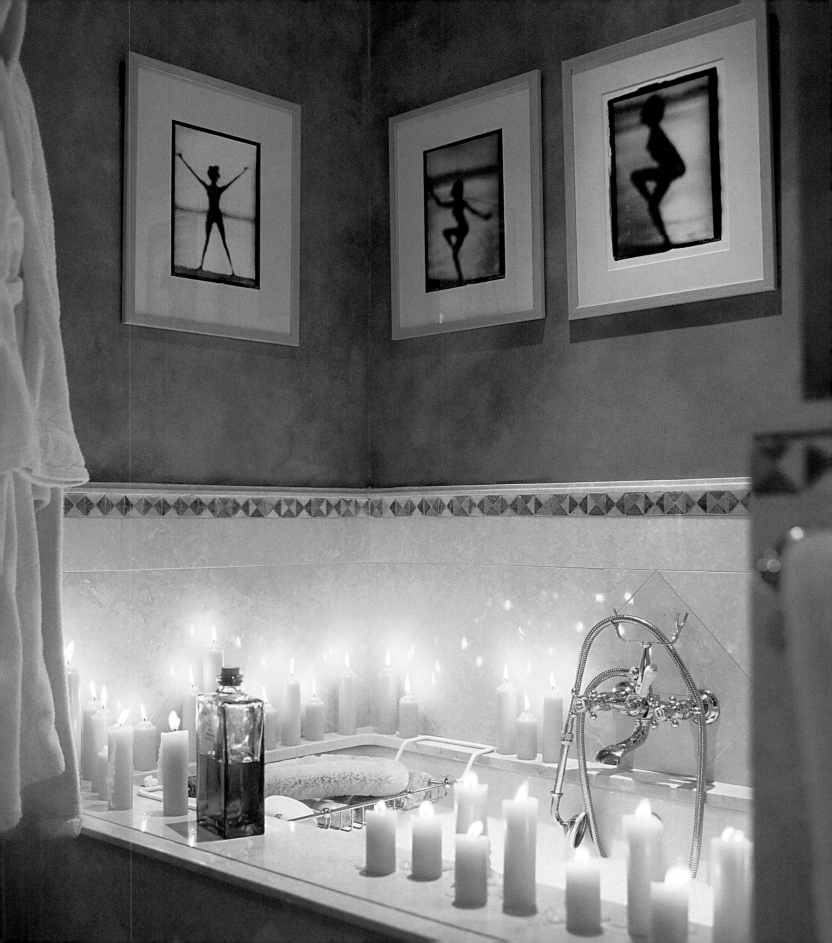

"Style is the dress of thought.

—SAMUEL WESLEY

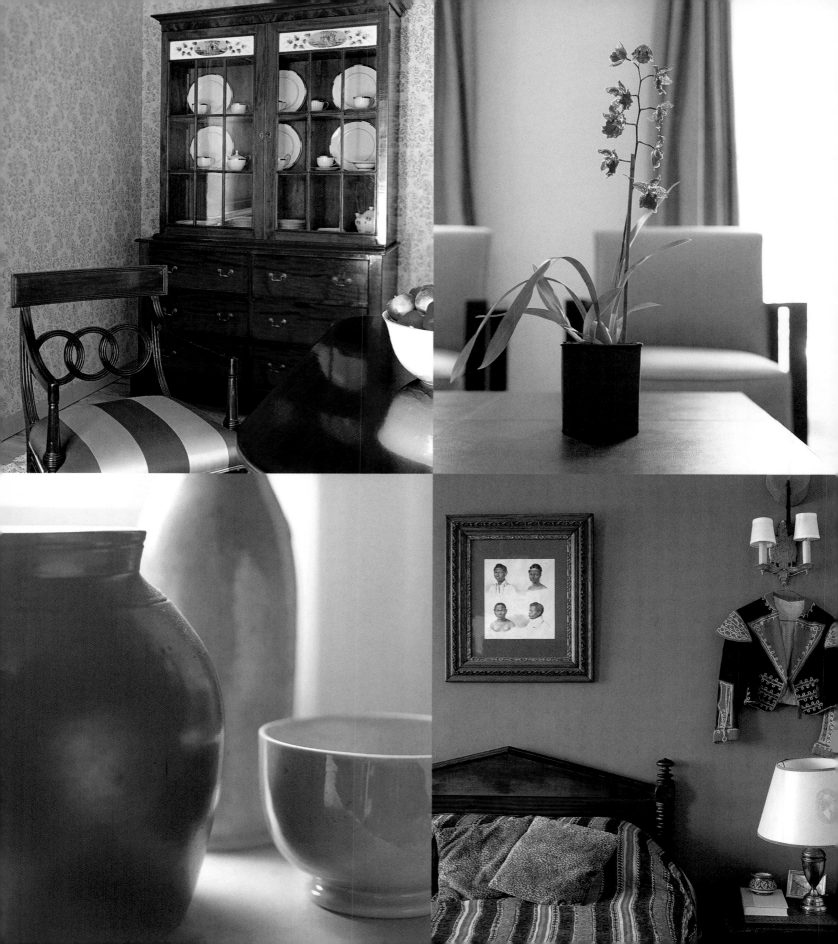

style schizophrenia

IDENTIFYING YOUR STYLE CATEGORY

Whether you express your style through the way you dress or the type of car you drive (or don't drive), all of us express our own personal style at every moment of every day. While style may be difficult to define, from an interior design standpoint, it is based largely on our ability to visually imprint the things in our homes in personal ways. Style is sometimes displayed consciously and in ways that are purposeful, but more frequently it is expressed unconsciously, as if it had a mind of its own. We are often completely unaware that our style is visible to other people. This is when style is in its purest and most revealing form, because it is being genuinely expressed without concern or regard for what other people think. Our sense of style reveals a lot about our psychological makeup. While some people spend a lot of money and energy trying to buy and borrow

styles that are not uniquely their own, others effortlessly stay true to their own voice. Those who try to masquerade their style sensibilities often end up with homes that may look nice on the surface but have no substance or depth. Style has a lot less to do with money and a lot more to do with confidence. Strangely enough, sometimes it seems that money and style have an inversely proportional relationship — meaning that the more wealth some folks acquire, the more the evidence of their own individual style diminishes. Most people would probably agree that many of the wealthiest people around are surely the tackiest. Too much money sometimes gives people the opportunity to give in to impulse and to indulge in ways and things that they ordinarily wouldn't even think of. We see examples of this all the time. The professional athlete, the rock star, the Hollywood actor, the Publishers Clearing House Sweepstakes winner. Ordinary people who suddenly find themselves with a lot of money and a lot of bad advice about what they should buy.

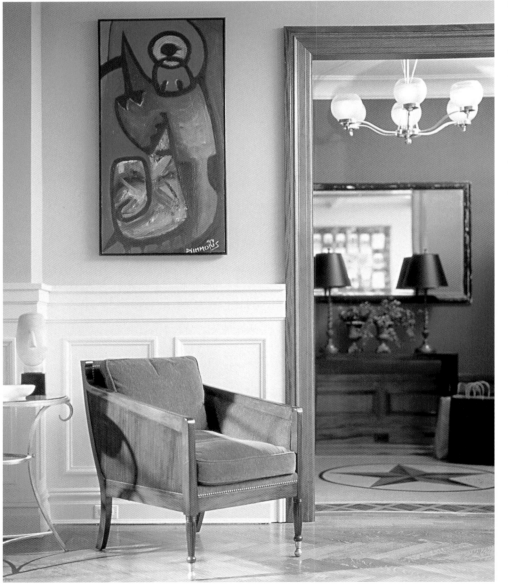

Whatever you determine your style to be, you should display it with grace, humility, and ease, never arrogance. In my estimation, the recipe for arrogant style calls for one cup of pretension and two tablespoons of insecurity. Arrogant style is practiced by a misguided few who are convinced that if it costs a lot or someone else has it, they should own it, too. Confusing expensiveness with stylishness is pretty com-

LEFT: This client has an eclectic sense of style and an appreciation of bright and bold colors.
OPPOSITE: Whoever said that blue and brown don't match obviously hadn't seen this bedroom. The owner of this home reflects his personal style in the creative color combinations that he has chosen to surround himself with.

mon when people aren't confident enough about their own judgment or sensibilities to let their own style show through. Instead of paying ransom to own things that you can't either relate to or understand, try to make conscious choices based on what you really like.

What is your style?

Your personal style may be seen in ways that are as basic as how you choose to wear your hair or the pace at which you naturally walk into a room. No matter how simple or complex, our individual styles are seen in our behavior, our attitudes, the way we dress, and certainly the way we choose to live. Whether you

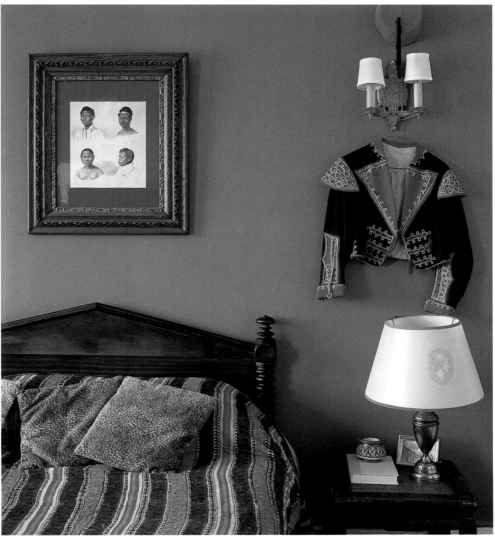

want to paint your entire home in Moroccan red or prefer to have a fresco painted on your bedroom ceiling, if you are truly sincere about how you express your style, chances are that you can pull it off. While I don't think anyone would like to be described as having "bad" style, I would think that "no style" would be far worse. We're all certainly born with some sense of style — albeit some people's style may be considered more socially acceptable than others'. The point is to try to embrace your style in ways that let you express the best you have to offer and create a home that you are happy in, even if other people just don't get it.

Do you have a distinctive style with respect to furniture? All of us have a particular style, even though we may not know exactly how to articulate what that style is. Ask friends what they think your style is and I guarantee that they will have an opinion about your style sensibilities. Chances are also that you might even disagree with the style that your friends suggest you like: "What do you mean I'm traditional?" Maybe you tend to gravitate toward prints rather than solids. Do you prefer light-colored woods like ash or maple to the deep brown tones of ebony or mahogany? We all have style preferences, and style categories can therefore be use-

ful to help define what it is that we like and dislike. Identifying your style category is less about fitting you and your preferences into nice, neat boxes and more about gaining insight into why you are attracted to certain types of interiors and pieces of furniture. Once you have a basic understanding of why you like or dislike certain things, you will be better able to grasp how these things translate themselves into your style.

When working with clients, I have often suggested that they look through interior decoration magazines or books and dog-ear the pages that show furniture styles they *don't* like. While this request raises a few eyebrows initially, I have found this approach to be useful since many of us have an easier time recognizing and articulating the things that we don't like rather than the things we do like. What we like is often highly cultivated and complex. It is inextricably tied to our own frame of reference — which includes where we are from, how we grew up, and what we have been exposed to throughout our lives. It is also shaped largely by what the media says we should like. When we don't like something, our response is usually precise and almost immediate. We can learn a lot about ourselves from what we don't like. If you have a mild anxiety attack every time you see vertical stripes, don't wallpaper your apartment in them. Listen to what you don't like, and you will learn from it.

Personally, I do not like rooms with lots of furniture or clutter. Anyone who knows me fairly well can tell you that sofas with fifteen toss pillows, mantels or tables with large floral arrangements, and knickknacks galore are definitely not my style. While many people find this ornate style of decorating and accessorizing charming,

I find an overabundance of decorative objects to be completely distracting and excessive. My own style is fairly minimal, understated, and architecturally driven. In fact, I could be the poster child for the adage "Less is more." If given the choice, I would prefer to own one exceptional piece of furniture than a roomful of mediocre things just to fill up the space. In my own home, I would gladly forgo the comfort of sitting at a table to eat my meals if it meant buying and sitting every day at a table that I didn't love. Call this extreme if you want to. I simply call it being honest about how passionate I feel about the type of furniture I own.

Things that have a powerful effect on you and your mood — both positively and negatively — are important to listen to intuitively. If clutter makes you shudder, then you probably should consider how you might approach furnishing your home in a way that will minimize the chance for things to accumulate and eventually become clutter. Maybe you should consider buying a big dresser with lots of drawers, a pair of bookcases, or file cabinets. Even the basic garbage bag may be your solution to this potential problem. If you feel strongly enough about what you like to make certain things a part of your life on a regular basis, you should try to furnish your home in ways that will support these routines. If you love to invite friends over on Friday nights to play bingo and strip poker, make sure that you have enough seating in your home to accommodate them.

All of us have friends or acquaintances who have a sense of style that we like and admire. We can never

Pay attention to the dishes, glasses, and table linens that you choose for your dining-room table.

quite put our finger on what it is or how it works exactly, but when we see it, the attraction is undeniable. Have you ever walked into the home of someone you didn't really know very well and thought, Wow, this person

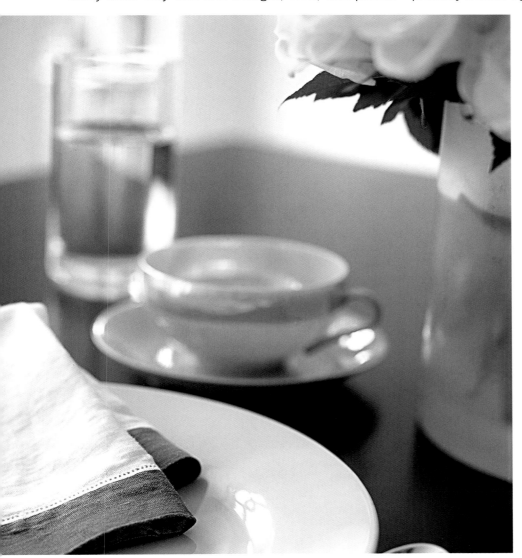

really has style? Or been someplace and thought that a space was great, even though you couldn't pinpoint what made it seem so great? If you were to analyze the individual components that make a room seem "great" or "stylish," the results would comprise many different

elements that collectively make that room visually exciting and appealing. If you were to ask the person who decorated it how he or she made it look that way, you probably wouldn't get very far in terms of an answer that would satisfy you. It's just not that easy for most people to explain what makes one room look more stylish than another. Again, while great style can be truly intuitive for a few people, most of us have to work a little harder at it.

There is some good news and some bad news when it comes to style. The bad news is that style (like good taste) can't be bought. You can buy all kinds of things that will say something about your style or your wallet, but you can't just simply walk into a showroom and order style the same way you would a cheeseburger and french fries at your local diner. The good news is that you can hire a designer or decorator with it, marry someone who has it, or take it up like a new hobby or sport and practice it regularly. The more you are exposed to a particular style, the more it will eventually begin to rub off on you.

Every time I go to the interior decorating section of a bookstore, I see more and more books on style. Japanese style, Caribbean style, French Country style, Swedish style, ethnic style, pure style, and so on. Apparently, store-bought examples of style are more in

demand nowadays than minivans and SUVs. And it is no surprise that people are bewildered about their own sense of personal style. Being bombarded with so many different styles is confusing at best. More specifically, prolonged exposure to so many different styles causes most people to experience the onset of an ailment that I like to call style schizophrenia. Style schizophrenia is not nearly as terrible as it might sound. It can be characterized by drastic and frequent shifts in your style category. One minute you're convincingly classical and buying a pair of Greek-inspired ceramic urns to display on your mantel above your fireplace, and two minutes later you are buying a high-tech, politically and ergonomically correct desk chair for your home office. All of us fall victim to this syndrome from time to time. There are so many different styles available to us nowadays, and many of us can find more than one style appealing; it is difficult to make furniture choices that we will not regret later. That is why the first step in furnishing your home is to identify your style category. These categories can help you decide what types of things you would like to have in your home and what types of things you wouldn't want to live with even if money were not an issue. You may find after reading this chapter that one style category may describe you completely and accurately. Or like me and probably most people, you may straddle two style categories rather than fitting neatly into one. In either case,

Furniture should have an "afterlife." The Victorian side chairs flanking my mantel were originally used as dining chairs in my studio apartment twelve years ago.

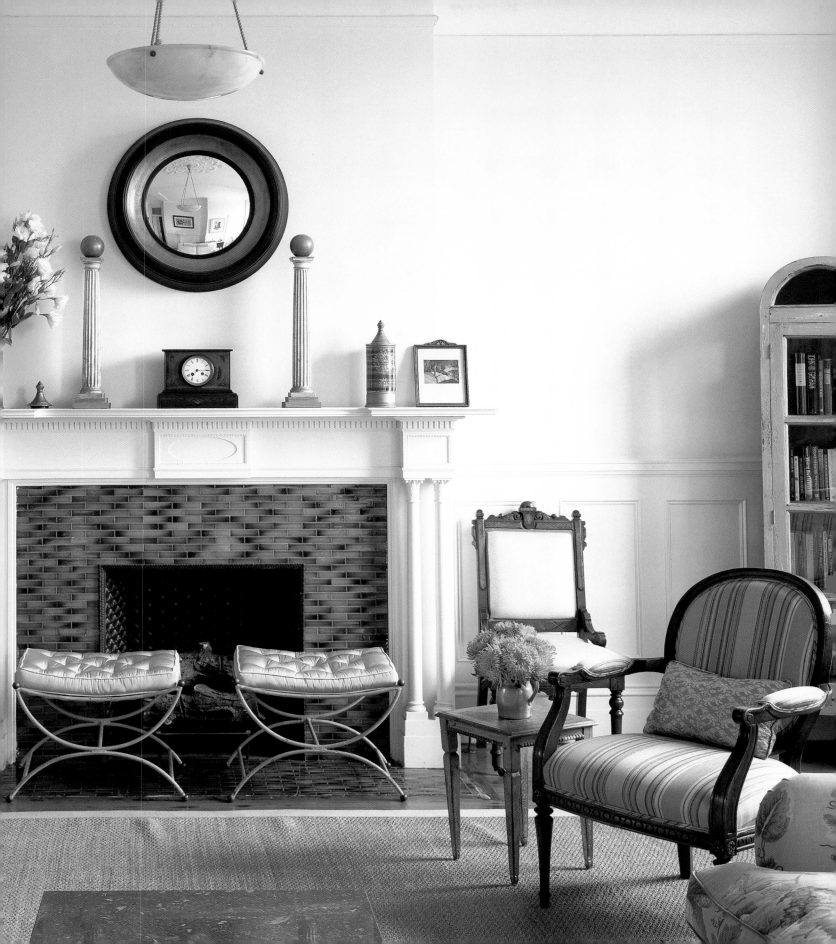

Traditional Style

If you fantasize about owning a mahogany sleigh bed or prefer draperies at your windows rather than aluminum miniblinds, you may be someone who fits into the "traditional" style category. Most traditionalists like Persian and Chinese rugs, and traditional furniture styles such as Chippendale and Queen Anne. Most traditionalists prefer darker stained woods like mahogany or walnut, and generally gravitate toward "sets" of things that match. This would probably mean that you would prefer to purchase your dining chairs, dining table, and china cabinet all from the same store or manufacturer. Traditionalists are not usually the big furniture risk-takers. The idea of one-stop shopping appeals to you more than purchas-

once you determine your style category (or categories), you can begin to understand the psychology behind the choices you make when you buy furniture or choose paint color. If you understand the motivations, it should be a lot easier to eventually furnish your home in a way that is representative of who you are or who you aspire to be. Whether your style is eclectic or traditional, modern or classic, style is about letting your individual personality express itself comfortably and confidently.

ing individual pieces at many different stores over time. You prefer more elaborate floral arrangements to simple vases with one type of flower. Your ideal home might be a center-hall colonial built in the late nineteenth century rather than a 5,000-square-foot downtown loft. You would probably like to have a kitchen with wood cabinetry rather than one that has

ABOVE AND OPPOSITE: Dark wood stains like walnut and mahogany are favorites among most traditionalists.

high-tech cabinets made from stainless steel. Most traditionalists like wide stripes and subtle patterns like damasks. Traditionalists rarely make hasty decisions or impulse purchases. Instead, they really think about the value and practicality of a piece of furniture before actually opening their wallets and handing over their credit cards. Photographs of parents, children, and nieces and nephews are usually nicely framed and prominently displayed on mantels and tables throughout traditionalists' homes. Most traditionalists save their formal china for special occasions or holidays such as Easter, Thanksgiving, Passover, or Christmas. They do not keep up with the latest trends in the world of interiors, because they know that it only makes sense to purchase things they will want to own for a long time. Traditionalists also love architectural details like crown moldings, Palladian windows, and columns. Although some of the decisions traditionalists make with respect to their homes might seem fairly predictable, they usually do make sense — and rarely do the people who fall into this style

category find themselves making decisions and purchases that are regrettable. Just as most traditionalists probably wouldn't consider getting their tongues pierced, most people in this style category wouldn't ever be tempted to spend an obscene amount of money on furniture they didn't need.

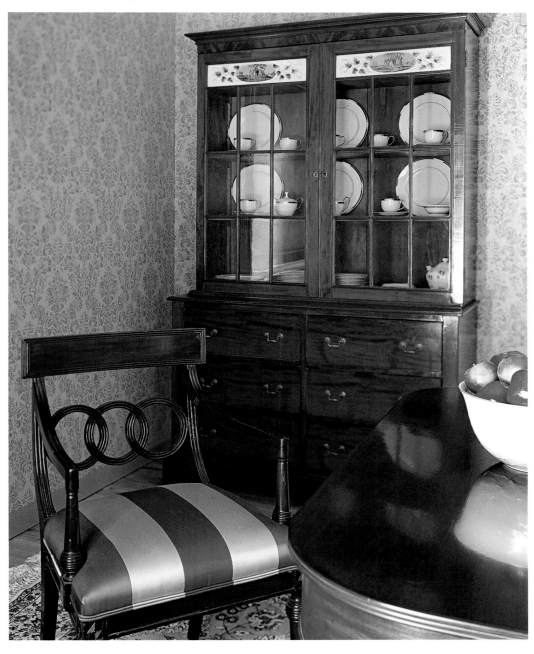

Modern Style

Modernists enjoy minimal furnishings in contemporary settings. Things that are rectilinear or that have clean lines turn them on. Modernists hate clutter (even if it's organized) and are willing to go to great extremes to rid their homes of it. In the words of Malcolm X, they are committed to keeping their homes minimally furnished "by any means necessary." If you fall into the modern/contemporary style category, you probably prefer solid fabrics over prints and plaids. The thought of a Ralph Lauren tartan wool throw makes you queasy. You do not like things that are fussy or overdone. You believe that windows are at their very best when left without draperies or shades. You would gladly leave the decorative hardware and accessories that most people enjoy to someone else. Modernists like geometric shapes and materials such as glass and metal. Le Corbusier, I. M. Pei, and Frank Gehry are some of your idols. You find abstract patterns far more intriguing than floral ones.

You probably believe that paisley or gingham is for people who haven't yet been enlightened. If you live in a city like New York, you probably have your fair share of black clothes in your wardrobe. You love lofts and architecturally dynamic spaces. You would prefer living in a warehouse district rather than in the suburbs. If given a choice between buying an Andy Warhol painting and an antique Ming vase, you would pick the painting without thinking twice. Most modernists prefer lighting their homes with recessed or halogen lighting to table or floor lamps. You would prefer to live in a penthouse apartment in Hong Kong than in a sprawling ranch in Nevada. You do believe in the philosophy that less is more, and your home reflects it on every visible level.

LEFT: The contemporary furniture in the breakfast room is complemented by contemporary art. OPPOSITE: This client opted for two different sofas upholstered in two different fabrics.

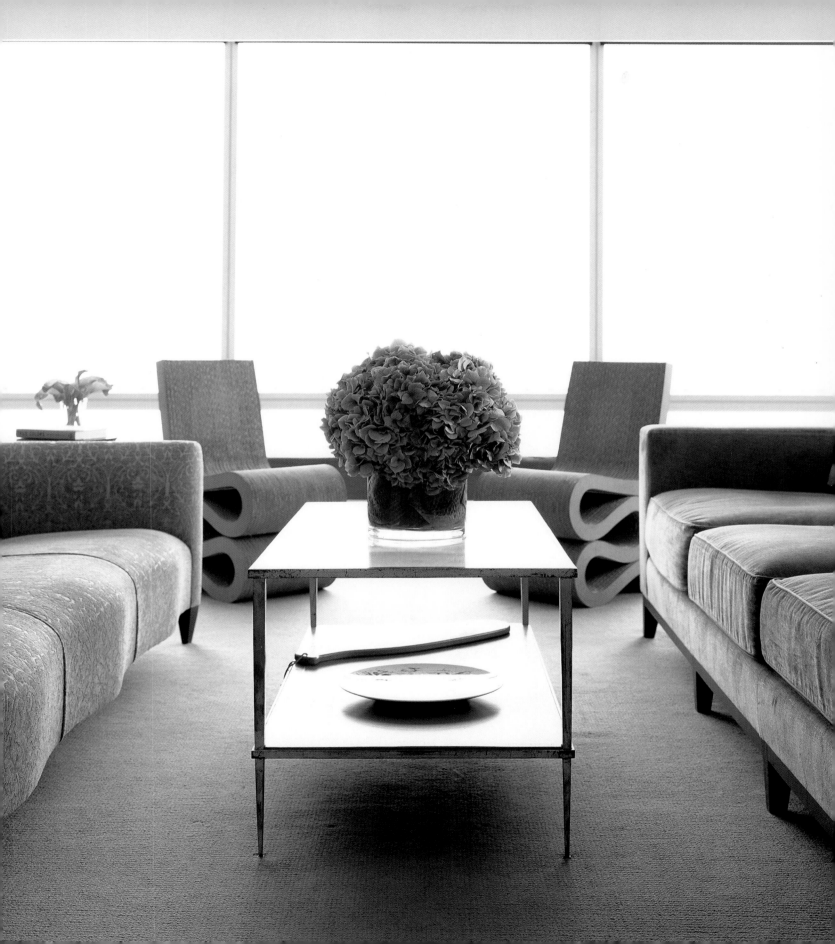

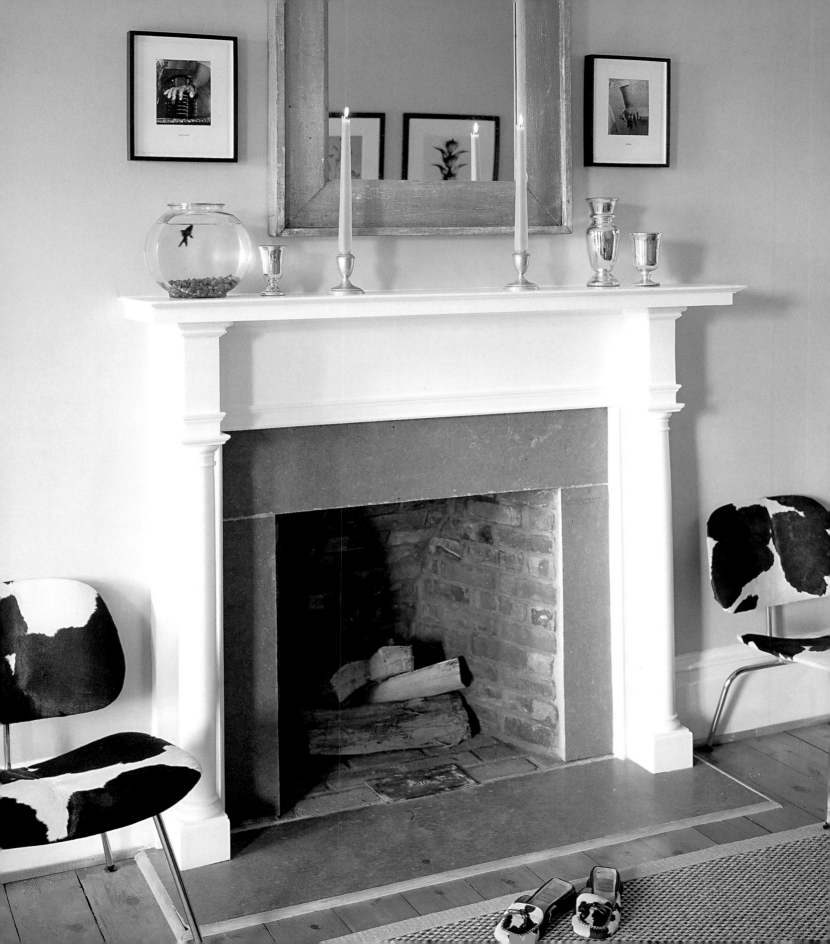

Eclectic Style

You like to mix old and new furniture in the same spaces, even when it seems a little unorthodox. You love furniture and fabrics from different places and periods. Your idea of decorating is using your grandmother's antique Victorian sofa slipcovered in cotton muslin with a Moroccan table, a shoji screen, a pair of 1950s lamps from the flea market, and a sisal rug. You might mix a few styles of dining chairs with a completely different style table. You take more furniture risks than the average person. You prefer small shops, the flea market, or specialty stores to large furniture showrooms or department stores. While you might like a pair of brass candlestick holders and an eight-arm brass chandelier, you would never consider putting them in the same room together. Most people who have funky/eclectic style usually take a very hands-on approach to decorating. Eclecticists will sometimes change the objects that they find or purchase by changing some of the original elements. You might find a pair of interesting wood-column lamps but decide that the color isn't right and change it to blue instead. Maybe you found a great piece of fabric on your trip to Zambia and decide to throw it over the arm of that classic arm

OPPOSITE: Who says your chairs shouldn't match your shoes? ABOVE LEFT: A goldfish in a glass bowl makes not only a nice household pet but a great decorative accent at the same time. ABOVE RIGHT: An eclectic interior even the Little Rascals would appreciate.

chair in your formal entry. Whatever the choices the eclecticist makes, they are usually varied and generally reflective of people with a very wide range of different tastes. You are not afraid to experiment with color, and you see paint as simply another opportunity to explore new boundaries that most people shy away from. You could be equally happy living in a small city apartment or in a spacious converted warehouse. You are far from predictable in your treatment of fabrics and colors and have been known to change things on a whim. You definitely know about the latest trends, but rarely do you fall victim to them. You somehow know how to incorporate the essential aspects of these trends into your own personal style. Most eclecticists love to travel and usually tend to have an adventurous spirit when it comes to furnishing their homes.

Simple Style

If you look up the word *simple* in the dictionary, you will see it defined as "easy and not difficult." While this may be true in a literary context, it is far from accurate in a decorating and design one. Most people do think that simple means plain. Plain suggests ordinary, and the people who fall into this style category are far from ordinary. Simplicity has more to do with restraint and discipline than it does with anything else.

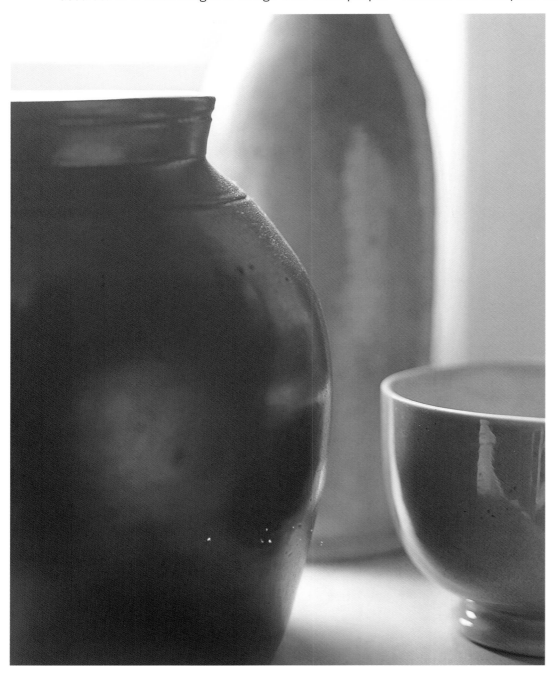

Most simplicitists have the ability to live life quietly and without a lot of things; purchasing things they need is somehow symbiotic with the things they want. I recently was at a photographer's home in Upstate New York. He and his wife and two kids lived in a way that I consider representative of someone who likes simplicity. Each room contained a minimal amount of furniture. In their master bedroom they had a bed, a dresser, a night table, and one lamp. The entire house was painted and plastered in white. There was something truly serene about their home that made me

LEFT: When grouped together, these simple ceramic pieces make a pretty yet unpretentious display. OPPOSITE: Surround yourself with the calming scent of flowers and with visually appealing yet simple accessories.

start walking around my own house, trying to figure out what I could get rid of when I returned home later that evening. Unfortunately, I realized that no matter how much I admired their simplicity, I couldn't part with my Sony television or alarm clock, numerous pictures on the walls, decorative objects, or scented candles. Swedish interiors and Shaker are two styles that often incorporate the principles of simplicity. The people who fall into this style category want to pare down and get back to basics. Like the modernists, they have a stong aversion to tchotchkes and knickknacks. Simplicitists probably would prefer an eighteenth-century post-and-beam barn in the woods to a prefab house in the suburbs. People who fit

into the "simple" style category like painted furniture and appreciate the natural patina of older things. Most simplicitists also like older and distressed furniture rather than things that are very new or elaborate and that don't involve some degree of history or craftsmanship. Most simplicitists savor the delicacy of spaces that are not overly adorned with things that basically aren't practical. It's not that they want to live in spaces that are void of personality — they just want things that lend themselves only to the necessities of everyday life. While many people might find these spaces slightly peculiar or think that they are half empty or unfinished, there is a certain elegance and ethereal quality to these minimally furnished dwellings.

Country Style

Countryphiles like big pine tables, stenciled chairs, and painted furniture. They enjoy fireplaces and big, comfortable sofas, iron lamps, and the feel of wooden furniture — generally pine or oak. You do not have to live in the country to be a countryphile. It is a generic style based on things that are consistent with country living. Countryphiles don't mind stuff that looks weathered or naturally distressed. They might like American country styles or European country. Countryphiles like the simplicity of Shaker, or maybe they also like the patina of old paint. People who fall into this category fantasize about owning land in the country and love to garden and enjoy a wide range of outdoor activities. Most countryphiles like plaids, prints, and stripes and may even feel comfortable combining these different patterns for the interior of their homes. Most countryphiles would prefer to buy a stone farmhouse with rolling hills and a pond rather than a brownstone in the city. Most aren't particularly concerned about the pieces they own being in perfect or pristine condition. They tend to appreciate the natural flaws of things and see these details as full of character rather than as imperfections. Most countryphiles do not like the rigidity of city life — noise, congestion, and traffic. Instead, they appreciate the mountains, the woods, green pastures, and a rushing river. Convenience for country folks means living close to nature, not living close to the subway. Most countryphiles like the idea of having a big kitchen and family room for friends and family to hang out in. While many people who fall in this category may prefer to only be part-time country people, they still enjoy the benefits of escaping to more rural places and love to shop at local flea markets for furniture and at local farmers' markets for fruits and vegetables.

LEFT: Despite what most people think, it is possible to be rustic and elegant at the same time. OPPOSITE: The brick floor and pine table make this breakfast room truly rustic in style.

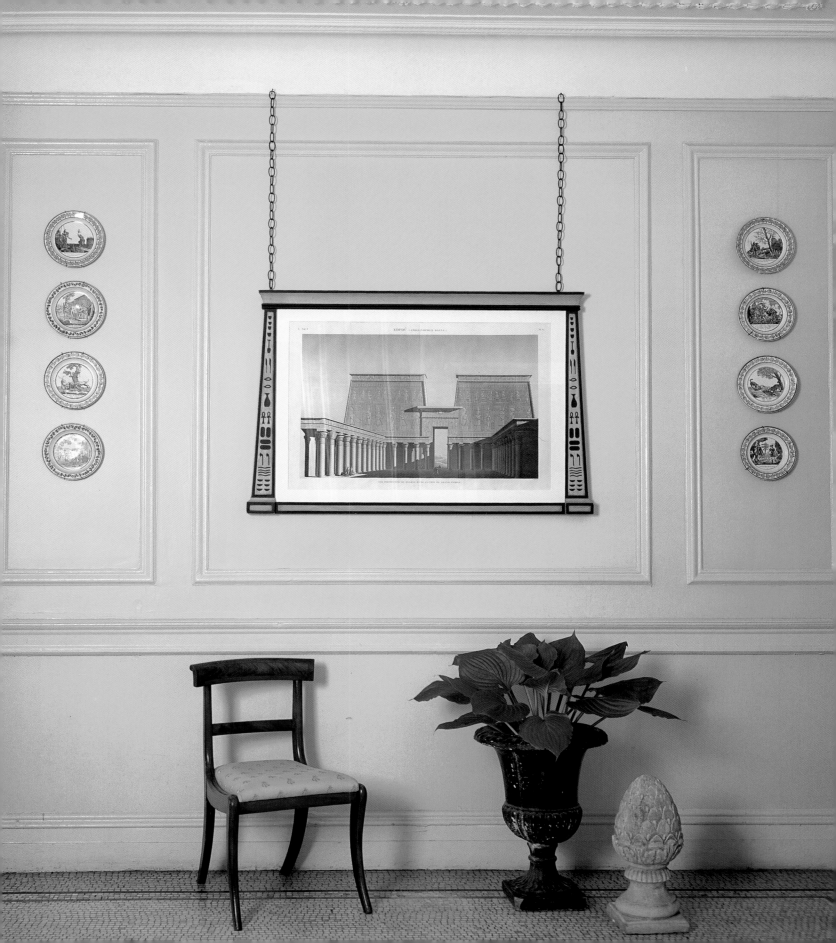

Classic Style

You are attracted to furniture that has a European influence. Generally, you like things that are not particularly ornate and pieces of furniture that have very clean lines. You like architectural details such as moldings and columns, and symmetry is important to you. You appreciate furniture designs that are elegant and timeless and things that won't ever go out of style. Laura Ashley florals and prints send you into a tailspin. You usually like monochromatic or duochromatic color schemes but also enjoy bold historical colors. You wholeheartedly support the tenets of classical architecture and often use those principles in your approach to decorating. Balance, whether it is a pair of chairs or a pair of vases or lamps, is extremely important to you. You probably would prefer to live in a town house rather than on a farm with an outhouse (unless the farmhouse or outhouse is classically proportioned and has distinctive charm and elegance!). Things must have a sense of order to them to be truly classical. Egypt and Rome would be on your list of places to visit because of their contributions to classicism. You like fireplaces and mantels and Greek Revival and Federal architecture. While you could probably make do living in a newly constructed home, it would not be your fantasy. Because you think that most pieces of furniture get better with age, you tend to buy older things that won't look dated. You can appreciate Biedermeier furniture as much as Regency or Empire.

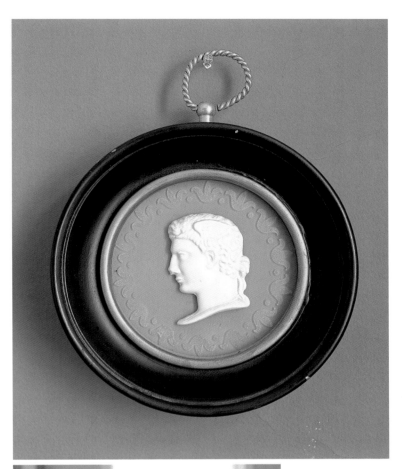

ABOVE: A Roman-inspired medallion is a classic motif commonly found in classic style. RIGHT: Blue and yellow used together is often considered a classic color combination. OPPOSITE: This entry hall is a perfect example of classic style.

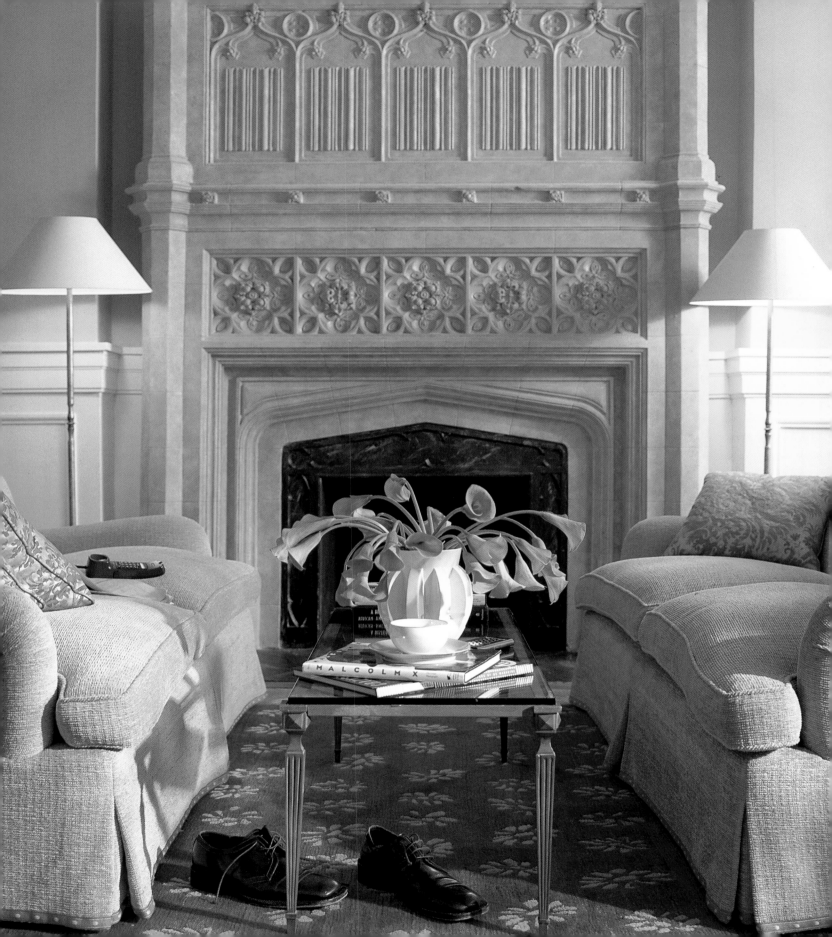

Comfortable/Casual Style

Your basic design philosophy is that if you have to worry about it, you don't want to own it. Your idea of style is simply related to comfort. You have no specific style that you clearly identify with. You just like things to look "nice" and be functional. You have no particular knowledge of furniture styles or periods and aren't really interested in learning about the history of furniture. All you know is that you want the sofa to be long enough for your head and feet to fit comfortably without hitting the armrest. You hate precious furniture — pieces that you, your kids, and your dog or cat can't hang out on. The dinner service you received for your wedding gift collects dust in the cupboard because you really don't have any occasion (other than major holidays) to use it. If your spouse would let you, you would have your refrigerator moved out of the kitchen and into the family room, right next to the sofa for convenience. You feel more comfortable living with white walls or shades of white rather than bright colors. Boldly colored rooms such as blue or red make your palms sweat. You would probably rather live in a single-family house in the suburbs than in a city apartment. You'd prefer a backyard barbecue to a formal sit-down dinner party. You've got lots of unfinished projects in the basement or garage. You would rather go to a football game than to the opera. Your idea of comfort is sleeping on a hammock between two trees or relaxing at the beach on a bright sunny day.

Comfort was a key component for the decoration of this living room. These plush sofas make you want to kick off your shoes and relax.

"A billion here, a billion there, and pretty soon you're talking about real money. "

—EVERETT McKINLEY DIRKSEN

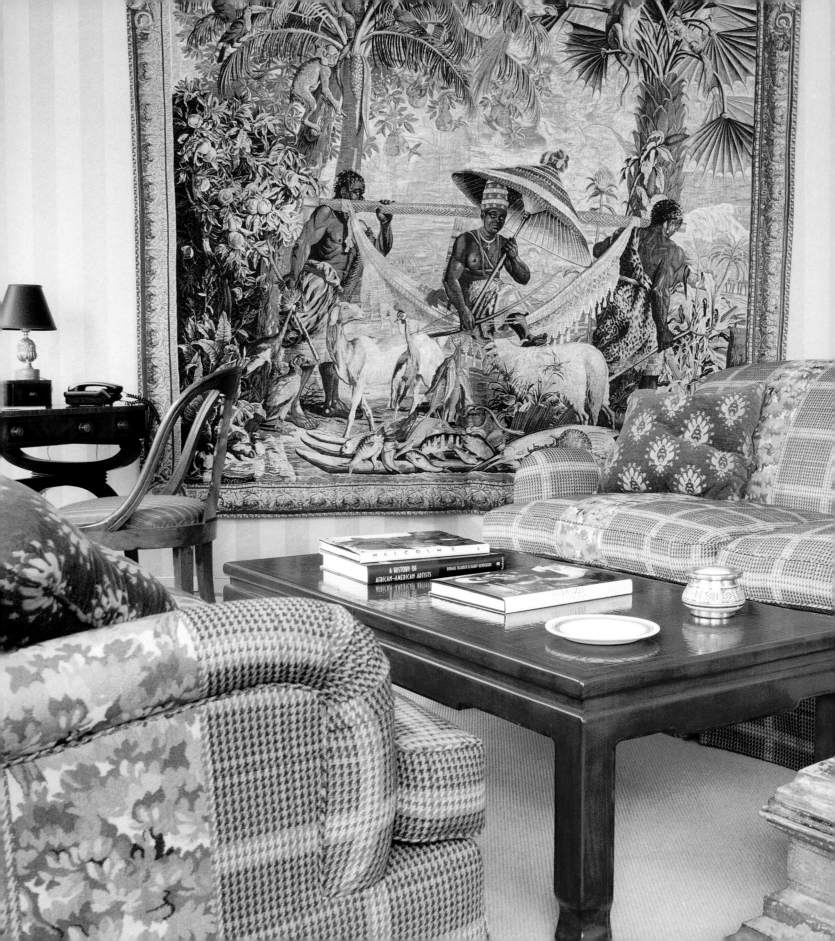

math anxiety

AND FEAR OF THE BUDGET.

One of the first questions an interior designer must ask potential clients is about their budget. For whatever reason, discussing a budget with a designer (even if you've hired him or her to decorate your home) seems to make people break out in hives. I sometimes wonder whether clients think that I will be inclined to judge them by their budget and pin them like Hester Prynne with a scarlet letter *B.* Establishing a realistic budget is quite simply an essential part of the furnishing process. While "What is your budget for furnishing your home?" appears to be a very personal question, it is one that needs to be seriously contemplated and addressed realistically. Everyone has a different idea of what a little or a lot of money is. On many occasions I have had potential clients say that their budget is "big" or "unlimited." When I ask specifics in order to understand exactly what "big" is,

sometimes I find out that we are not on the same budgetary page at all. I may think that a big budget is $100,000, and you may think that a big budget is $10,000, or vice versa. In either case, it is important for the designer and the client to be at least in the same budgetary hemisphere. As designers and decorators, we need to ask this question in order to figure out how to approach the project at hand. We do not ask because we want to know how much money you earn!

If you tell me that your furniture budget is $10,000, I know that I might have to approach your project differently than someone who has a $100,000 budget. For the person who has a $10,000 budget, I will be looking for furniture primarily at flea markets, estate sales, and showroom sample sales rather than shopping at showrooms or buying antiques from exclusive dealers or expensive auction houses like Sotheby's or Christie's. If you have a budget that is closer to $100,000, then obvi-

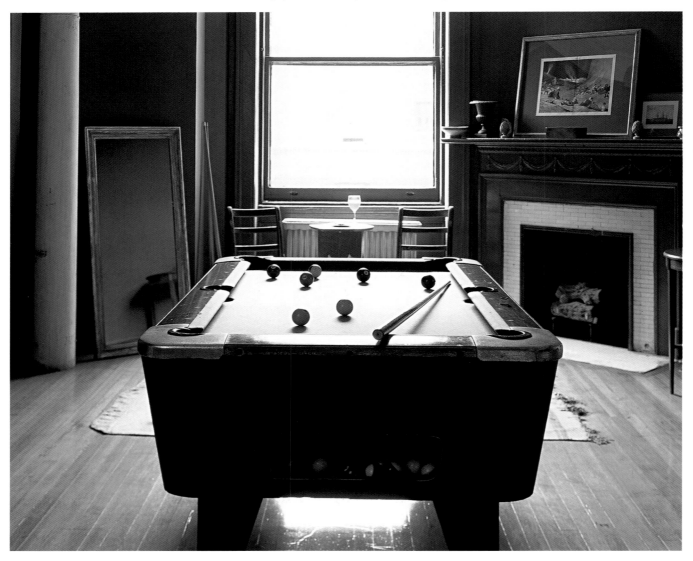

ously there are many more options with respect to where you can buy furniture and the choices available to you. You can shop at the same places as the person with the $10,000 budget, but you will also be able to shop at the more costly showrooms and retail stores. With a $100,000 budget, you can even afford to have many pieces of furniture designed and custom made for you.

Remember this important budgetary rule: bigger is not always better — especially if you do not spend your money wisely. Many people purchase expensive furniture and decorative items that do not wear well or that look dated or out of style within months of buying them. If you are willing to commit financially and emotionally to making significant furniture purchases for your home, you should really consider purchasing items that you will have for a lifetime. And if a lifetime seems too intimidating, at least be willing to settle for a long time. In my own experience, it is very frustrating to have spent money on a piece of furniture that does not live up to the expectation you had before you purchased it. That is why it is extremely important to really contemplate the pros and cons of the items that you are interested in, *before* you make the actual purchase. Whether you have $10,000 or $10,000,000, try to purchase things that are reasonably within your financial limits and things that you can imagine still wanting to own in five to ten years. If you think that you are simply buying something to satisfy some other craving (like you just went on a business trip to New Mexico and now you want to buy everything in Santa Fe style), you are probably making a decision you will regret later.

Ultimately, there is no reason to be self-conscious about wanting to spend a lot or a little bit of money on

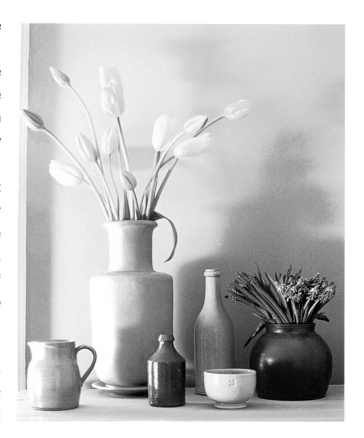

PAGE 44: This pair of custom-made sofas and colorful wall tapestry are valuable purchases that can be used even if the client eventually moves to another home. OPPOSITE: Budget for big pieces. If you love to play pool, try to save up for that antique pool table that you think you can't afford. ABOVE: You don't have to break your piggy bank to decorate tastefully. I bought this inexpensive collection of assorted ceramic pieces at the flea market.

furnishing your home. Only you can determine what is realistic for you to spend to make your home as beautiful and stylishly livable as possible. Most people wish that they had more money with which to decorate or renovate, but in reality we know that spending money on your child's tuition or on your mortgage is a lot more important than purchasing that English side chair or that dazzling Venetian chandelier.

Establish a budget for home-related things the same way you would set aside money for a set of golf clubs, a new snowboard, or a spring vacation. If you are really disciplined, you might consider opening a separate account just for home-related purchases. By establishing a "furniture fund" that you can withdraw money from instead of taking it from other places where it's needed — like your IRA or 401(k) — you will have funds readily available when you come across pieces of furniture that you really love and want to purchase.

One of the other things that I have noticed when talking to people about budgets is that most folks don't seem to know how much furniture *really* costs. When was the last time you priced a sofa or a bed or found out the price of a dining table you saw in a magazine? Spend a Saturday morning going to various retail shops to look at the price tags. Or if you are feeling social, engage a salesperson in conversation, and talk to him or her about how much things cost. You may find that things are a lot more expensive than you had originally thought. Most likely, that eight-foot French Country pine dining table you've had your eye on is actually $2,500 instead of $250.

Take your time to do the required research. When most people consider buying a car, they have a few models in mind before they actually start pricing them or going to car dealers. Say that you want to buy an SUV. Maybe you are thinking about a Ford Explorer, a Land Cruiser, or a Land Rover. Whatever your budget, you would probably look for the best deal once you had decided on the model and year of the SUV you wanted. You might purchase it from an ad you saw online or in the newspaper. Or maybe you have decided you would rather lease that new Land Cruiser from your local Toyota dealer instead. The point is that you probably did your homework before making the purchase.

For bigger and more expensive furniture purchases, you should go to quite a few stores to check out prices. Is anyone having a year-end furniture clearance sale or floor-sample sale? Read the newspaper. You'll be sur-

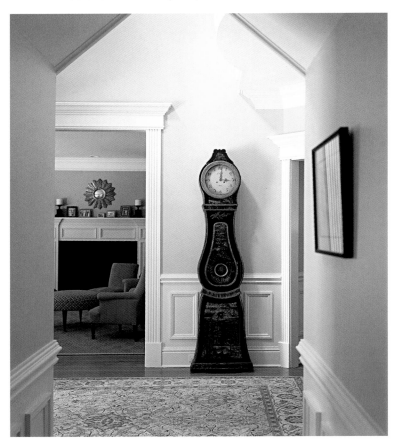

LEFT: This antique Swedish clock and Oriental rug add color and texture to this entry hall. OPPOSITE: I originally purchased this set of six oak dining chairs at a flea market but later resold them to a client.

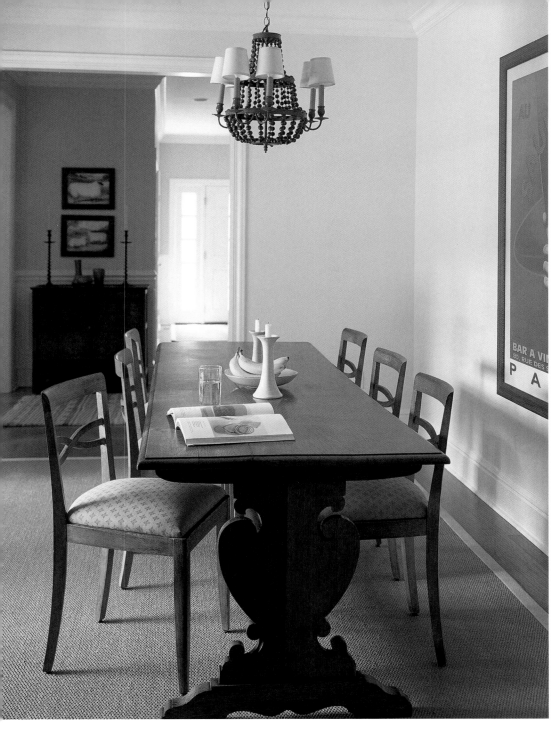

sales provide great opportunities for people to find nice furniture at reasonable prices. I have a friend who used to bring $100 with him to his local flea market each weekend. He would leave his wallet at home in order to avoid the temptation to spend more money. That was his way of establishing a budget.

Be realistic about what you can and can't afford to buy. Just because you can't afford that Biedermeier chest today doesn't mean that you won't be able to afford it next year. There is nothing wrong with wanting to live comfortably. But living comfortably should not make you go broke. If keeping up with the Joneses means filing Chapter 11 and losing your home in the process, apparently you need to reevaluate a lot more than just your furniture budget. And

prised at how many furniture sales are advertised weekly. Again, there are many places to shop for things. Don't feel as though you are restricted to a furniture store or showroom. We tend to be creatures of habit. Be open to shopping at places you've never been to before. Flea markets, estate sales, auctions, tag sales, and rummage besides, weren't the Joneses the people down the block with the black lacquer and leather furniture and the aboveground kidney-shaped pool in the backyard? Try to live and furnish within your means. Only you can know how disciplined you are and what type of spending habits you have.

"Thought is free."

—*The Tempest,* **3.2.133**

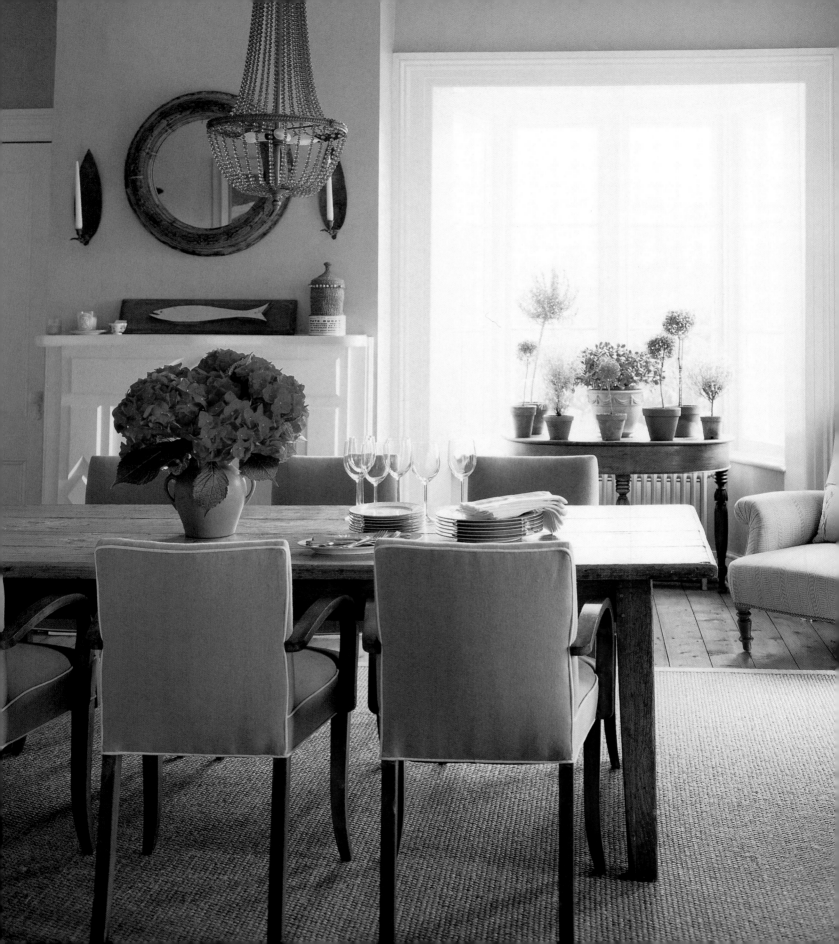

furniture codependency
AND SEPARATION ANXIETY.

Recently I had the good fortune to be invited over to an ex-boyfriend's apartment, only to find that ten years later he was still living (very comfortably, I might add) with my parents' old geometric-patterned shag rug, my IKEA particleboard stereo table, and my Conran's television stand. Even my old ficus tree was alive and well, thriving in his sparsely furnished bachelor pad. I must admit that it was oddly flattering to see that this man was either too emotionally attached or too lazy to get rid of my old furniture. Seeing all that stuff not only brought back memories but, more important, helped me realize that I have grown leaps and bounds with respect to implementing the philosophy of Furnishing Forward in my own life. The furniture I owned at twenty-six, in all of its particleboard splendor, had its rightful place in my life at that time. It was basic, economical, and extremely practical. Ten

years later my needs and lifestyle have changed dramatically. While these changes are visible in pretty much every aspect of my life, they are most evident — visually — in the type of furniture I now buy.

I still need to own a sofa, but it no longer has to have a pull-out bed for friends who want to crash at my place because they are either too drunk or too tired to make it home on a Saturday night. When I was twenty-six, the motivation to buy a dining chair had only to do with needing something to sit on to eat my meals. Where else was I going to sit when eating my takeout Chinese food every night of the week? Though I may have cared somewhat about the overall style of that chair, I didn't think too much about how it was actually made or what materials it was made of. At this point in my life, I think about those things and more. Now when I'm even remotely beginning to think about buying a chair for my home, the first question I usually ask myself is task- or purpose-related. Is the chair for dining, or is it going to be used for watching TV or reading? Is it a desk chair I am going to be sitting at for more than four hours in front of a computer screen? If so, does it have good lumbar support to alleviate the back pain that I get from time to time? Does it have adjustable seat height? Does it have casters so that I can roll around? Is it something that I will want to own for more than six months? Is the fabric durable or is it cleanable, since I always eat at my desk and tend to drop food on my chair? And, of course, the bottom line: how much does it cost? All these questions now come into play every time I consider buying a substantial piece of furniture. If you are in your twenties and find yourself thinking about these things before you make furniture purchases, then I would say that you are way ahead of the rest of the pack. Or at least you are certainly way ahead of where I was at that age.

At twenty-two a bed was simply a place for me to lie down at night. I gave no more consideration to the quality of the mattress and box spring I was sleeping on than to the pillows and pillowcases that I chose to rest my head on. None of it really mattered. While I look back on my twenties now with a broad smile about the completely nonchalant attitude I had about furnishing my home, I do not confuse nostalgia for wanting to live that way again.

At some point it becomes apparent that we are getting older and might want to live in a way that reflects our increasing maturity. But older does not necessarily mean more serious, boring, or predictable. I have many clients who are well into their

PAGE 52: My dining table not only works well for entertaining but doubles as a makeshift worktable when I need to spread out. OPPOSITE: This family room manages to be elegant and comfortable at the same time.

fifties and have some of the most youthful and playful homes I have ever seen. And despite all of the stigmas attached to age, there's nothing really wrong with getting older. And contrary to popular belief, you don't have to let osteoporosis set in before you decide that it's okay to spend money on that walnut side table you've been eyeing in that store window you pass every day on your way to work. In fact, one of the rewarding things about getting older is that you can justify purchases like that. When you are younger, people expect you to buy things that are impractical and unnecessary.

Although I cannot pinpoint when this transition into adulthood takes place, let's just assume that you begin to recognize some of the signs. You spend most of your waking hours at your job rather than in front of a TV watching *Sesame Street,* cartoons, or old sitcoms. Beer in your fridge starts to be replaced by chardonnay or white Bordeaux. You start ordering cocktails like cosmopolitans or vodka martinis when you go to bars or restaurants. You can't remember the last time you had a shot of tequila. Foie gras begins to replace french fries at dinner parties. You are a frequent flyer and think about the number of miles you are earning when you travel. You have a credit card that isn't cosigned by one of your parents. You look forward to having no plans on the weekend so that you can catch up on rest or reading. Whatever the sign is to you personally, pay attention to it and begin to approach the way you furnish your home in the spirit of your new adulthood. Embrace the fact that you can actually afford to sleep on something other than a futon for the first time in ten years. You'll find the view eight inches above the floor to be more breathtaking than you ever imagined.

Begin with small forward steps and minor changes. Start asking questions about the way you live or want to live. Try to answer those questions honestly without making up lame excuses or sneaking out the back door. I remember a friend of mine telling me a few years ago that she didn't have time to focus on her home and that when she eventually met her future

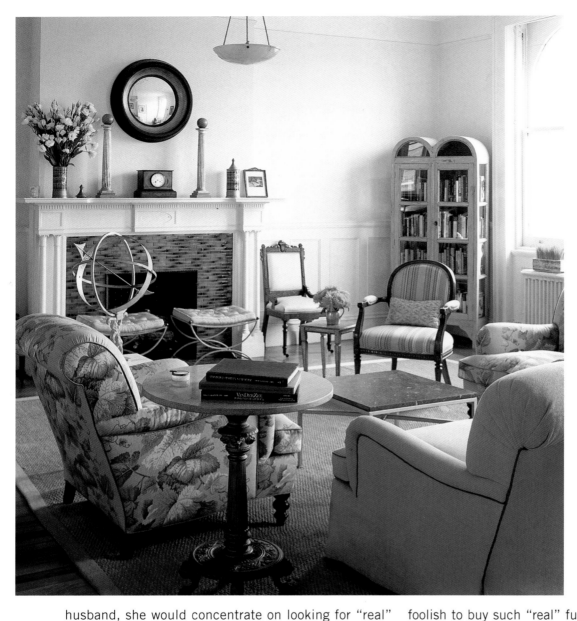

horse, but the horse would be hauling a houseful of exquisite furniture for her to choose from.

I remember about ten years ago when I was working for another interior designer, I arrived at the office, excited about the possibility of getting a great deal on some very well crafted, handmade upholstered furniture for my living room. An architect whom I worked with at the time told me that I was

husband, she would concentrate on looking for "real" furniture after she got engaged. Initially, my feeling was that any man who had any sense (or had seen her unfurnished apartment) would have run in the other direction instead of thinking about marriage. Finally, I became convinced that someone had read her too many Sleeping Beauty–type fairy tales as a child. My friend was emotionally attached to a fantasy that Prince Charming was going to suddenly appear at her front door. Not only was he going to be riding a white

foolish to buy such "real" furniture when I wasn't even dating anyone seriously. "What does buying a club chair and a two-seat sofa have to do with having a boyfriend, exactly?" I asked. He replied that it made it seem that I was inflexible and set in my ways. He proceeded to explain that men wanted to be with women who would be open to *their* suggestions as to the type of furniture they would eventually live with. The idea of putting my life on hold for someone who didn't exist in my life was completely absurd to me. Although I appreciated his point

about being flexible in a relationship, I found the concept that my owning something as basic as a chair and sofa might be off-putting to a potential mate slightly foreign and even a little bit scary. His comments reminded me of my girlfriend who was sitting around her unfurnished apartment, still anxiously awaiting Mr. Right's arrival. And today I can stand up straight and proudly say that the very same sofa and club chair have outlasted many marriages, including that of the chauvinistic architect I used to work with.

Before you begin to think seriously about furnishing your home, begin to look critically at the things you already own. Do you like your furniture? Does it reflect who you are, and is it consistent with your lifestyle? If it isn't, consider starting to buy things that will at least support if not completely embrace your lifestyle. Do you love to have people over to play cards? Maybe you should think about buying that round oak table you saw when your girlfriend dragged you to the flea market last Saturday morning. Or maybe you should revisit that online furniture site that was selling an interesting set of metal dining chairs when you were surfing the Web last week. At some point it becomes necessary to take some initiative. Why not shock your friends and family by snapping out of your decorating stupor and making that first *real* furniture purchase? You will find that it becomes much easier once you actually begin.

One of the decorating hurdles that people find most difficult to get over has

to do with their emotional attachment to furniture. Everyone is attached to things for different reasons. Some of those reasons help provide convincingly legitimate explanations for why you need to hold on to certain things. But more often those explanations are just ridiculous attempts to rationalize why we can't get rid of stuff we've clearly outgrown. Clients, friends, and family members often explain to me why they can't bear to part with something. Their thinly veiled excuses range from "My ex-husband slept here" to "My dog peed there" or "My wife's cousin's brother-in-law's step-

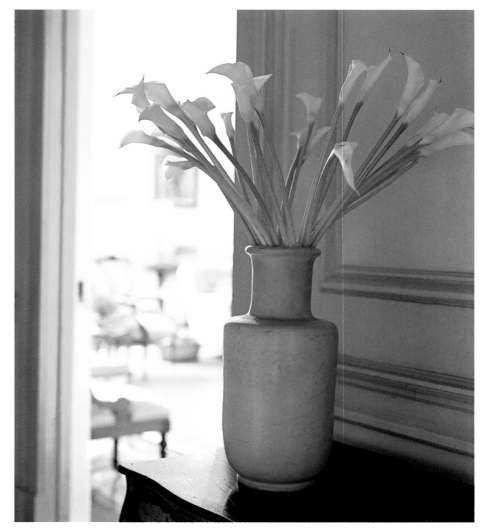

sister owned that table." Try to reasonably separate what really matters from what doesn't. Does it matter that you keep your wife's cousin's brother-in-law's stepsister's old table? Probably not. Consider giving the furniture in question to someone that might appreciate it more than you do. In this instance, that someone might be your wife's cousin or your wife's cousin's brother-in-law.

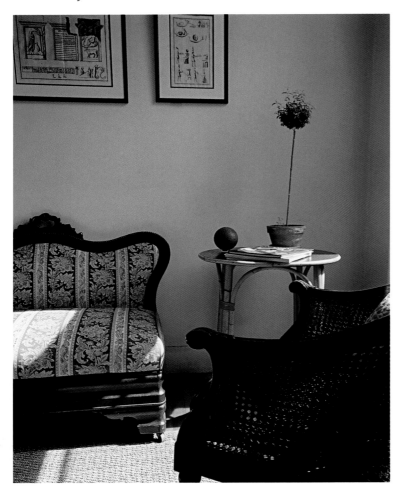

ABOVE: Since this east-facing room basks in the early-morning sunlight, it has become the perfect place for drinking a cup of coffee and reading the morning newspaper.
OPPOSITE: The theory that less is definitely more is illustrated by this simple painted antique sideboard accessorized with a small pair of lamps and a colorful painting on the wall.

Nostalgia can sometimes get the best of us, but don't let it be the driving force that guides you through the process of design and decoration. I had a client who once took a fabulous trip to the Greek island of Santorini. Everything about his vacation was wonderful, including the women, the weather, the beaches, the hotel, and the food. Upon his return, he suggested that we "whitewash everything and completely change the decor to have a Mediterranean feel." I suggested that we go out for a Greek salad and talk about the NBA playoffs instead. People often take the nostalgia ball and run with it. Keep things in perspective if you can. Some of what makes a vacation special is that it is so very different from your everyday routine and existence at home. Don't try to re-create an experience that is truly original and authentic. That's part of what makes it memorable in the first place.

The same theory applies to impulse purchases. Just because you are overwhelmed with a sudden urge to buy a pint of Häagen-Dazs ice cream doesn't mean that you should always succumb to it — especially if you are trying to lose fifteen pounds before Memorial Day. Letting yourself be driven by nostalgia, sentiment, or impulse will probably only guarantee that eventually you'll wind up in a pretty bad accident. And unfortunately there's no AAA equivalent in the decorating world to help you tow your La-Z-Boy chair out of the house.

We also inherit furniture from friends and family members. It may be that your grandfather passed away and left you his favorite maple desk. Or perhaps your parents moved to Florida recently and left you the bedroom furniture from your childhood years. We attach a great deal of significance to these objects because of

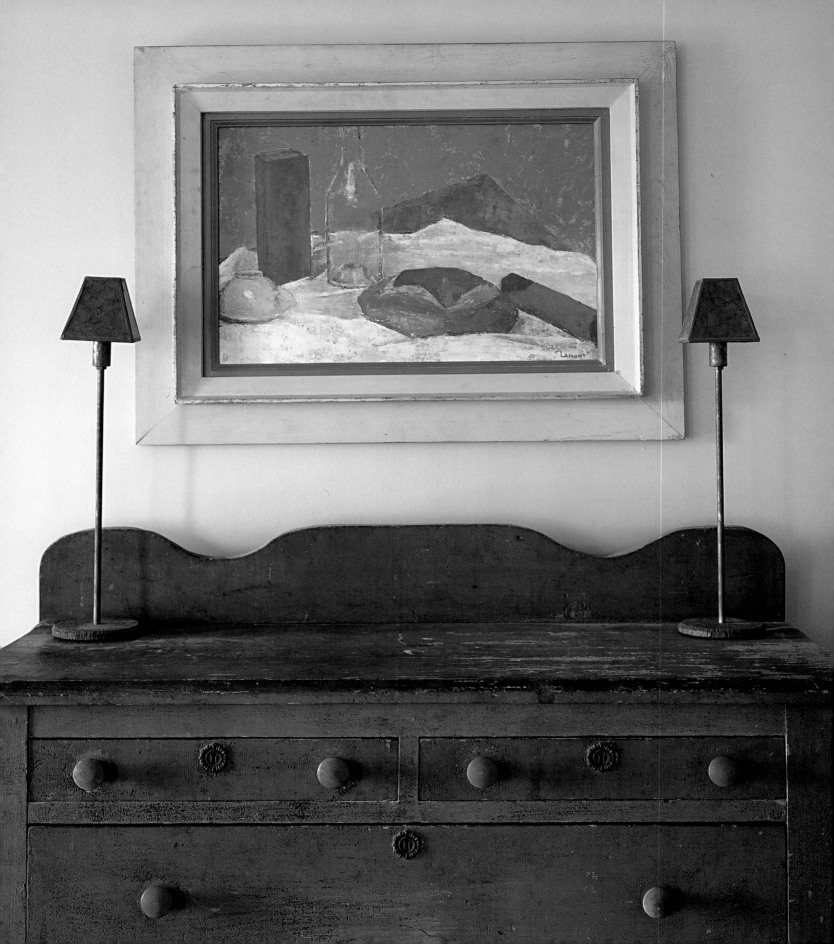

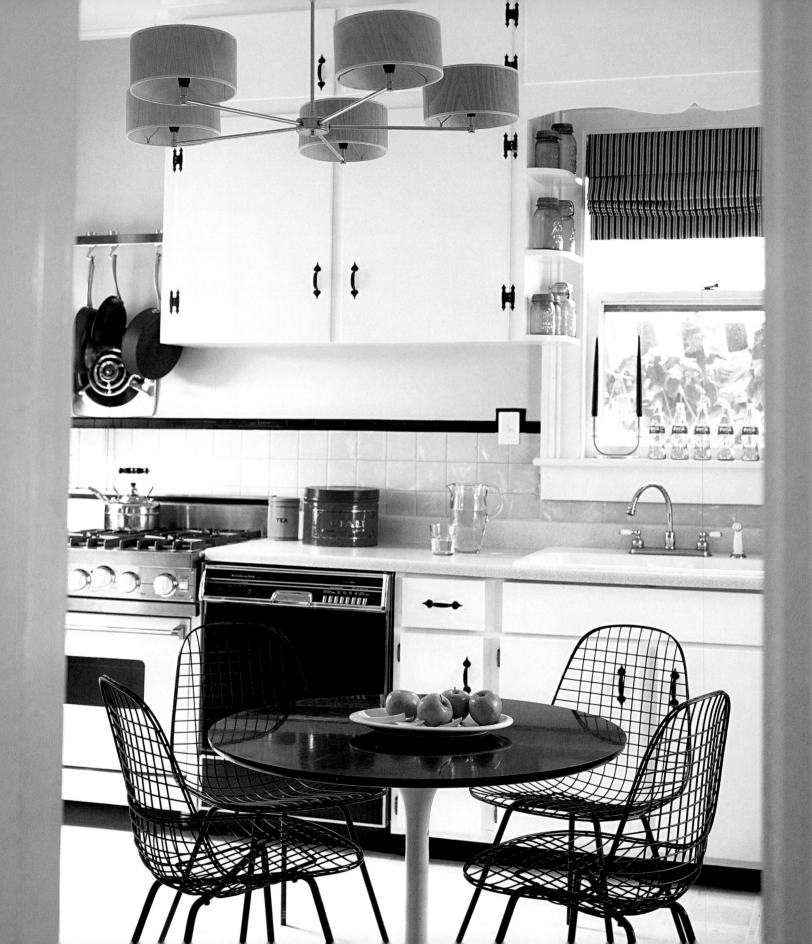

the memories and experiences associated with them. Your grandmother's oak rocker may conjure up images of your visits to Virginia as a child, while other objects may stir up emotions far less positive and infinitely less meaningful. Either way, it is important for you not to be overwhelmed by guilt when making decisions about what you should and should not keep. I've always thought that it was kind of ironic that the people who've known us the longest usually give us gifts that we don't want, need, or like. That sterling-silver platter that was *not* on the bridal registry. That housewarming gift from Kmart that even Martha Stewart would want to hide in the bottom of her closet. If you can help it, try not to engage in "decorating deception." Decorating deception is what you do when you know that someone who has given you something you don't like or can't use is coming to your home to visit. You begin a search-and-rescue mission to retrieve that set of paper doilies that your mother gave you three years ago as a housewarming gift. Suddenly, that cut-glass vase from Tiffany that you never liked comes down from the top shelf of your cupboard and is displayed with flowers in the middle of your coffee table. Although your intentions are well meaning, sometimes you do yourself and the gift giver a disservice. Taking that gift out of hiding and displaying it front and center may send a deceptive message. My next-door neighbor is an emergency-room doctor at a local hospital in Upstate New York. Periodically one of the older nurses he works with brought him chocolate-covered prunes for holidays and other special occasions. He was

Mixing old and new styles in the same space can help you to achieve an eclectic interior.

so complimentary of her generosity that she mistook his compliments for a love of chocolate-covered prunes. Never mind holidays and special occasions, now she regularly throws caution to the wind and brings him cans of chocolate-covered prunes. Although he feels guilty, he nonetheless accepts those prunes graciously, knowing that they will eventually be fed to his dog.

Unless you know someone extremely well and know what his or her tastes are, you probably should buy gifts that have nothing to do with the home. People give us things all the time. Some people really think a lot about what they are giving, and other people don't. And yes, what your mother told you was true. It *is* the thought that counts. But don't feel compelled to make things work in your home if the thought that counts happens to clash with your living-room sofa. In reality, if you are really given something that is from the heart, and you feel good about, it will work in your home.

Conversely, there have been situations in which as a designer I have been asked to make something of emotional significance fit into a space. Many people have collections of things that they want to have incorporated into the design scheme of their home. Maybe you collect Arts and Crafts vases, Depression glass, or antique dolls. All these personal collections should be able to fit into your decor if you plan ahead properly. It may necessitate that you build a special cabinet or delegate a certain amount of wall space to them. But no matter how you display them, your individual collections are a terrific way of expressing your personal interests and passions.

I have found emotional-attachment issues most prevalent among recently married couples. He may insist on keeping the king-size black lacquer and leather

headboard from his bachelor days. She may try to convince you that it will be more romantic to sleep in her full-size canopy bed with the frilly dust ruffle and floral shams. Either way, it boils down to flexibility and willingness to compromise. While most couples' tastes seem to become more similar over time, some may stay vehemently opposed. Realize that there are some instances when you will have to yield, and vice versa. Don't break up a perfectly good relationship over a set of stemware. If compromise could get us out of the Cuban missile crisis, surely it can get us out of decorating disagreements. It's okay that he likes using paper napkins and you prefer linen. It doesn't mean that you are headed for a divorce. Use paper Monday through Thursday and linen on the weekends. Whatever works so that you can continue to break bread together rather than apart.

Shop for things together so that both parties can share equally in the process. Or if there is no way to compromise on certain items, buy a house that is large enough for both of you to have your own private spaces in which to indulge your individual and idiosyncratic furniture fantasies. If you want that pink velvet chair and he doesn't, maybe it should go in your study instead of the living room. One of the terrific things about well-thought-out furniture purchases is that most things can work in spaces they weren't originally intended for. I can't even remember how many times I've bought something with a certain room in mind, only to find that when I unloaded the piece from the backseat of my car, it actually looked better somewhere else in my house. When you think forward about buying furniture, always think about its potential afterlife. By "afterlife," I mean that furniture can serve one purpose for a few years and then move on to another function at a later date or time. I often have clients who periodically change things in their homes. If they are fortunate enough to own multiple residences, one of the easiest solutions is to send things to one of their other homes. Maybe it worked for a few years in the city, but now we'll send it to the beach house. You may not have multiple homes, but you do have multiple uses for things. A dining table may be used to eat at, but it may also be used as a work surface. I will never forget waking up at 5 A.M. in high school so that my father could help me cram for chem-

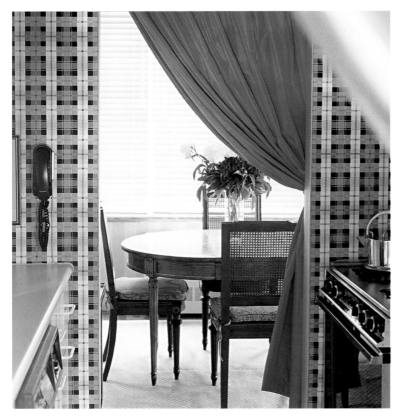

LEFT AND OPPOSITE: We installed a "portière," or curtain, in this client's home to separate his dining room from his kitchen. The fabric is red on one side and gold on the other.

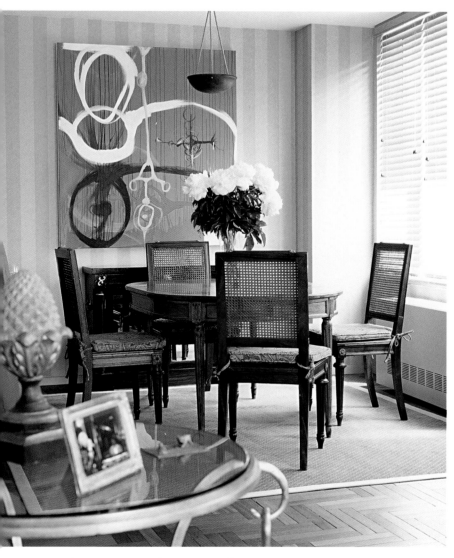

satility and adaptability of that five-foot-round white-pedestal table in my parents' breakfast room.

Good furniture should be versatile. It should be able to move and work in a multiplicity of roles and places in your home. Maybe you eventually find a new dining table and want to retire your old one. Don't simply put that old table out to pasture. Find another place for it, another use for it. Maybe you could use it at your country house. Maybe it works in your garage as a fancy worktable. Or maybe it finds a new home in your greenhouse as a place for potted plants. Just because you retire from the workforce at sixty-five doesn't mean that you can't or don't want to work anymore.

Think about what things in your home you can truly live without. Some things without a doubt are just there, simply taking up space. Think about what you've spent on an item and ask yourself if in fact you got your money's worth. You don't need an MBA from Harvard to do this type of regression analysis.

istry exams before school. These last-minute study sessions were always conducted at our breakfast-room table. The table was large enough to comfortably spread out books, papers, calculators, and notes. Chemical equations and empirical formulae were written on napkins and paper towels. Periodic tables took the place of cups, saucers, and silverware. When it was time for us to eat breakfast, my last-minute chemistry lesson came to a screeching halt as the breakfast table suddenly changed back to its former self. While I may not remember how many solute molecules are contained in a milliliter of a 0.1-M solution of a nonelectrolyte, I do remember the ver-

Buying good furniture is a little like eating a box of delicious chocolates. Once you eat one, it's hard to convince yourself to stop eating them and put the box away. The more you purchase great furniture, the more obvious it will become to you that other pieces in your home can also be dramatically improved upon. Once you are exposed to one piece of smartly designed and beautifully crafted furniture, you will probably begin to understand the inherent value in owning multiple pieces. Understanding this value is what will ultimately help you break the emotional ties to furniture that you know you have probably outgrown.

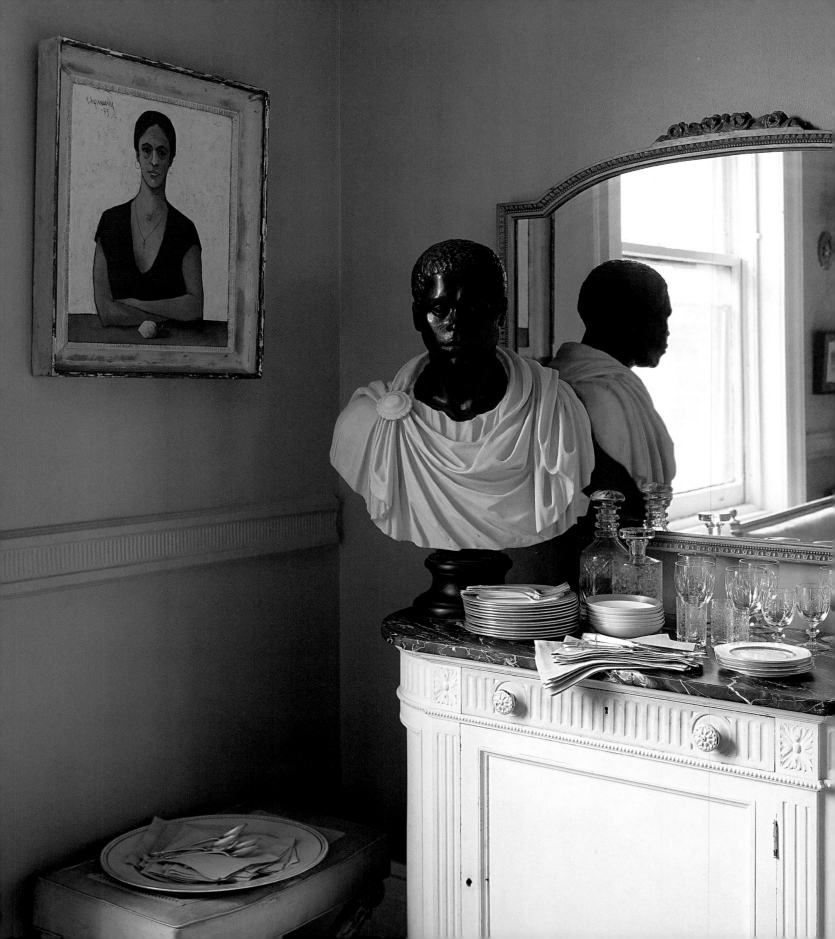

"It's not that easy bein' green."

—KERMIT THE FROG

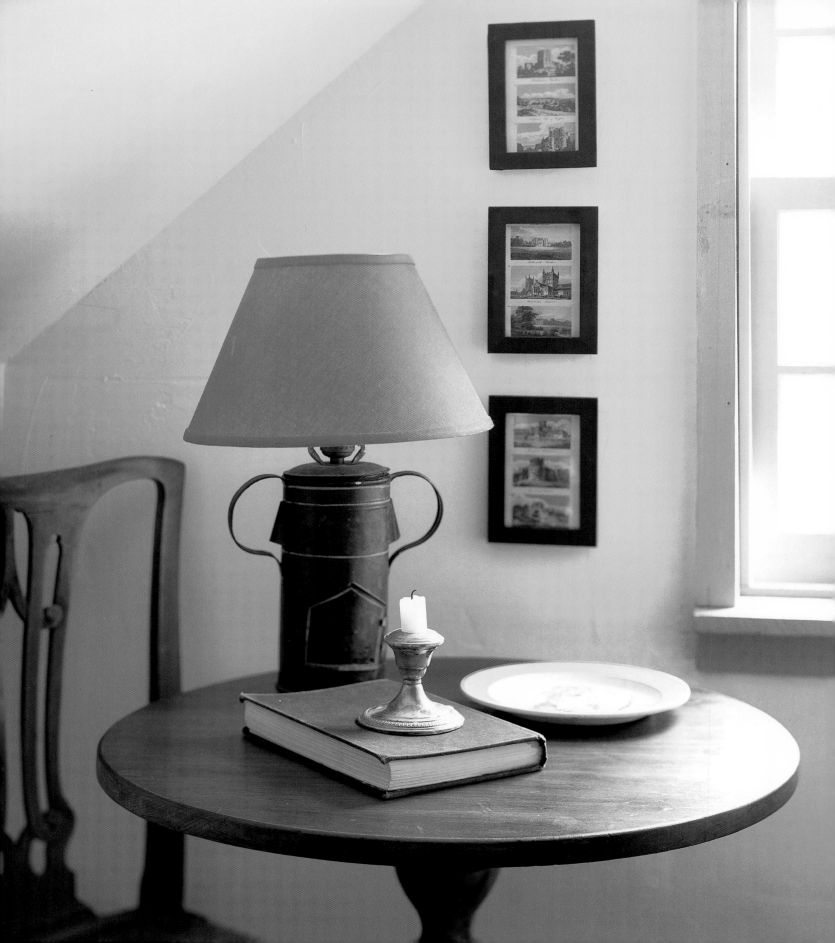

the color inferiority complex

WHILE I MAY HAVE inherited my mother's height and my father's hair, I know that I could not have inherited my color inferiority complex from either of my parents. Throughout my childhood I watched with fascination as my parents jointly chose atypical color schemes to decorate the various rooms in their home. Whether they were choosing bathroom tile or bedroom carpet, my parents seemed to embrace color with a passion that would have made you wonder if they were reincarnated decorators or had been color-blind in a previous lifetime. They boldly created color combinations that I would have never thought of and that probably didn't even exist on the color wheel. Maybe it had less to do with them and more to do with the times. The sixties' psychedelic color influences combined with the seventies' disco flair helped give them a type of confidence that I have yet to duplicate. In the late 1970s, our sunporch

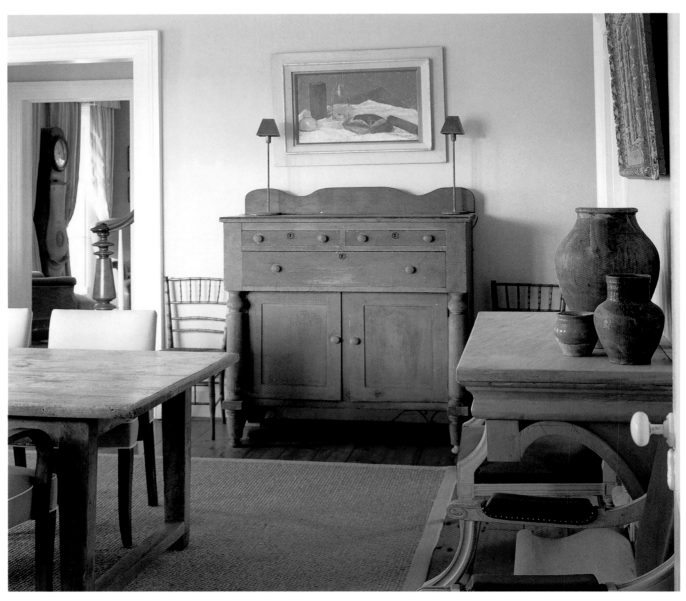

had a black-and-white zebra-print floor with two small shag area rugs on top — one red, one white. The contrast between the black-and-white floor and the black baby grand piano and black floor-to-ceiling bookcases seemed to make everything in the room come to life. The red and white shag rugs matched the red leather love seat and white fiberglass chairs. There was no doubt about it. The colors were cutting edge. I remember my friends saying that our sunporch was unabashedly hip and that my parents were cooler than theirs. The same bold scheme continued into my parents' master bedroom, which had red wall-to-wall carpeting, black-and-white wallpaper, and black, gray, and red accessories. Even their bathroom matched. My mother even hooked a small bathroom rug in red, gray, and black so that the bathroom would match their bedroom down to the finest detail.

When I was a teenager, I was given a choice of two color schemes for my bedroom. The alternatives were in the plum family or the orange family. Since I didn't want my bedroom to look as if it had been hijacked by a Creamsicle or a glass of Tang, I chose the plum scheme. I ended up with an abstract floral wallpaper that was plum, gray, pink, and white. My father installed the wallpaper with little help from me, although I do remember cutting out a small piece the size of a quarter to fit in the middle of my white rotary telephone. My bedroom was appointed with white furniture trimmed in polished brass, a plush plum carpet, and a reversible pink and plum bedspread and comforter. I lived in that bedroom well into my late teens and never complained, but slowly developed what I consider in retrospect to have been an acute color inferiority complex. A color inferiority complex is basically a fear of any room that is painted any color other than white. The bolder and deeper the color, the bigger the complex.

At eighteen, off I went to college, and not only did I love my new, supposedly adult indepen-

dence but I equally loved my white dormitory room. I was thrilled to have all-white walls — a blank canvas to create my own personal decorating imprint. My choice was a Marimekko flower pattern in primary colors with a white background. The inspiration for those colors initially came from two posters (one by Alexander Calder and the other by Henri Matisse) that I had purchased from the Philadelphia Museum of Art. Like so many other designers in the making, I found the same kind of inspiration in art at eighteen that I still find at thirty-seven. I even went to the trouble of trying to convince my new roommate (whom I had not yet met) that she should bring a similar bedspread or comforter so that our room would match.

PAGE 66: Don't be afraid to experiment with color. This red lampshade gives this yellow room an unexpected splash of additional color. OPPOSITE: This green cupboard was the inspiration for the color scheme in my dining room. RIGHT: Minimally furnished rooms can often have an ethereal quality to them.

After graduating from college and moving to New York City, I continued on the same sorry path, embracing every white boxy rental apartment more than the last. White walls were all I could relate to. Every time I went home to my parents' house for vacation or a holiday, I cringed at all of those colors that I had grown up with and that my parents still comfortably lived with. My room remained intact, exactly as it had been left in 1982: a plum, pink, white, and gray shrine to a former life.

Although I'm not exactly sure when I got over or grew out of my color inferiority complex, I'm sure that it happened in stages. I do remember that my apprehension toward color initially began to subside after my first trip to Europe, where I saw all sorts of colors used in interesting and nonthreatening ways. After I took my first color theory class in design school, I was sold on color and really never turned back. The first time I painted a room in my own home with color, it was as though I had experienced a rite of passage. I still have an appreciation for white paint, but I am no longer afraid to experiment with the wide range of colors that exists. Maybe we develop more of an appreciation for color as we get older. Or maybe like many things, we just begin to get bored with the sometimes generic and predictable quality of white walls.

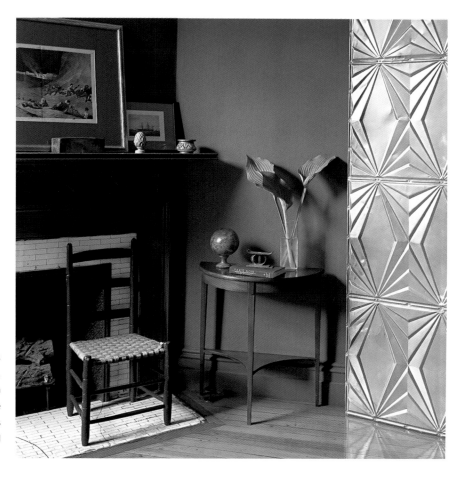

OPPOSITE LEFT: Although some people might find my color choices odd, I think that reds and blacks look great against light blue walls. OPPOSITE RIGHT: There is strength in subtlety. Blue hydrangea in an antique brass vase adds the final, elegant touch that this bedroom table needs. RIGHT: Experiment with darker colors for a change of pace. This deep blue is nicely contrasted with an aluminum folding screen and medium-toned floor.

Painting a room with color is by far one of the easiest and most dramatic ways to completely change the look of a space. It allows you to take less permanent and less costly risks than you would probably be willing to take with fabrics or furniture. If you paint a room with a new color and suddenly start to have nightmares or hallucinate, then you probably should consider repainting. I recently worked with a client who was very particular about a certain shade of green. We ended up repainting the room three times before she considered the color perfect. Worst-case scenario, if you don't like the color of a room, you buy a gallon of paint and a paintbrush, find a pair of old

jeans and a T-shirt that you'd be too embarrassed to be seen in public in, and get started.

We often underestimate the power and psychology of color. By doing so, we cheat ourselves of the opportunity to create home environments that inspire and invigorate, soothe and comfort. Despite what some people think, color really does influence your moods and emotions. Yellows, whites, and greens are generally more soothing than reds or oranges. Blues are said to be more motivating than grays. While there is a science to color, a lot of how we respond to it has to do with our own individual psyches. I recently was purchasing some new computers for my office. The computer con-

sultant I was working with gave me two choices — indigo blue or ruby red. My first inclination was to go with the ruby red. It sounded fun and interesting — a departure from what you'd expect to see in most offices. I told someone about the choices and he immediately said, "Oh no, whatever you do, don't buy red. Red means stop. No one in your office will do any work if you buy red computers!" While I think his theory was a little extreme, he did make me insecure enough that I ended up choosing the blue instead.

Feel free to experiment with paint color in ways that you wouldn't with hair color. There should be some reassurance in the knowledge that it can always be changed if necessary. I recently changed some of the colors in my own apartment in a fairly extreme way. I had lived happily with an all-white bathroom for five years. For the most part, I was fairly content; my bathroom was bright and light and airy, and always felt clean (even if it wasn't). One night last summer I awoke in the middle

of the night amid a color epiphany that inspired me to change my bathroom-wall color from white to black. Sounds drastic? Not really. But then if that wasn't enough, I decided that I wanted to incorporate a bright shade of blue into the bathroom. So, how do you get white, black, and blue to work together in a bathroom? With the help of two friends who happen to be decorative painters, my bathroom quickly underwent a total transformation. Since the bathroom already had white wall tiles and black and white floor tiles, we went about making the change by painting the walls and medicine cabinet black and the ceiling blue. The result was refreshingly beautiful. My bathroom still feels bright to me but now has a different level of sophistication and intrigue created by the infusion of color.

Once you have decided on a color for a room, you

OPPOSITE AND ABOVE: My bathroom was originally white and underwent a complete transformation when I decided to paint the walls black and the ceiling blue.

should think about how you want to deal with color in terms of your furniture and fabrics. Do you want to use fabrics that are the same as the color of the walls, or do you want the fabrics or furniture to contrast the wall color in order to create a little drama? One of the things I think works very successfully is to cut soft, pastel colors with furniture that is very dark. While this seems somewhat counterintuitive, it actually works by creating a significant contrast with your furniture and furnishings. Also remember that you can't go wrong with white or off-white trim for doors, moldings, windows, and ceilings. For instance, if you paint a room with a shade of light blue, green, or pink that seems slightly feminine or in the pastel family, cut the color with either ebonized or dark brown wooden furniture. Always remember that you have to tie the dark contrast to something, whether it be the legs of a chair or a dresser or a picture frame. Multiple objects in a room can make this contrast work, as the elements will play off one another. Take a chance by doing a small room like a home office or a closet in a color and see how you like it. I have a good friend who is passionate about the colors he chooses for the rooms in his home. I have witnessed him painting and repainting again and again until he perceives the color to be no less than perfect.

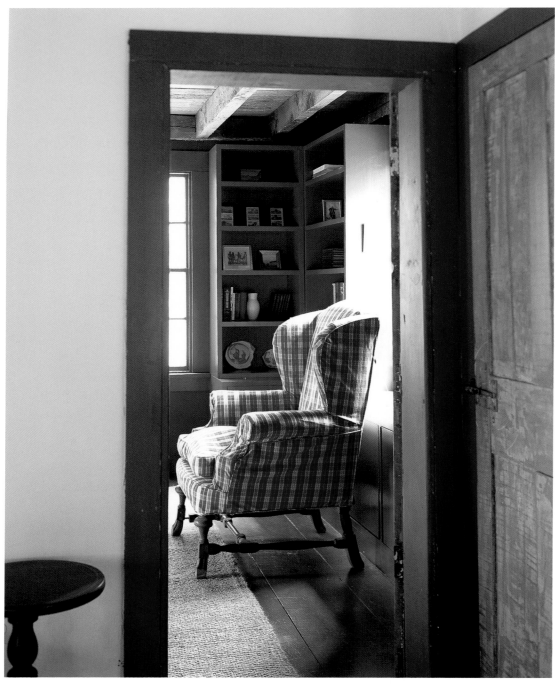

of his closet to hang up their coats.

Aspire to using color schemes that can draw you in and keep you there indefinitely. Color combinations can be every bit as simple or complex as you want to make them. I have found that the use of color is fairly contagious. If you like the feel of a bright color in one space, chances are you will be inclined to try vivid or bold colors in another space. Save superbold exotic colors for smaller, more private spaces. Try more neutral and soothing tones in more public spaces of your home or areas where you like to kick back and relax. Although colors do not necessarily have to be subtle to be pleasing to the eye, they should never be so subtle that you get

A few years ago he painted his very large walk-in coat closet a brilliant shade of blue and then hung a huge painting with bold colors on the back wall. He even took great care in choosing beautiful dark-wood hangers for his coats. Since then I have watched his dinner guests gasp with surprise whenever they open the door bored. In the same way, colors should not be so neon or superbright that they scare people.

A lot of how color works has to do with the way natural light and artificial lighting fall upon it. Obviously, almost all colors look good when you have great lighting. Natural light is preferable, but if you have to use

store-bought lighting, it is safer to stick with lamps than lots of ceiling fixtures. Since colors become visible to our eyes only when light falls upon them, take the time to select light fixtures that don't sabotage your color schemes.

The use of color isn't just about paint. It is just as much about the furniture and objects that you select to put in a space. I have a weakness for painted antique furniture. The colors are often quirky and totally unexpected. A sideboard that may have started out in a traditional shade of green may now look off-kilter because it has slowly faded over time. Colors that dramatically change because of aging (which is often called patina) are often individual and richly intriguing. Use these colors to inspire you. The color of that green sideboard is what inspired me to choose the window treatment for my dining room. Keep in mind that your walls do not always have to make the biggest color statements. Colored furniture and fabrics can say just as much.

Give children a box of crayons and see how wide their eyes open when they look at all the colors available for them to draw with. Children's bedrooms should create the same type of interest and enthusiasm as a new box of crayons. When decorating children's rooms, I often like to use white paint on the walls. This might sound somewhat contradictory since I have professed to be such a staunch supporter of color, but again, it is about

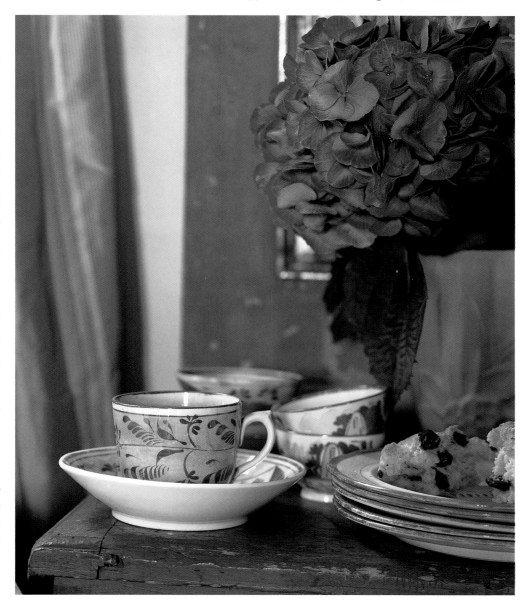

OPPOSITE: This red and white checked wing chair adds another element of color to this country house. RIGHT: The color in these lusterware dishes blends with the surrounding furnishings and flowers.

how you use the color. White rooms provide a bright, clean backdrop for all of the color that children themselves bring to a space. Toys, stuffed animals, games, books, imaginary friends and foes are all part of a child's existence in our homes. If you decide that you want to paint or wallpaper with a color other than white, pick three colors that you can live with and then let your child make the final choice. Making children a part of the process is good not only for their psyche but for yours as well. Children's furniture comes in so many colors, shapes, and sizes nowadays that it will be hard to go wrong. Create fun and playful color combinations that excite you and your kids. In children's rooms you are free to break through the color barriers that exist in the other rooms of your home. In the world of a five-year-old-child, a red dresser does match a blue bed, an orange desk, and a yellow bookcase. Again, kids' bedrooms are great places to try things that you may not want to try in your own bedroom. And don't simply stop with the walls and furniture. There are so many great places to buy fun, colorful sheets, comforters, rugs, lamps, and other accessories for your child's room that you have no excuse for not making his or her personal space as inspired as yours.

ABOVE AND OPPOSITE: I often use white walls in children's rooms but add bright and colorful furniture to give rooms personality.

"Let there be light."

—GOD, *Genesis 1:3*

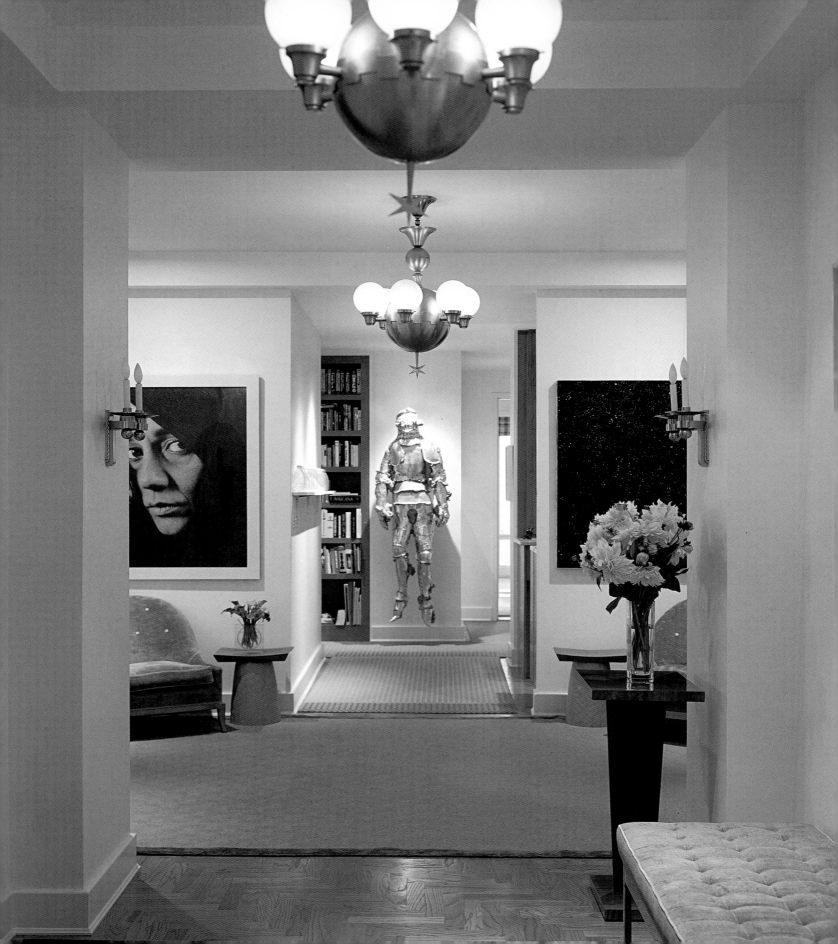

... and there was light

ALMOST EVERYONE,

except your average possum or fruit bat, has to admit that sunlight is one of the greatest things we have in existence and in abundance. Although there is something beautifully dramatic about the rain, nothing can really compete with the charisma of a sunny day. The sun has transformative powers that can lift our spirits, renew our faith, and change a bad mood to one that is upbeat. It can also seriously alter the way we see things. I remember when I began looking to buy a house in Upstate New York. It was a gloriously sunny day, and when I arrived at the first house shown by the real estate broker, I was completely taken with the way the sunlight seemed to light up the rooms, even though I didn't particularly like the decor. I looked at a few other houses but decided to come back to the first house to take a second look. Again, the

candles; photometrics; lumen depreciation; stroboscopics; lighting calculations; spherical, parabolic, and elliptical reflectors — the list goes on and on, and gets only uglier. You don't have to be Tom Edison to understand the technical minutia that is set in motion every time you turn on a light switch, but it would probably help if you were. Make no mistake about it. Truly understanding the science of lighting involves mathematical formulae and all sorts of arcane calculations. If you are interested in learning more, there are books that focus specifically on residential lighting. Most of us just want to be able to light up our homes in ways that flatter us and allow us to see well enough to do what needs to get done. Successful lighting strikes a careful balance between both artificial and natural sources. Negotiating this balance can sometimes be a bit tricky, even for many design professionals.

There is a lot more to lighting than being able to walk into a room so that you can see without stubbing your toe. Good lighting helps create moods and important memories in addition to helping us see what leftovers are in the fridge. It is essential that you consider the overall mood or impression you want to make when you approach lighting schemes in your home. In most

light and the view were equally astounding. For many people, sunlight can be truly inspirational and motivational. I consider myself one of these people. I wanted to spend my weekends at a place that was inspiring and thought-evoking. I wanted a home that could become a spiritual, intellectual, and personal retreat from my hectic life in the city. Though the sunlight didn't help me get a mortgage, it did help convince me to buy the house.

Natural light can be great. Especially when we embrace its natural qualities. Western and southern light is warmer than northern and eastern light. This is important to consider if you are planning to rely solely upon sunlight to help you decorate your home. Direct sunlight is great until it prevents you from taking your afternoon nap or wreaks havoc on those plants on your window ledge. Sunlight, like everything else, has to be managed. Understanding the way natural light works is something that we can all grasp without too much difficulty. But artificial lighting really is a specific science unto itself. Electrical codes and circuiting; foot-

PAGE 80: Two chandeliers combined with recessed lighting and wall sconces light the entry hall of this contemporary apartment. ABOVE: Lamps are a necessary part of everyday life, but there really is no substitute for a room that gets a lot of sunlight. OPPOSITE: Lamps don't have to be boring. Buy lamps that are fun and colorful like this painted wooden table lamp.

instances you will find that your needs for light vary from room to room. If you need lighting for your desk, you probably want something that casts a cool, directional light that will help you focus and concentrate on what you are doing. If you are planning an intimate dinner for two, you will want to use lighting that is warm and romantic rather than bright and cold.

Although we probably don't think much about it, lighting has always been used not only for the practical purposes of illumination but also as a source of communication, whether you are floating in a life raft at sea or lost in the forest. In our homes we use timers on our lamps to communicate to potential intruders that we are home, even though we aren't. Remember those high-school parties when we danced in the dark in someone's basement? At some point during the evening, the lights flicked on and off, sending a very clear message that it was time to go home.

In general, different types of light are generated by different sources. The light cast by table and floor lamps is usually a lot more flattering to you and your room than overhead lighting. Someone recently asked me if it is preferable to buy table lamps that are all the same height if they are going to be placed in the same room. The answer is most certainly *no.* While a pair of perfectly placed lamps can look wonderful on a sideboard or a console, there is no

steadfast rule that your lamps be the same height. In fact, varying lamp heights can help you create additional points of interest in the space. You might also consider experimenting with different shapes, sizes, and colors of lampshades. Different types of lampshades will cast and diffuse various degrees of light. Don't hesitate to ask the salesperson at the lampshade store which type will help you achieve the look you want. While I prefer paper lampshades to fabric, it really is a matter of personal preference. If you find a

LEFT: Keep bulbs simple. Save the curved-tip, colored, iridescent, and prismatic bulbs for the Christmas tree. OPPOSITE LEFT: Use floor lamps near seating areas so that you can read or entertain comfortably. OPPOSITE RIGHT: While table lamps don't have to be the same height, the symmetry of this pair complements the classic interior.

great lamp at a garage sale or flea market and the cord looks battered or frayed, consider having the lamp rewired. It is a minimal expense, and I guarantee that it will help you sleep better at night knowing that your new purchase isn't going to start an electrical fire in your house.

Most houses and apartments come with overhead lighting in place or a receptacle indicating that a lighting fixture should be installed there. Do not feel that it is necessary to shove something up to the ceiling simply because there are wires and a switch on the wall. If you do decide to use an overhead light, consider using hanging fixtures rather than regular fixtures that are surface-mounted. Of the hanging fixtures that are available, chandeliers are probably my favorite. And contrary to what your mother told you, they aren't used just in dining rooms anymore. I have installed chandeliers in bathrooms, hallways, bedrooms, and kitchens, without their looking excessively formal or out of place. When used in conjunction with other, more efficient sources of lighting, chandeliers can create a special type of radiance that is distinctly different from other types of lighting in your home. The types of chandeliers available nowadays are enormously varied. Crystal, wrought iron, brass, alabaster, and wooden and glass beads are some of my personal favorites. While many

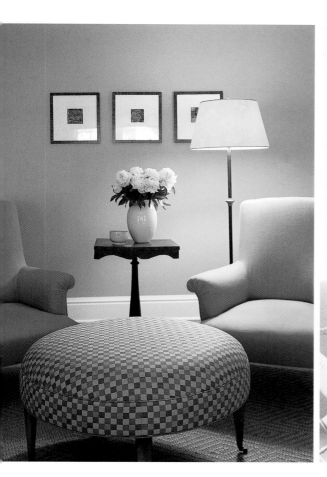
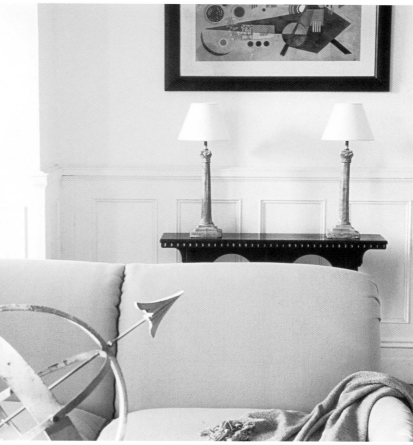

hanging fixtures would probably look better with candles than bulbs, most people have their hanging fixtures electrified for obvious reasons. So unless you really are using a candelabra with actual candles, I wouldn't suggest trying to fake the flame by using bulbs that look like candles. A word of advice about the bulbs you buy for your chandeliers: frosted bulbs diffuse more light than clear bulbs. And save the curved-tip, colored, iridescent, or prismatic bulbs for the Christmas tree. Use low-wattage, frosted bulbs, and stick with simple and basic shapes like torpedo bulbs.

I would also suggest installing dimmer switches wherever you possibly can. Dimmers allow you to manipulate the light in ways that ordinary light switches don't. Though most people only use dimmers for aesthetic reasons, there is also a practical reason for using them. They save energy as well as help prolong the life of your bulbs.

One of the most common types of lighting that you have probably seen in people's homes is recessed downlights. While there are many types to choose from, depending on your specific needs, most are used for interior spaces that need overall general illumination. I tend to use downlights in kitchens more than in any other room in people's homes. Whether you are in the kitchen to do something as basic as boiling water or as

elaborate as boiling a bunny (like Glenn Close in *Fatal Attraction*), downlights help you see evenly throughout the space. Wall washers and track lighting are used when you want to highlight something on a wall like a painting or photograph. These types of lights "wash" specific areas of vertical wall space, allowing you to focus on a specific portion. Even though the choices available in track lighting have improved dramatically over the past decade, I still find most track-light systems to look somewhat dated. Although they now make small luminaires (or "cans" as some people call them), many people still like to use the original large white cans on thick tracks. Unless you are a seventies devotee with eight-track tapes in your car and beanbag chairs in your living room, if you do decide to use track lighting, at least order the smaller versions that are available in both halogen and regular bulbs.

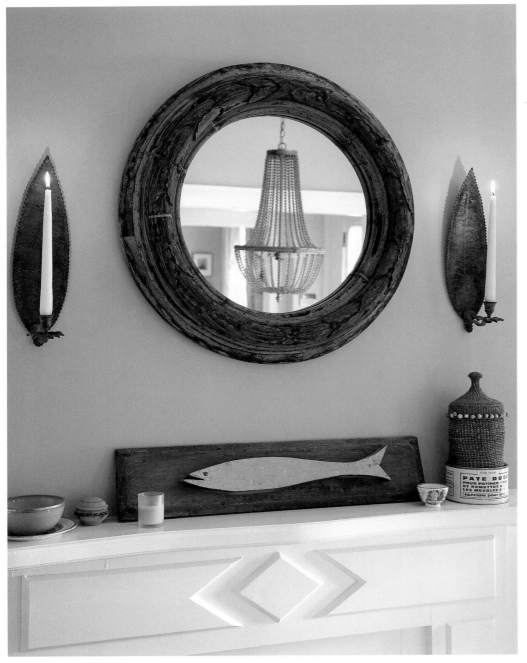

Task lights are used for the sole purpose of lighting specific areas so that we can perform specific tasks. Maybe you are writing your first novel — which means you need a desk lamp so that you can see while you hover over that laptop. Or maybe you are afraid of ghosts, in which

LEFT: Candles can be used to make any space seem more intimate and personal. OPPOSITE: Successful lighting incorporates the use of both natural and artificial sources.

case you might need a night-
light plugged into an outlet on
the baseboard of your hallway.
Anything that needs to be
directly illuminated probably
needs a task light. Like for any
other source of light, the choices
are numerous, so take the time
to choose carefully. Flexibility is
also important to consider when
you are dealing with lighting. Can
your desk lamp be angled or
adjusted in case you feel inspired
to work from the floor? Be sure
that the lighting you choose can
keep pace with your ever-changing
moods, needs, and requirements.

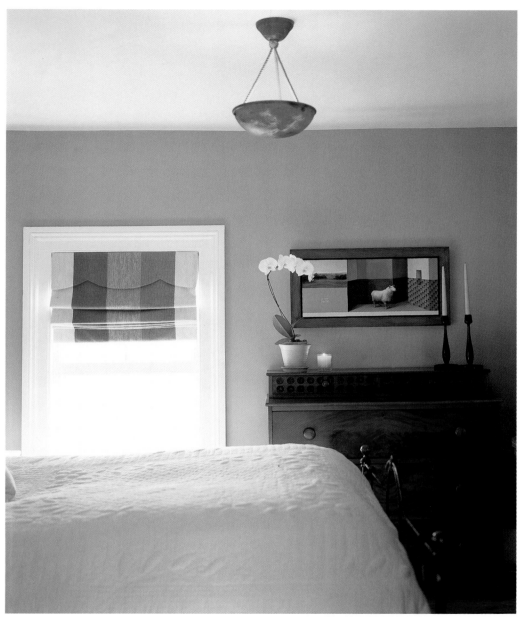

Don't shy away from decora-
tive lighting, even though it may
seem somewhat impractical
from an illumination standpoint.
While many types of decorative
lights emit very low levels of
light, they can uniquely enhance
interior spaces. While I wouldn't suggest trying to read
by a pair of sconces or by a string of red bulbs on your
Christmas tree, your home wouldn't be the same with-
out them. Imagine what it would be like to have a cock-
tail party with superbright overhead lights, spotlights, or
recessed lighting turned on. Talk about killing a festive
mood. Your guests should be able to mingle and social-
ize without feeling like deer staring into the headlights
of a car. Decorative lighting and soft accent lights can

help you and your guests see each other (and the glasses
of champagne) in a kinder and gentler way. Styles can
range from the traditional to the contemporary, so you will
have many options to choose from. I find that sconces
generally look best when presented in pairs over mantels
or on large unadorned walls (which can tend to look
monotonous without something to break up long expanses
of wall space). Whatever your choice, try to choose lighting
that relates stylistically to the rest of your home.

"... snug as a bug in a rug."

—BENJAMIN FRANKLIN

chapter **6**

floor fetishes
and rug phobias

MOST HOUSES AND APARTMENTS

nowadays come with hardwood flooring. Although the styles may vary, wooden floors are about as American as baseball and apple pie. Your preference may be wide-board pine or thin oak strip, but either way, investing in good wooden floors for your home (or any other flooring surface, for that matter) is like investing in a well-tailored suit. Nice floors are the basic foundation of any room, just as a good suit is one of the basic foundations of most workingmen's and -women's wardrobes.

Whether or not you have rugs, one of the first things people notice when they enter your home is your floors. There's nothing worse than prefab wooden floors or high-gloss finishes on traditional wooden flooring. Don't finish wooden floors with three coats of supershiny, wow-I-can-see-myself-in-it, high-gloss polyurethane, unless of course you prefer to arrange your

bathrooms in my own country house had wide-board pine floors that were not in great shape. Instead of sanding, staining, and polyurethaning the floors, I decided to have them painted. The floorboards were sanded lightly and then painted in three colors of custom-mixed deck paint. I chose the three colors (green, salmon, and white) I wanted to use, and then had the floor stenciled in a "tumbling block" pattern. Each color was put on individually, and after the paint dried, three coats of oil-based polyurethane were applied to ensure that the floors would be sealed (since water was inevitably going to splash from the tub, shower, and sink onto the floor). What's so terrific about this bathroom floor — aside from the fact that it looks great — is that it feels nice under bare feet. Sometimes tile and marble can be cold and slippery — especially during the winter. In this instance, having my wooden floors painted provided a much more interesting and less expensive alternative to tile.

furniture courtside and require that guests wear Rollerblades or basketball sneakers in your home. I usually recommend to clients and friends that they use a "satin" finish, which adds a little sheen without looking overly shiny. In my experience, oil-based polyurethane, while certainly more costly and a little more difficult to work with than water-based polyurethane, provides a finish that will last a very long time.

Traditional wooden flooring can be quite beautiful. But there are many alternatives to just simply laying straight floorboards in your home. I have often recommended painting floors before they are polyurethaned for a fresh alternative to traditional wooden flooring. One of the

One of my clients used to love to have dinner parties at his apartment in New York City. Thursday-night dinner parties with ten guests became routine for him in the same way that I do my laundry on Saturday mornings. When thinking about the design scheme of his dining room, we took his particular penchant for entertaining into consideration. Instead of purchasing an

expensive rug that would have been hidden under his large mahogany dining table, I convinced him that we should design and paint a ten-by-twelve-foot "rug" on his dining-room floor where the dining table and chairs would be. At first, the idea was met with raised eyebrows and some apprehension. After I wore him down about the idea, he finally agreed to give it a try. Sometimes you can convince a client to take a risk by explaining the worst-case scenario if your idea turns out to be a mistake. Here, the worst thing that could happen would be that we would end up purchasing a rug to put on top of the area we had painted. I am glad to say that our idea did not turn out to be a belly flop and that the client never did end up purchasing a rug to hide our "painted rug" underneath.

While area rugs can look nice under dining tables from an aesthetic standpoint, they are not always the most practical solution for dressing up a naked dining-room floor. One of the big problems is that rugs get ruined easily when they are under dining-room tables and chairs. One evening I had the opportunity to be a guest at one of my client's famous dinner parties. Instead of enjoying the wonderful food, wine, and conversation like most of the other guests, I spent the entire evening fixating on the colorful floor that we had designed and painted underneath the table. I was curi-

PAGE 90: A painted floor instead of a traditional rug is an elegant and economical solution for this formal dining room. The owner of this home does not have to worry about a rug getting soiled from feet or food spills or from chairs being pulled in and out from the dining-room table. OPPOSITE: I saved money by painting the pine floors in my guest bathroom rather than buying expensive marble tile. RIGHT: Rugs don't have to be rectangular or square. We had this large area rug custom made in a circular shape to mimic the design of the ceiling.

ous about whether our design would work the way we had hoped and planned. I sat stunned as a woman spilled a glass of red wine as she animatedly told a story to the other guests at the table. I watched intently as crumbs and napkins fell out of people's laps and onto the floor. Chairs moved in and out from the table constantly as people rose and sat to get more food and wine, and simply to move around. By the end of the

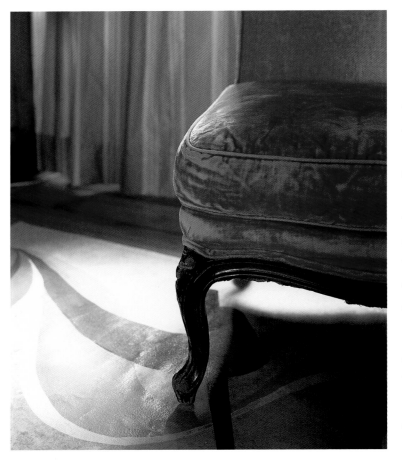

BELOW: Painted canvas floorcloths are another alternative to traditional area rugs. OPPOSITE: A simple sea grass rug helps to dress down this otherwise formal dining room.

meal I was thoroughly convinced that my client's decision to try the "painted rug" instead of a real rug had turned out to be a wise one. Not only was the painted floor much more durable than a rug but we were able to create our own design to complement the room's overall scheme. Finally, we saved a lot of time and energy by not having to search for the "perfect" rug for months and months.

It is not uncommon in the interior design industry for custom rugs to take anywhere from four to six months to be made and then delivered to a client's home. Custom rugs are often a designer's preference because they offer an opportunity to create something individual and special for a client's home. Not only is it great to be able to design a specific pattern, size, or shape (which may be difficult to find in a store) but it's also ideal to be able to customize the colors and textures.

I guess you could say that my general rule of thumb about rugs and carpets is the following: if you can't afford the real thing, please don't try to fake it. I'd rather live with an inexpensive sisal or sea grass rug any day over a bad imitation Oriental or Aubusson. Bad rugs are like bad hairpieces. Only the person wearing the rug thinks it looks real. Thanks in part to Michael Jordan, it's okay to be seen nowadays without any hair on your head. While there's no Michael Jordan equivalent to extol the virtues of bare floors, floors really can also look amazing without rugs, especially if they are well maintained.

In the world of floor coverings, I believe that sea grass and sisal are two of the greatest inventions of all time. What linoleum was to the 1960s and shag was to the 1970s, sisal and sea grass were to the 1990s. We have entered the new millennium with many new flooring and

rug materials to choose from, but sisal and sea grass still have not been dethroned as the king and queen of inexpensive rugs. One of the exciting things about these natural floor coverings is that they are available in a wide range of weights and textures. Most decorators and designers would agree that they provide an interesting and reasonably priced alternative to other types of rugs and carpets. I use sisal and sea grass rugs everywhere. Because they come in such a wide variety of styles and patterns, I am able to use them in my clients' homes as well as my own. I've specified them for bathrooms and bedrooms, living rooms and dining rooms. I also had a stair runner in sea grass installed in my own home. There are many people who think that sisal doesn't look particularly interesting and that it feels "rough" on bare feet. I would suggest to those people that they consider wool sisal, since it is much softer to the touch and far less coarse.

One of the other things I like about sisal and sea grass rugs is that they help create a neutral backdrop for anything else you might do to a room. Whether you like contemporary furniture or antiques, chances are sisal will work well. Most sea grass or sisal rugs are neutral in color — mostly in the beige and khaki family, but you can always add a colored border to brighten them and to match the room you are decorating. Sometimes I choose to leave these rugs completely plain with no border, and other times I might use canvas fabric, linen, or leather to make a two-inch border around the entire rug. Borders also give you the opportunity to introduce other textures and colors to a room. I have a friend who has a

classic dining room full of antiques. At first glance this room looks extremely formal because of the polished mahogany dining table and English bull's-eye mirror above the fireplace mantel. Most people would be surprised that his eight-by-ten-foot sea grass rug was purchased through Pottery Barn. You can get these rugs with or without borders so that you can customize them for your own interior. They can be ordered in any custom size through most rug manufacturers as well as in standard sizes like five by seven or six by eight through various mail-order catalogs like Crate & Barrel. You may also want to check out www.sisalcarpet.com if you want more information on all of the different styles and colors available to you.

The other nice thing about sisal and sea grass is that they look great with smaller, more colorful rugs on top of them. Layering rugs like this can add a rich textural element to a room while creating new points of interest. Kilim rugs are a type of colorful, flat-weave rugs that are usually made of wool and silk. Originally these rugs were created for their basic practicality in nomadic and tribal life. Kilims have been in existence since the fourth and fifth centuries B.C. to help transport items or to be used as eating cloths, and some were used for prayer. Kilims are one of my favorite types of rugs to use when I am layering on top of sisal or sea grass. If you purchase a kilim with some of the same colors that are in your fabrics or on the walls, you will have another chance to subtly reinforce the color scheme you have chosen to implement in the space.

Rush mats and straw rugs are another great and inexpensive option for people who are looking to use something other than traditional area rugs for their homes. They are lightweight, informal, and neutral in color.

Historically, people have been using them since the eighteenth century during the summer months of the year. Simple straw rugs can be purchased from stores like IKEA. You can sew small rugs together to make larger rugs, or spread them individually throughout the room you are decorating. Personally, I like to put them on the floor next to the sides and foots of beds. Like any area rugs, they tend to look better on wooden floors that are attractive and well maintained.

Maintaining wooden floors doesn't require a lot of work, but it is still a good idea to get into the habit of keeping them clean. If you care at all about their appearance as well as their longevity, you should try to sweep them regularly. Having limbo contests in your home should not be the only reason you take your broom out of the kitchen

Natural straw mats are used as a simple and inexpensive alternative to traditional rugs in this country bedroom.

pantry. It seems so basic, but people tend to forget that wooden floors do not completely take care of themselves. And if you can find the motivation to find a bucket, some warm water, a mop, and a little Murphy oil soap, your floors will be forever thankful. However, if you choose to abuse your wooden floors, people will probably know. Though most wooden floors can withstand years of abuse without filing charges against you, I wouldn't suggest you treat them this way.

It wouldn't be fair to talk about flooring without mentioning the virtues of wall-to-wall carpeting. Area rugs are wonderful, but nothing feels quite like plush, soft carpet underneath your feet. For most of us, wall-to-wall carpeting brings back memories of our childhood. As I recall,

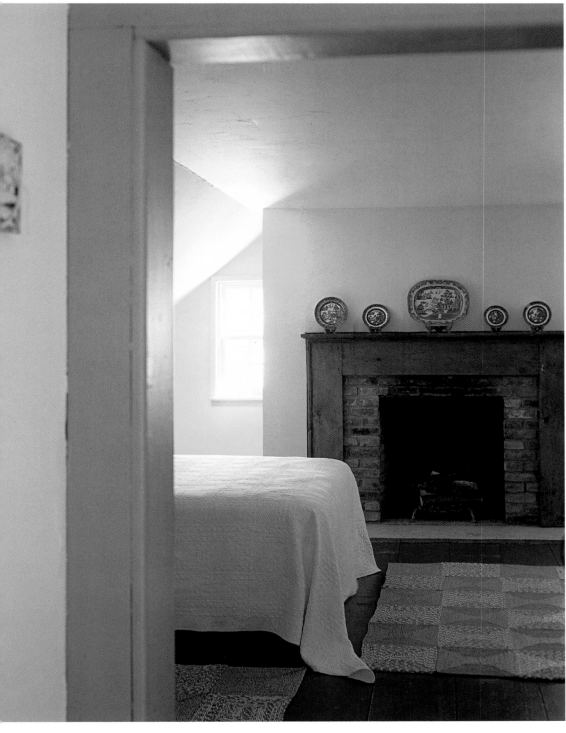

battlefield and makeshift ocean. Children's rooms are one area of the home where wall-to-wall carpeting really works. While there are many choices for synthetic carpets, I generally prefer wool. Wool carpeting is more durable, looks better, and wears better over time. Wall-to-wall carpeting also helps absorb sound, helping to take the edge off your heavy-footed husband who walks around like Sasquatch as well as the screaming sounds of your children when they are playing indoors. Carpeting comes in so many colors, patterns, and textures nowadays, you should be able to find one that can blend harmoniously with your interior. Just make sure that if you are going to have wall-to-wall carpeting installed, you also

my friends and I spent a lot of time rolling around and playing on the floor when we were kids. The royal blue wall-to-wall carpeting that my parents had installed in their living room helped inspire many a make-believe own a vacuum cleaner or have access to one. Although most wall-to-wall carpeting does hide dirt, your basic vacuum cleaner is essential to maintaining its beauty.

"A chair is a very difficult object. A skyscraper is almost easier. That is why Chippendale is famous."

—MIES VAN DER ROHE

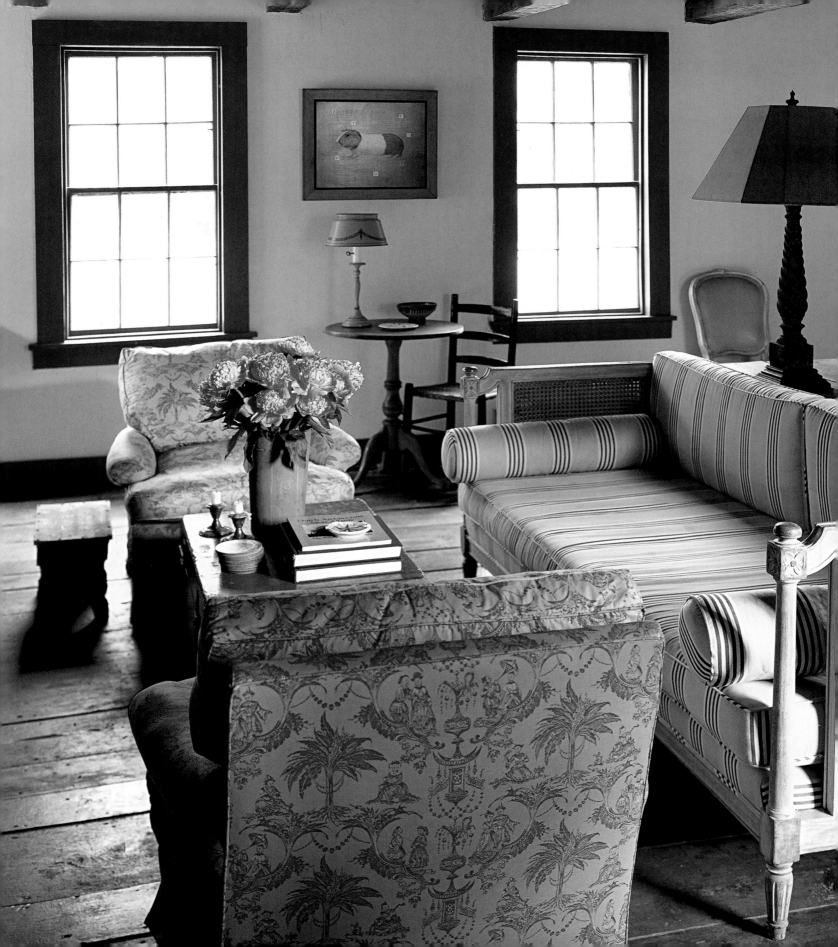

seating disorders
AND OTHER FURNITURE-RELATED PROBLEMS

Even though I love the sensation of eating a York peppermint pattie, I can honestly say that I love the sensation of walking into a well-thought-out and smartly arranged room even more. Have you ever been to someone's home and immediately noticed that something didn't seem right about either the size or the amount of furniture in the room? People often buy sofas, chairs, and other big, upholstered pieces of furniture in sizes that are too large for their homes, instead of purchasing based on the proportions of the room that they are furnishing. If you have a big room with high ceilings and tall windows, the space can withstand larger, heavier, and more imposing furniture. If you live in a studio that is the size of a postage stamp, chances are that you should not be thinking about buying that ten-foot-long George Smith sofa. Beware of significantly overstuffed furniture

if you don't have the space to accommodate those types of pieces. I would advise you to err on the side of smaller versus larger. I may not be a math wiz, but I know from experience that it is always a lot easier to add than it is to subtract from a furniture equation with the wrong amount of furniture.

If you live in New York, I'm sure you've heard the story of the very famous and fabulous New York decorator who purchased a very fabulous and expensive sofa for a very rich and fabulous client in a high-rise apartment in Manhattan. When the very fabulous and expensive sofa was delivered to the very fabulous client, it did not fit into the building's elevator or stairwell. How could this possibly happen? How often does this type of thing happen? Unfortunately, the answer is easily and more often than it might seem. Believe me, while we design professionals may not always be as skilled as we should be with a measuring tape, we are certainly resourceful and innovative when it comes to saving our necks. The very fabulous (and apparently well-connected) decorator enlisted the services of a forklift operator so that the sofa could be hoisted up and brought in through the client's window. Of course all of this happened before the very fabulous and rich client ever arrived home to know what had transpired earlier that afternoon. Though this example is pretty

PAGE 100: Wide-board pine floors and exposed beams add rustic charm to this country interior. RIGHT: We tried to keep flexibility as well as comfort in mind when arranging the furniture in this living room.

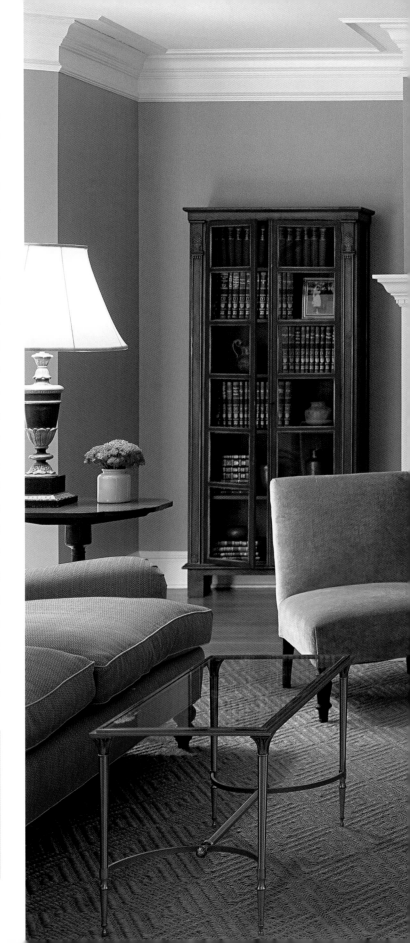

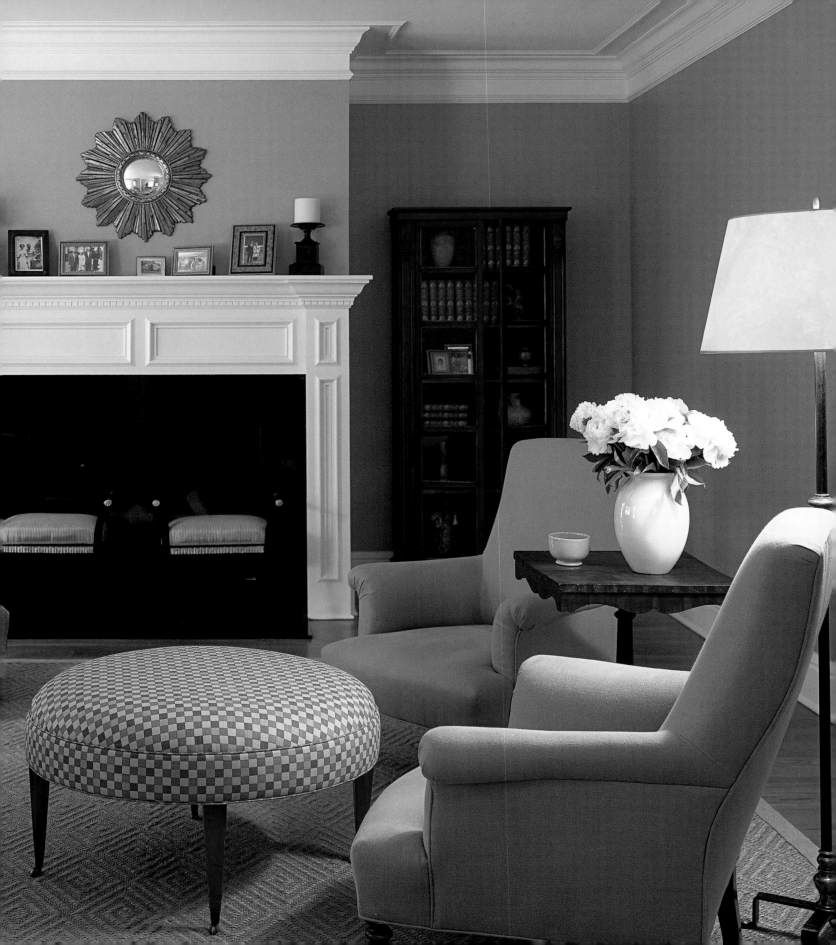

extreme, the point I am trying to make is pretty basic. Always "forwardly" think about the size of your rooms, hallways, doorways, and stairwells before you decide to buy a bookcase more suitable to the Jolly Green Giant's house than your own.

When creating a seating arrangement, think about where the largest piece of furniture will go first, and try

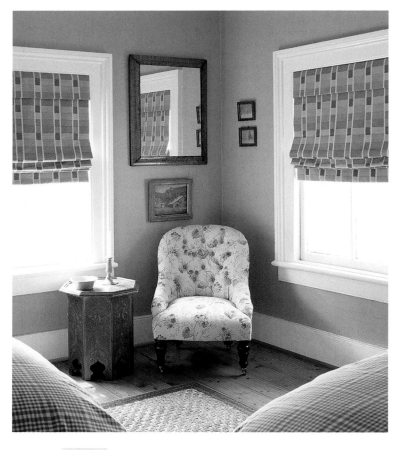

ABOVE: Try not to forget about the scale of the furniture you purchase. The furniture in this bedroom is small in scale because the room is small. OPPOSITE: I'm not big on matching dining sets. I didn't want my dining room to look anything like my friends', clients', or neighbors', so I purchased each of the pieces individually.

to arrange the other pieces around it. This usually means that the sofa will come first. I prefer sofas to face the opening of a room, so that if you are entertaining guests, you will be facing them as they enter the space. If you have a fireplace or some other focal point in a room, the sofa can be centered on that instead. Either way, since your sofa probably takes up the most space, it should be placed before anything and everything else. In addition to the sofa, you will probably want to arrange your club chairs (club chairs are basically upholstered chairs that are generous in size) next. Club chairs should be comfortable and inviting, and they should complement the sofa.

Whether you choose solids, stripes, or prints to put on your upholstered pieces of furniture, make sure that there is a unifying color tying them all together. It may simply be in the welting (the trim) that is on your sofa or in the background of the print — but somehow these things should look as though they belong in the same room. It might sound a little ridiculous, but think about your furniture as being part of a "furniture family." Each individual piece should somehow relate to the other pieces in the room. The resemblance, no matter how small, can make everything seem unified. Maybe the shape of the chair is different, but the legs are the same style. Maybe the color is the same, but the finish is totally different. Like members of a family, there should be distinct similarities as well as differences between the pieces of furniture that you choose to put in a room. Once you determine what those pieces are, make sure that you arrange them in a way that is logical. The arrangement of your seated furniture should allow you to engage in conversation comfortably, with-

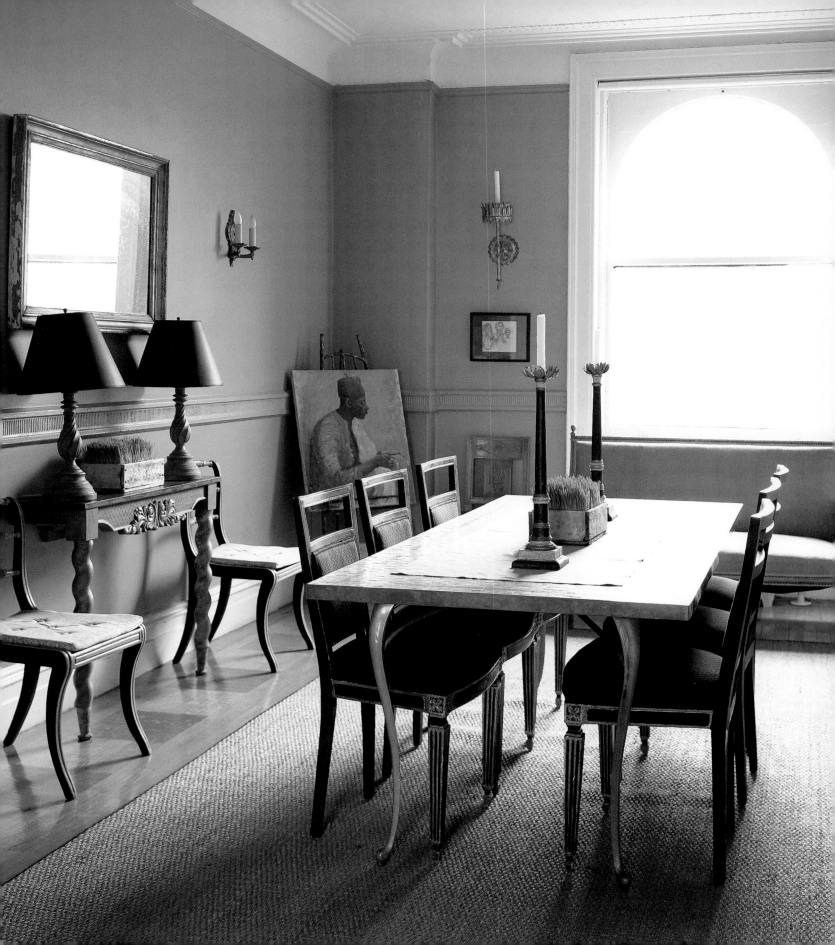

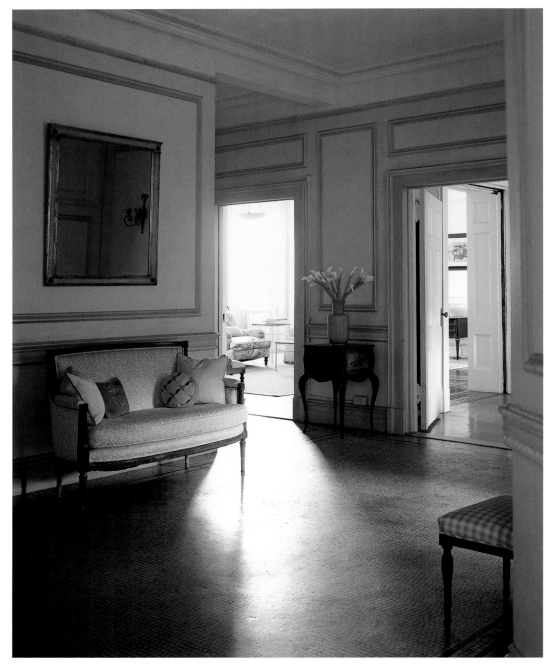

out having to scream across the room at one another.

I have never liked things to match perfectly. I have been criticized for wearing brown with black, and white with off-white. Although this may be considered a fashion faux pas by some, I still maintain that these atypical color combinations look terrific together. Contrary to what the furniture police might tell you, it is not a crime to buy dining chairs that are a different style from the dining table. In fact, it's preferable that you do. I vigorously try to talk my clients out of buying sets of things. I always tell them that if they do, they will look lazy. One-stop shopping is great if you are shopping for hardware, groceries, and a lawn mower, but forget furnishing your home that way.

Individuality is one of the most important components of Furnishing Forward. It's important to remember that our individual preferences are what help make our homes look different from one another. But different shouldn't be otherworldly. And if you have to strive to make your home seem *so* incredibly different from mine, you are wasting a lot of energy. If you are buying

ABOVE: If you are fortunate enough to have a formal entry, try not to clutter it with lots of furniture. **OPPOSITE:** Traditional interiors don't have to be boring. We used the bold colors in this area rug as inspiration for the rest of the living room.

stylish, classically designed pieces of furniture, stick to your guns even if it seems as though your furniture doesn't totally "match." Again, it is important to remember that you are furnishing for yourself. In the 1980s a childrenswear line called Garanimals was introduced into department stores throughout the country. The concept behind this new clothing line was that it made matching easy for kids. If a sweater had a green hippo tag on it, then it matched with a pair of pants with a hippo tag. Shorts with a lion tag matched with shirts with a lion tag. Furniture shouldn't be like Garanimals in terms of how it matches. And besides, who says that a giraffe chair might not look better with an elephant sofa than with a zebra table?

I remember that when I first moved to New York and started riding the subway, there were advertisements plastered everywhere about a furniture store called Jennifer Convertibles. You had to be on another planet not to know that Jennifer Convertibles offered great deals on matching sofas, love seats, and chairs — all for one low price (which could be financed, of course). I know many people who took advantage of this great offer; I am proud to say that I didn't. To this day, I still don't know who

Jennifer was and why she wanted everyone's living-room furniture to look just like everyone else's.

Often when a client needs to buy two sofas, we suggest that he or she purchase two different styles instead of one, even when they are for the same room. Although Jennifer (of Jennifer Convertibles) would probably disagree, two different styles of sofa can often be quite complementary to each other. Again, the idea is to buy well-designed and timeless furniture that works together without perfectly "matching." What makes it "match" is that the furniture has stylistic similarities. Or depending on how you upholster the sofas, they may "match" because there is a unifying color or texture that helps create a visually harmonious relationship between them.

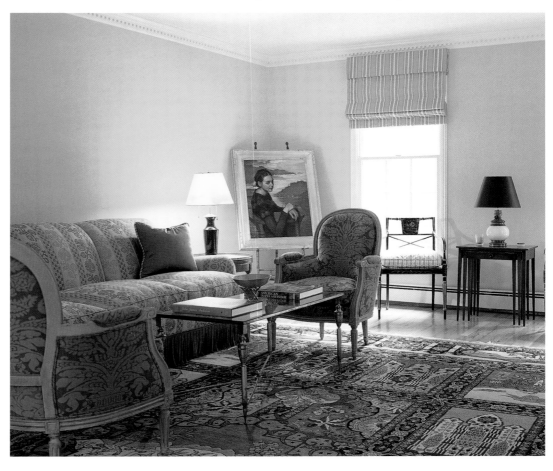

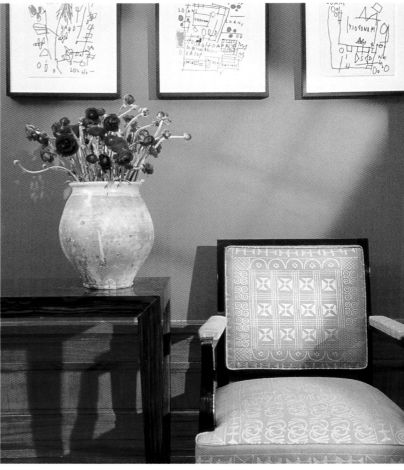

Chairs

While some people may characterize themselves as having a foot fetish, I most definitely have a side-chair fetish. Big, small, new, old, Louis XVI, Charles and Ray Eames, Gio Ponti, Frank Gehry, wood, upholstered, metal, English, French, Swedish, American — I am discriminating but not discriminatory when it comes to side chairs. You name the style or period, and chances are that I probably own one or maybe even two. The wonderful thing about side chairs is that they can fit just about anywhere in a room. In fact, I don't think that most rooms look completely finished or well appointed unless they have their fair share of side chairs. For me, a room without side chairs is sort of like the ice-cream sundae without the cherry on top. Side chairs can be found just about everywhere and for very little money. Though there's certainly nothing wrong with purchasing chairs from stores and showrooms, you can probably get your best deals at local flea markets, auctions, garage sales, and estate sales. My never-ending search for the perfect side chair has taken me all over the world. I have even been known to rescue a chair or two from the street curb before garbage pickup. Friends used to refer to the back room of my apartment

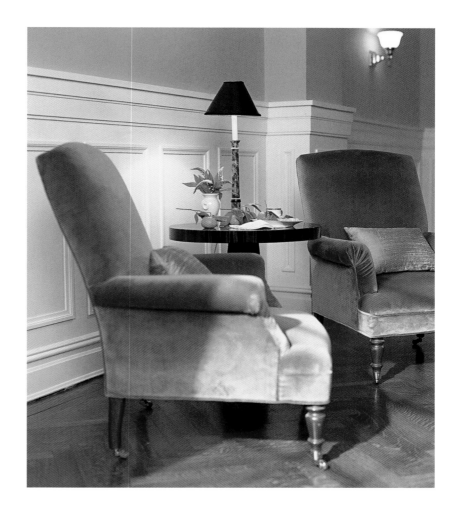

OPPOSITE LEFT: We used two different colors of the same fabric to upholster the backs of these dining chairs. OPPOSITE RIGHT: Side and arm chairs are great because they don't take up a lot of space but come in handy when unexpected guests show up at your door. RIGHT: Everyone should own at least one pair of comfortable jeans and at least one pair of comfortable club chairs. We upholstered these in a durable linen velvet fabric.

as the *Friday the 13th* room because there were so many pieces of frightening furniture I had rescued and planned to eventually fix, strip, or reupholster. To most people, the idea of a project like this is scarier than the actual furniture itself. To me, it is a low-risk, high-return venture in many ways. Let's just say that I rescued from the street a small upholstered Victorian side chair that someone else apparently thought was garbage. A side chair with an upholstered seat requires such a minimal amount of fabric that I would be willing to experiment with a fabric or a finish I might be afraid to try on a bigger and more expensive piece of furniture. Maybe I'll use that piece of red

silk that has been sitting in my closet for the past two years. Or maybe I'll take a risk and use a bold pattern that is a little over the top or that I don't have the courage to use in my draperies. Remember, it's a good idea to walk before you can run. Small projects can help you save money while helping you build confidence. And once you start to build confidence in your ability to pick and choose things that look great, you will be well on your way to decorating spaces that are as interesting as they are beautiful. Finally, there is the great amount of satisfaction you get when someone asks you the history behind that terrific Victorian chair sitting in your living room.

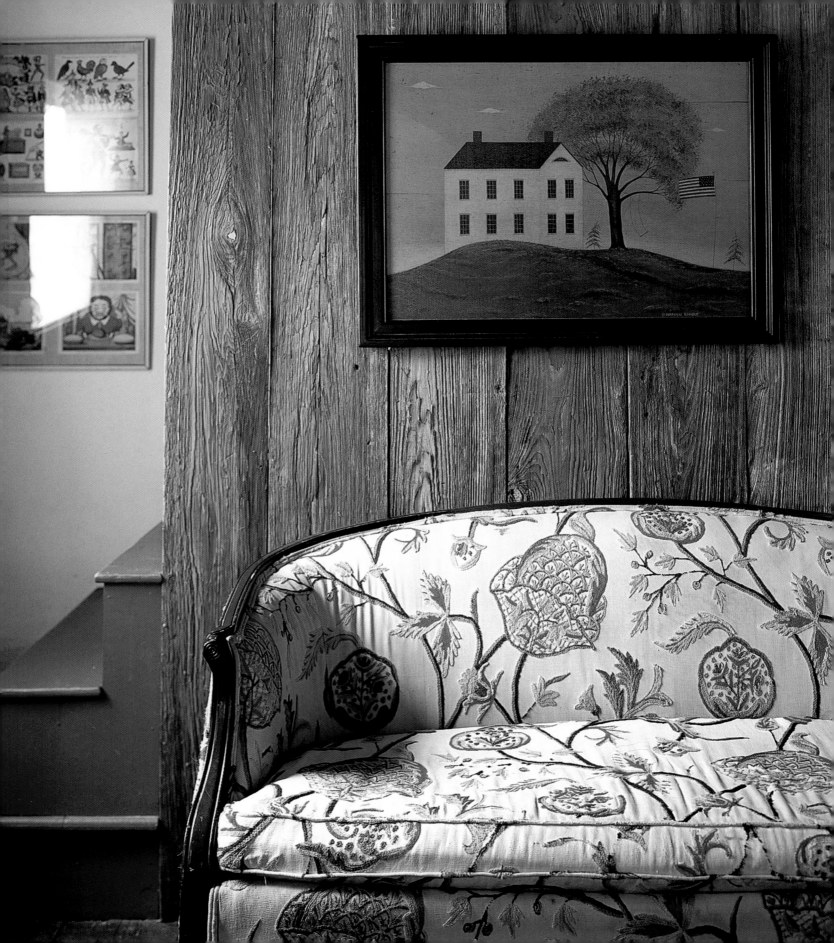

Sofas

When I finished college and got my first apartment in New York, my parents told me that it was time to "invest" in a sofa. Like so many other people in their early twenties, I decided to buy my sofa from Conran's. During the 1980s stores like IKEA and Conran's had great-looking furniture at great prices. So, in 1986 I became the proud owner of a bluish gray two-seat sofa from Conran's. While it came at a great price and looked nice from a distance, it was not particularly comfortable to sit on and even worse to sleep on. Six months after I bought it, the foam that it was made of seemed to suffer a nervous breakdown. Daily, I would come home from work and find little bits and pieces of the beige foam on the floor. I vacuumed the pieces up each day, with the hope that my sofa was just shedding its winter coat in preparation for the summer to come, but to no avail. It kept shedding foam until it became as disfigured as the Elephant Man. At that point I had no choice but to get rid of it. I watched from the living-room window of my apartment as the Department of Sanitation truck drove off with my first and last foam sofa. So much for my so-called investment.

Part of what caused my first sofa to fall apart so quickly was the fact that it had no springs underneath. Even though you may not be able to see under the fabric a sofa is upholstered in, you should be able to tell whether it is made with springs. Good springs, in addition to stuffing, filling, webbing, and a strong frame, are an important component of the foundation of any type of upholstered furniture like sofas or chairs. Springs come in different sizes, which refer to the number of metal coils that are used. Different springs are used for different types of furniture. For instance a #2 spring (which usually has eight coils) might be used for a sofa. You might also note that seat springs are different from back springs, both in terms of size and the number of coils. A typical back spring might contain six coils that are thinner or of a lighter gauge than those used for a seat. Beware of zigzag springs (the cheapo version of the real McCoy). While it may not be necessary to jump up and down on a sofa before you purchase it, try to make a conscious attempt to find out how it was made. You want a sofa that will support you indefinitely, without the worry that it will collapse or sag onto the floor.

Today I have a well-designed, custom-built sofa that was made by an upholsterer at a professional furniture workroom. Although this sofa certainly cost a lot more than my first sofa from Conran's, it was well worth it. It is now seven years old, and I imagine that I will own it for many more years to come. Even if I eventually tire of the fabric that it was upholstered in seven years ago, I know that I will always like its basic style and shape. For the record, a "real sofa" that will withstand the test of time, small children, the family dog, and years of TV watching is probably priced somewhere between $1,800 and $3,500 rather than $600 to $900. Remember that you usually get what you pay for. Don't misinterpret this to mean that there aren't deals to be had. But if it feels as if it's going to fall apart fifteen minutes after you buy it, it probably will. Spend a little more on well-designed, well-made, and smartly crafted

Sofas are available in many different shapes and styles. Consider using an older style or antique sofa in addition to something more contemporary. This "crewel" sofa was purchased at an auction.

pieces of furniture, and chances are that you will own them a lot longer than inexpensive and cheaply made imitations.

Down sofas look great in the showroom but are often a pain in the neck when you get them home. Everyone who owns a down sofa knows about pillow maintenance. Down-sofa pillows need to be constantly fluffed and shaken, and since you probably don't employ a full-time sofa-maintenance person, you will find yourself constantly fluffing. Conversely, polyfoam cushions can be very stiff and inflexible. I prefer to use foam-core cushions that are wrapped in down. This way you get the best of both worlds. You get the stability and firmness that the polyfoam provides, with the softness of down. And most important, you save money because you do not need to hire a full-time professional pillow-fluffer so that your sofa looks terrific at all times.

Though the style of the sofa you choose is completely up to you (sofas have all kinds of fancy names like Bridgewater, Chesterfield, English, Billy Baldwin), I do have a few recommendations. If you pointed a gun at my head and told me that my life depended on choosing between a sofa with loose pillows and a sofa with a tight back, I would choose the tight-back sofa in less time than it would take you to pull the trigger. Sofas that are upholstered with the fabric tightly pulled over their bodies generally look more tailored and much neater than their more casual cousins with the loose pillows. It's an old wives' tale that sofas with loose pillows are more comfortable than those with tight backs. If you still want pillows on your sofa, I would recommend buying a couple of down or feather toss pillows to use as decorative accents or simply for lounging.

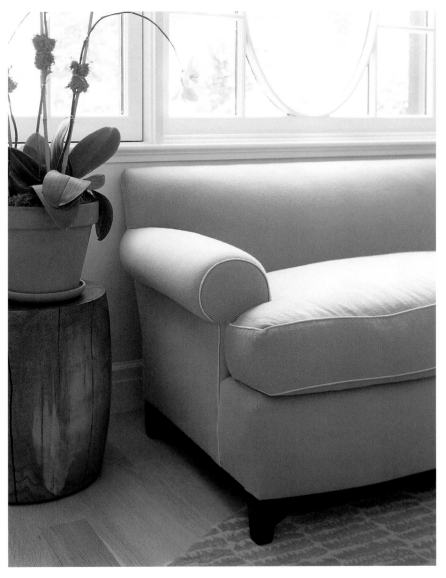

LEFT: Try not to forget the details. The colors of the rug are also used in the upholstery and trim on this love seat. **OPPOSITE:** Ottomans can be used to provide additional seating, or they can also be used as makeshift coffee tables by simply adding a tray.

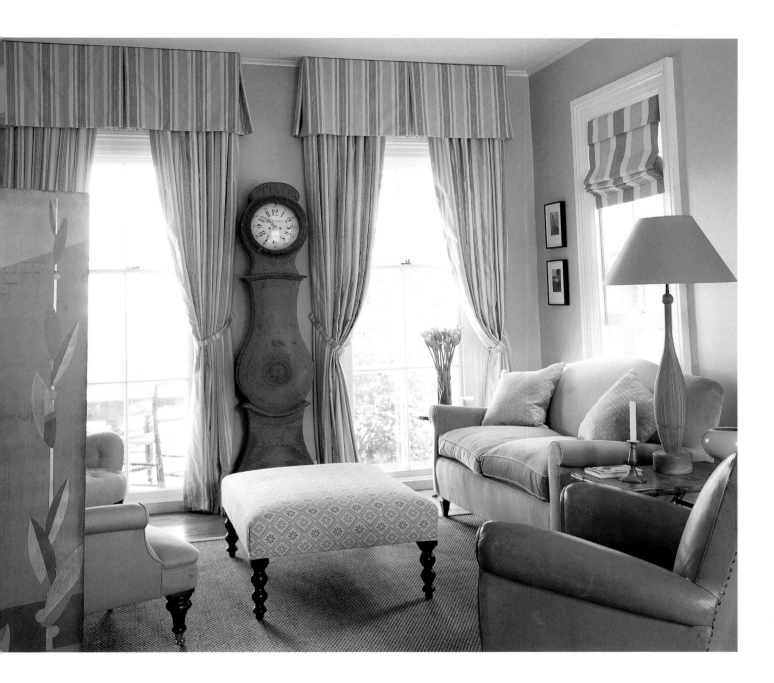

Coffee Tables

While I like traditional coffee tables with glass, marble, or stone tops, I also like to substitute upholstered ottomans in their place. I have found that an upholstered ottoman with a serving tray on top works just as well as most coffee tables. The only difference is that when you don't need a hard surface to put things on, you get some additional seating. Many of my clients with small children do not want to own glass coffee tables or side tables with sharp edges until their children are old enough not to get injured by them. Still wanting to have coffee tables for entertaining purposes or to put their feet up on, they have asked for less dan-

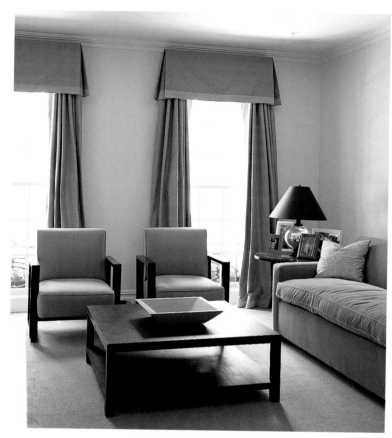

LEFT: Since this client has two small children, we used a leather coffee table instead of glass or marble. OPPOSITE: This coffee table was made from an antique iron gate. Once you add legs and a glass top, you're all set to entertain.

gerous alternatives. Apparently both decorating and child-rearing practices have changed significantly over the past couple of decades. When I was a child, my brother and I were told not to run or play in the living room near the coffee table. If we chose to ignore our parents' warnings, we ran the risk of getting hurt. Both my brother and I have a few battle scars, thanks to our stubbornness about furniture with sharp edges. But, for the most part, furniture that was off-limits was simply off-limits. We were more afraid of what our parents would say or do than what would happen if we hit our head on the glass coffee table. Nowadays more children have free rein throughout their homes, and living rooms and dining rooms are no longer used only for special occasions. This is what motivated me to start using upholstered ottomans and leather coffee tables instead of glass ones. I also like incorporating wooden

tables that are round or oval and have no sharp edges. These tables are just as attractive and practical as the typical glass or stone coffee-table top that you might expect to see in someone's living room. The difference is that when Timothy Jr. crashes into one of these coffee tables on his tricycle, his parents probably don't have to rush him to the emergency room.

End tables, or "occasional tables" as I like to call them, can be used in most spaces of your home with ease. Fit them wherever you feel a need. What makes them easy is that they do not require the same kind of contemplation as large pieces. They make the most sense next to upholstered pieces such as chairs and sofas for all the obvious reasons, including a place to set down a glass of wine or a plate of food. Small occasional tables also help contribute to the overall comfort and balance in a room. While some of this balance is natural, a portion of it is based on applying the knowledge that your eye needs to be stimulated by a variety of textures and shapes to stay focused and interested. Tables are always available in various shapes, sizes, and finishes and help "cut" the upholstered furniture by creating a contrast between hard things (like wood and metal) and soft things (like chairs and sofas). Use these tables to display some personal accents or decorative objects like candles or books — but try not to go overboard. An overabundance of personal accents,

foibles, and indulgences can easily tip the scale, making your room look out of balance.

When trying to achieve balance in a space, think about incorporating the many different furniture styles you have to choose from. For instance, if you have a big upholstered sofa with a skirt, maybe try a variation of club chairs with casters (wheels) or turned (carved) legs instead. When furnishing a room, always try to create a healthy balance of skirts, legs, fringes, wheels, etc. Too much of one thing is usually not a good thing. Rooms can look "leggy" if you have too many chair legs, table legs, and sofa legs all together in one small space. Although the concept of balancing your chair legs and sofa skirt might sound a bit odd, its implementation is important to the overall feeling that a room projects. I am sure there are rooms that you walk into and say, "Wow," because the room looks great. Though you may not be able to put your finger on what makes it look great, I guarantee that a lot of it has to do with the balance and proportion of the things in it. If you have too many upholstered pieces, a room can tend to look a little swollen, bloated, and heavy. Too little furniture and you may think that the room looks too sparse. Creating a successful balance can be a bit like juggling three oranges. It seems a little tricky at first, but the more you practice, the easier it gets.

If the furniture in your living room has been arranged in a way that makes sense, people ought to be able to

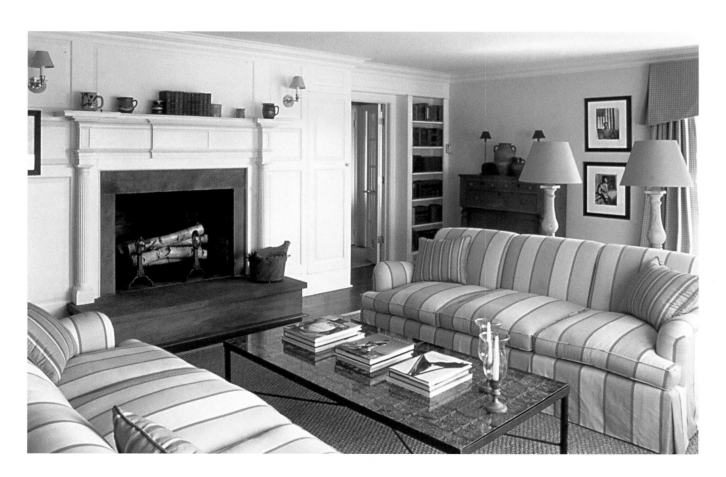

move about the room with ease. A little logic goes a very long way in arranging your furniture. Your coffee table should never be so close to your sofa or chairs that anytime you want to get up from your seat, you feel as if you are in a movie theater. There's nothing worse than having to ask the people in your row to get up so that you can slide out to buy a box of Raisinets or use the bathroom. You also shouldn't feel as though you need to fill up any and every available bit of free space with furniture. You and your furniture should have room to breathe. You should be able to stretch out without feeling restricted and be confident enough to lean back without worrying about hitting something behind you. Just because you live in a studio doesn't mean that you won't want to do hatha yoga in the morning and play Twister in the exact same place that afternoon.

The furniture arrangements that we live with should be able to accommodate most of our ever-changing needs and whims, no matter how odd they may appear to other people. If you routinely like to swing from the dining-room chandelier, fine. Just make sure that you have enough room so that you don't break up the place. How you arrange your furniture also has a lot to do with the way you intend to use the room you are decorating. For instance, if you know that you are always going to be watching television in your family room, obviously you should arrange the furniture in a way that will allow you to accomplish your mission. Don't place the television in direct sunlight or in shadows that will inhibit your ability to see the screen clearly. If you want your bedroom to be a quiet sanctuary in which to read and sleep, I would suggest locating your coffee grinder, treadmill, and fax machine in another room. When rooms work the way we intend them to, we are able to truly relax and enjoy these spaces. We are also usually inspired to make other rooms in our homes seem more like them. Exercise some creativity when deciding where furniture goes after the main pieces have been located. Put a comfortable chaise near a window for reading or simply for daydreaming. Locate a desk in a private alcove or nook somewhere that will allow you to have the type of privacy and quiet that you require to get your work done. While your furniture won't exactly talk to you, it does communicate with you if you are willing to pay attention. If you put a table and chair in a corner and step back, either you like what you see or you don't. If it doesn't look good, then it is probably telling you that you should move it somewhere else. Listen. There are many times I have drawn elaborate

TVs are what they are. Don't feel that you have to hide them in a television cabinet or armoire.

furniture plans that made sense on paper but didn't work in the actual space. Take the time to place your furniture and step away. Don't rush it and don't be rigid. The more patient and flexible you are, the better the chance that your furniture will end up in its rightful place. While I do not practice feng shui (the Chinese art of placement), I do believe that there are natural places where things intuitively seem to belong. If you are willing, move things around and try things in different places. You not only will develop more defined biceps but will have a more defined understanding of the important role that placement and arrangement plays in the design process.

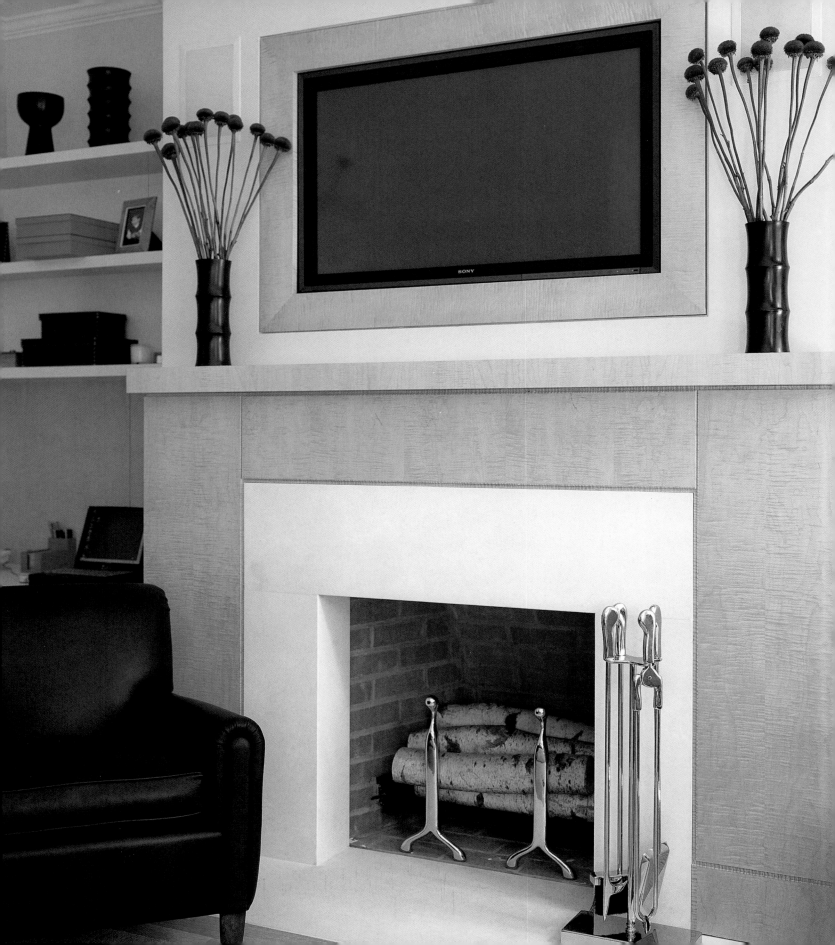

"Oh, give me a home where the buffalo roam . . ."

— *"Home on the Range"*

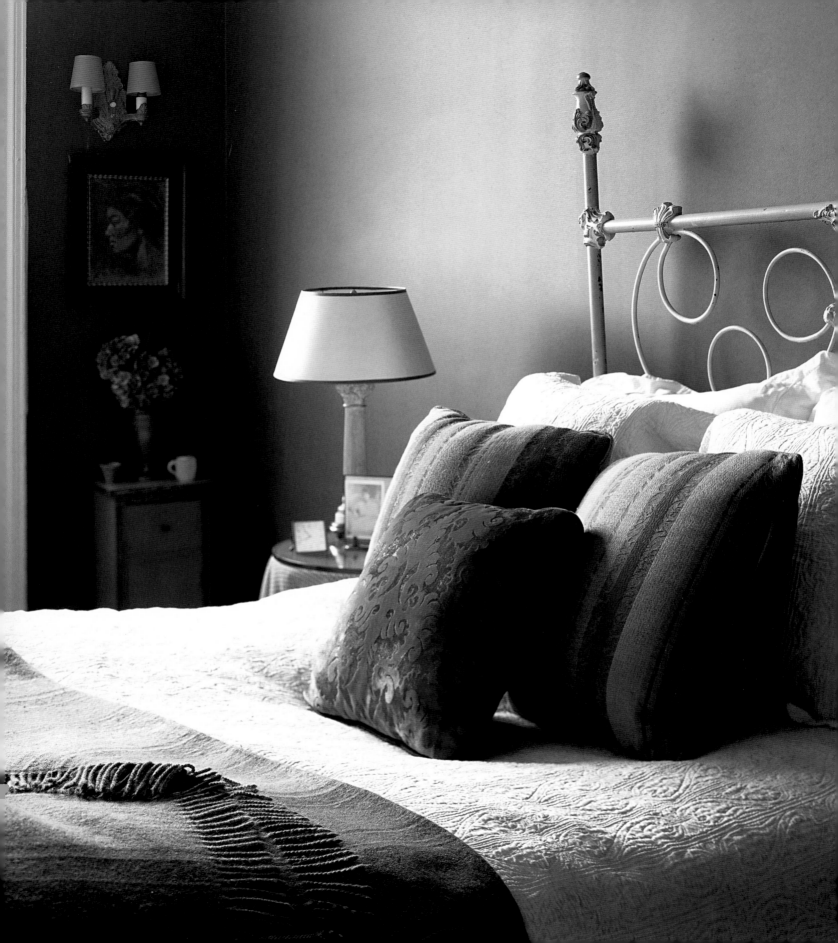

the comfort zone: beds, pillows, and upholstery

GOLDILOCKS and the three bears knew a thing or two about the importance of comfort. In case you have forgotten this classic childhood fable, the interior designer Cliffs Notes version goes something like this: Goldilocks goes to the three bears' cottage in the forest and basically takes over the place. Apparently, the three bears had a pretty well appointed home with stylish and comfortable furnishings and some porridge fresh off the Viking range. Goldilocks is hungry and tries a couple of bowls of porridge before she finds one that's "just right." After eating the bowl of porridge belonging to the baby bear, Goldilocks went off in search of a comfortable chair to relax in. The first chair she tried was much too hard and too big. The second chair she sat on was much too soft, even though the size was a little better than the first one. Finally she came upon the perfect-size chair, which looked as if it was made for someone

her shape and size. She liked the chair and sat in it until it broke beneath her. The chair didn't break because Goldilocks was a particularly big girl, it broke because it was poorly crafted and made of an inferior quality of wood. Like most people who have had a good meal and are in a relaxing home environment, Goldilocks began to feel sleepy and decided to take a nap. She tried the papa bear's bed first, but the mattress was way too hard. She then tried the bed belonging to the mama bear, but that was way too soft. There was only one bed left for Goldilocks to try, and to our surprise, not only were the scale and proportions of baby bear's bed perfect for Goldilocks but the 300-thread-count Egyptian cotton sheets were so comfortable that she fell into a deep and peaceful sleep. When the three bears finally arrived back at their home, they were dismayed to find that their porridge had been

eaten and that someone had sat in two of their chairs and broken the other. Finally, they noticed that someone had even had the audacity to climb into their beds uninvited and that a blond girl named Goldilocks was still asleep in the baby bear's bed. Goldilocks was awakened by all of the bear commotion, realized that she was in the bears' house, and jumped out the window before they could call the cops.

Comfort means different things to different people. For some people, comfort has to do with privacy and security. It may be installing an alarm system so that you feel safe from potential intruders. For a cowboy, it might mean a place "where the deer and the antelope play." For Goldilocks, comfort meant having a great chair to sit on and a perfect bed to sleep in. But comfort also has to do with establishing boundaries for yourself and other people in your home. While some of these boundaries can be physically established, many are based upon verbal communication, like telling your kids that your office is off-limits. If you don't want everyone who comes to your home to know everything about you, keep the personal photos, your diary, that family heirloom, and your favorite sex toy in your bedroom rather than in the kitchen. Boundaries help you keep your sanity if nothing else.

PAGE 120 AND LEFT: Beds should be luxurious. I usually prefer white cotton sheets but use bold colors and heavier textures for pillows and throws. OPPOSITE: Your home shouldn't be so perfect that you are afraid to invite people over to enjoy what you have created.

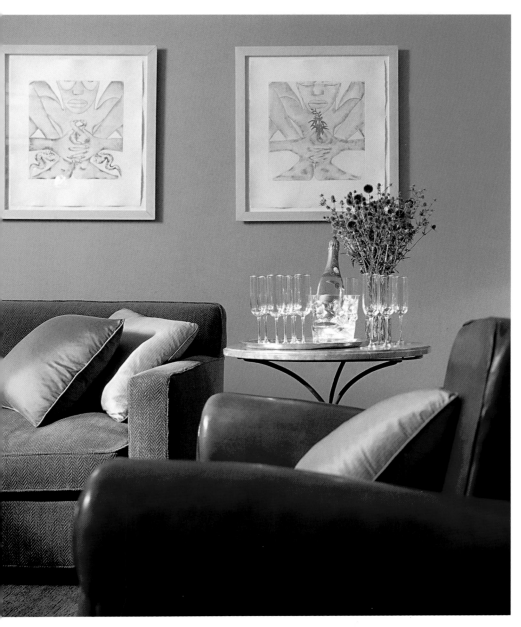

incorporate these choices into our living spaces has to do with the function of the room we are trying to establish comfort in. For instance, a dining chair should be comfortable to sit in but not so comfortable that we fall asleep in it. While we might love the warmth of natural sunlight through our windows, our rooms shouldn't be so bright that we are almost blinded when we open our eyes in the morning.

People should care about the level of comfort that their homes provide. And comfort is not just about the purely physical, as in the chair that your cat is curled up in or the plush carpet underneath your feet. Comfort also has to do with a sense of belonging and ease. I'm sure that at one time or another, you have been in someone's home that made you feel slightly uncomfortable or self-conscious. I recently

Establish comfort in your home wherever you see fit and however you deem appropriate. At five foot three I think that my full-size bed is extremely comfortable. It has a painted iron headboard and footboard that have aged gracefully with the passing of time. If I were six-five instead of five-three, I imagine that I wouldn't feel too comfortable with my feet sticking through the footboard. There are various degrees of comfort that we selectively choose for different rooms. A lot of how we

visited a potential client's home that was so full of fragile-looking and perfectly placed furniture that I thought I would surely break something if I spoke too loudly or breathed too hard. While I can respect one's choice to surround oneself with beautiful things, our furnishings should not be so precious that they interfere with our ability to live with ease. If you want to live in a visually flawless, climate-controlled, look-but-don't-touch environment, you might consider moving into a museum.

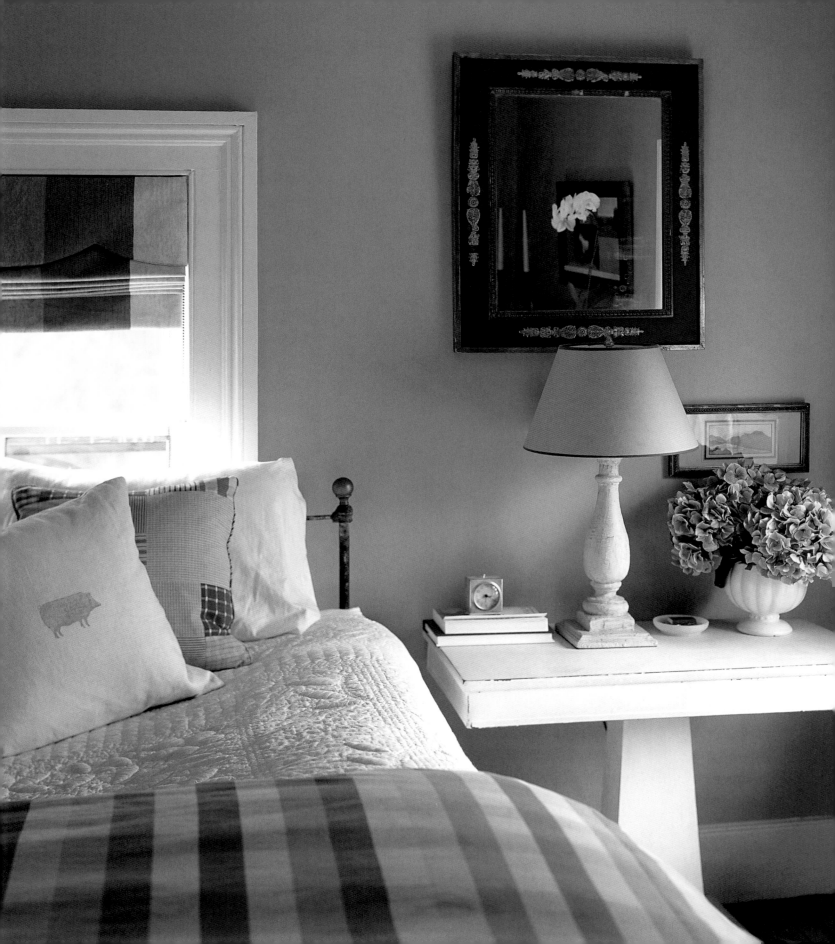

Beds and Bedding

I may not be able to bake a casserole worthy of Julia Child's praise, but I sure can make the hell out of a bed. There aren't too many things that I think I'm particularly skilled at, but my ability to make a great bed is one of them.

My fascination with beds and bedding started in the summer of 1977 when I was in the seventh grade. Thanks to my parents' generosity (and their unspoken desire to get me out of the house for two months), I spent eight weeks of my summer at an overnight horseback-riding camp in a rural part of Pennsylvania. I shared a cabin called Cree with five other girls, all of whom shared the same passion for horses, riding, and other outdoor activities. Every morning our cabins were routinely inspected by our camp counselor for neatness and cleanliness. Our clothes were supposed to be folded, our beds made, our personal belongings put away. Junk food, candy, or soda, if found, would be confiscated like contraband. Judging by the strictness of the inspections, you would have thought that we were in the military instead of at summer camp. On the weekends the inspections became even more rigorous, as the camp director and her assistant walked around our cabins with a clipboard in hand, checking our names off a list as they went from bed to bed checking the various tucks and folds of our blankets

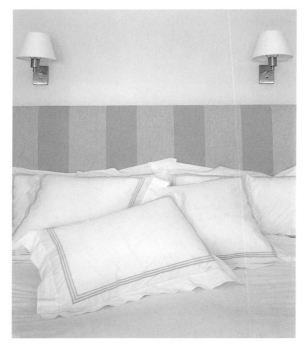

and the precision of our hospital corners. That summer was memorable for many reasons, but three things in particular stick out. The first was that I learned a proper hunt seat and how to jump a two-foot crossrail without killing myself. The second was how to hide bags of Doritos and cans of Pringles underneath rotted floorboards. Finally, and probably most important, I learned how to make a bed that looked neat and presentable. To this day, I can't stand to sleep in a bed that doesn't have the sheets and blankets neatly tucked in. Although I can't explain it, there is something about the sensation of having my feet nakedly exposed to the elements that seems completely frightful to me.

Ever since those camp years, I have been on a personal and professional crusade to convince friends, family, and clients that they should make good investments in their mattresses and bedding. Everyone ought to be able to take true and complete refuge in one's bed. Where else do you spend as much as eight hours at a time horizontally in your home? Though most people neglected to sign up for Bedding 101 while registering for freshman English, there still is time to take

OPPOSITE: This bedroom is all about comfort and style. ABOVE: These classic and tailored bed linens have just a hint of color to accentuate the upholstered headboard.

the remedial crash course. Take notes, please. There may be a pop quiz at the end of the chapter.

The components of a great bed are really pretty basic. And no matter what your budget, there is no excuse for having an uncomfortable or unattractive bed. Buy a great mattress that suits you. Soft, firm, extra firm — it's your preference. Personally, I like firm mattresses. Having nice sheets without having a good mattress is like buying an expensive stereo without good speakers. After you have a mattress and box spring, you will need a mattress pad (I prefer the quilted ones) and something to cover the exposed box spring. While some people like bed skirts (or dust ruffles, as they are also called), I prefer to use box spring covers. If you don't want to purchase a special box spring cover, you can use a fitted sheet over the box spring so that you don't see the fabric of the box spring (which usually is in a satiny blue or beige color). Once you've got your box spring covered and the mattress is on your bed, you should cover the mattress with a mattress pad. Mattress pads come in a variety of styles and textures. If you have a tendency to wet your bed at night, I would suggest that you buy a waterproof mattress pad. Otherwise, you have a huge range of fabrics to choose from, including cotton, fleece, wool, down, and chenille. Again, the choice is up to you.

After the mattress pad comes the feather bed. Feather beds are kind of like comforters but heavier. The other difference is that you put them under you rather than on top of you. Even if you are allergic to feathers, there are many bedding products on the market nowadays that feel just like down but wouldn't offend Mother Goose or Donald Duck. I usually put my feather bed in a plain featherbed cover under the fitted sheet so that it's nice and snug. This way, I am reminded to shift it and fluff it whenever I change my sheets. Put the flat sheet on top of the fitted sheet and then put on a good blanket — wool or cotton depending on the time of year and the climate of where you live. And please don't forget to tuck in the sheets and blanket. I think that every bed should be finished off with a coverlet or bedspread of some sort. I prefer cotton bedspreads or coverlets to those that are made with synthetics. The icing on the cake is the down comforter and duvet cover. There is nothing quite like snuggling under the warmth of a down comforter with someone you love on a cold night. The down comforter (in the duvet cover, of course) should sit at the foot of your bed for extra-cold nights,

Stripes, plaids, and checks can be mixed together without making you dizzy.

while the other components of your bed pretty much stay tucked in at all times.

Personally I prefer very classic and tailored-looking beds to those that are overly ornate and fussy. Once again, the choice is yours to make. Feel free to add a great throw or toss pillows to the bedroom scheme if it makes your bed seem luxurious. While some people like to buy queen-size pillows, European squares, bolsters, and neck rolls, I tend to stick with what I know and like — namely, the standard pillow. Give me two quality, somewhat firm, standard-size down pillows, and I'm good to go.

I prefer white or off-white sheets; if I want to introduce color, then I tend to buy white sheets with a contrasting trim or embroidery. There is something about

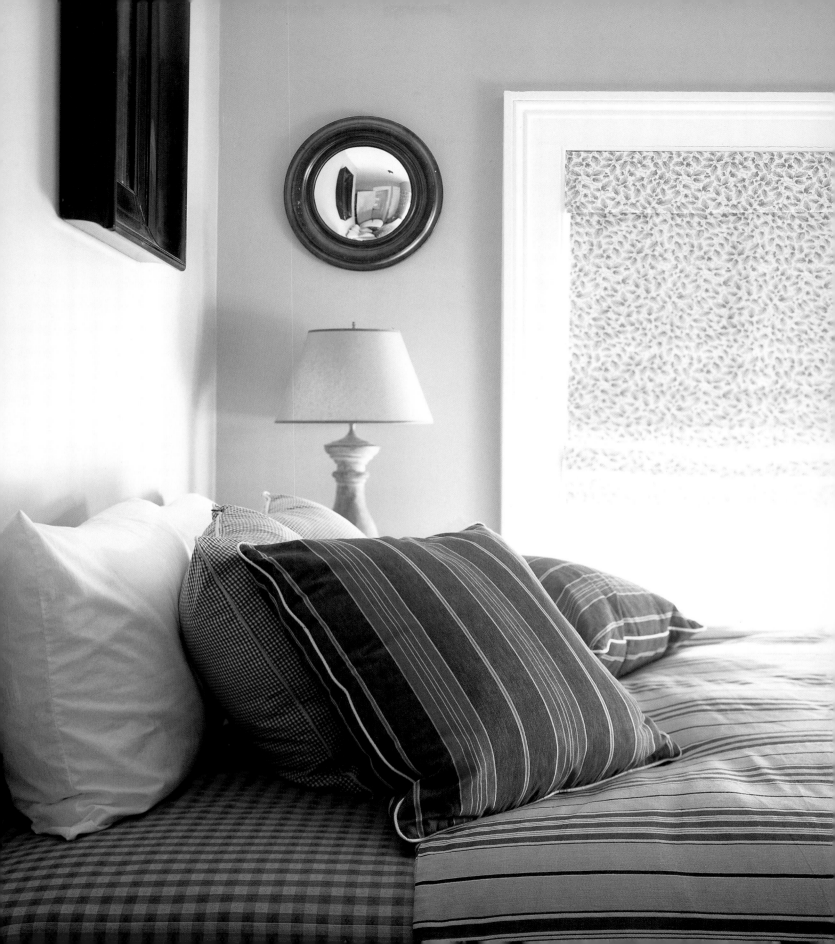

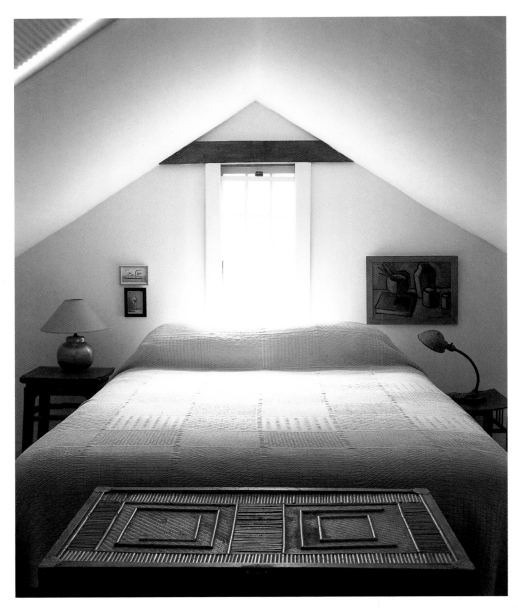

some people complain that they find this whitewashing somewhat sterile and cold, I find it soothing.

I am a firm believer that sleeping on psychedelic-patterned or intensely floral sheets induces nightmares. Although Freud never discussed this in his book *The Interpretation of Dreams,* I'm sure that if he were alive today, he would probably agree with me. Forget the satin, silk, or polyester sheets and stick with 100 percent cotton. Even John Travolta in *Saturday Night Fever* didn't sleep on silky, satiny sheets. A new set of cotton sheets, a new bedspread, or

sleeping on crisp and clean, soft, 100 percent cotton white sheets that is heavenly. If you have ever stayed at the Delano Hotel in Miami's South Beach, then you've experienced the seduction of white sheets. All the rooms at this chic hotel (which was designed by the French designer Phillipe Starck) are completely white. Literally everything is white, including the walls, the stereo, the TV, the minibar, night tables, lamps, window treatments, upholstered furniture, and, most important, the beds and bedding. Although I've heard

pillow shams can immediately refresh a tired bedroom. Change your bedding scheme with the change of season. Cotton flannel sheets are warm and toasty in the winter; white Egyptian cotton sheets keep you cool and refreshed during the hot or humid summer months. You do not have to buy expensive sheets but at least try to buy sheets that have a higher thread count than 200. It really makes a difference. A great bed should embody the idea of luxe without fuss.

We all have access to great sources for bedding

nowadays, thanks to the Internet and mail-order cata- logs. Some of my favorites are Chambers, Pottery Barn, and Eddie Bauer Home. While I regularly purchase much more expensive and higher-quality sheets at stores like Pratesi for clients, I still use these other sources for my own bedding. I think everyone would agree that there's nothing quite like getting a good night's sleep to help get you ready for the day ahead. Though a lot of that has to do with your basic ability to just lie down, relax, and sleep, some of it really does have to do with what you are sleeping on.

Freudian Slipcovers Pillows, and Upholstery

If we could assume that Freud would have had strong opinions about the types of sheets we sleep on, he would more than likely have had something to say about why our psyches need slipcovers, pillows, and uphol- stery. Maybe he would have suggested that we use pil- lows, slipcovers, and upholstery to hide our repressed or subconscious wishes for new furniture. In Freud's own words, maybe these things simply represent "a round- about way to wish fulfillment." Wish fulfillment or no, slipcov- ers and decorative toss pillows provide a quick and inexpen- sive way to add finishing touches to any room. Make the finishing touches and the details count for something. Use contrast welting (different color and/or texture) on the

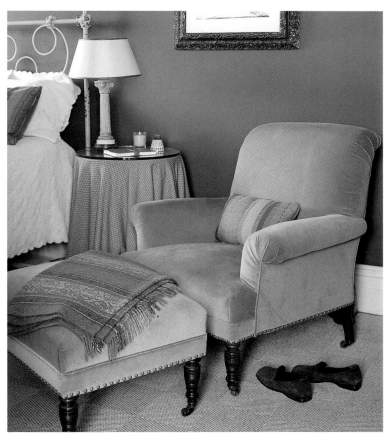

sofa in your study, but self-welt (using the same fabric as trim) the wicker chair seat in your sunporch. Use nailheads on that leather wing chair in your office, and boullion fringe on the low velvet slipper chair in your bathroom. The details make the difference between what looks acceptable and what looks phenomenal.

The texture of the fabrics that you choose is just as important and as distinctive as the furniture you put them on. Use common sense when choosing fabrics with which to upholster or slipcover your furniture. Obviously, it probably wouldn't make a lot of sense to slipcover your breakfast-room chairs in black silk taffeta. Do yourself a favor and save it for your cocktail dress. Do a reality check from time to time by asking

yourself some basic questions about the way you live. If you have twin boys under the age of five, you probably ought to steer away from an all-white interior unless you have a full-time staff of eight. If you have a husband who likes to drink beer and eat pizza with his buddies on the family-room sofa, you probably should think about using durable, all-over print fabrics in medium to dark colors. If you think you live in a way that is rougher and tougher on things than most people are, maybe you should consider Scotchgarding your fabrics. You can forget the context in which you live if you like, but chances are that you'll end up making some mistakes you could have easily avoided.

While I usually prefer solids or subtle patterns on sofas, I tend to use fabrics that are very durable and soft to the touch. Cottons, linens, wools, chenilles, velvets, and combinations of these materials will probably work well for most people because they wear well and sometimes even look better as they age. Most stores nowadays have fairly extensive fabric collections for you to choose from. The choices are unlimited and easily changeable.

Once in a while I work with a client who insists that all the furniture in a certain room be upholstered in the same color. Though I have nothing against someone's furniture being in the same color family, I do think that all the textures or fabrics should be slightly different. Let's just say that robin's-egg blue happens to be your favorite color. So go ahead and upholster your sofa in light blue cotton damask. Buy club chairs that are upholstered in blue velvet and detailed with blue fringe. Maybe your ottoman is made of blue linen but trimmed in a blue canvas. Accent pillows are striped

blue-silk taffeta. Go hog wild with the blue scheme as you see fit, just try to mix the textures so it doesn't look as though there was a tag sale on only one robin's-egg blue material at your local fabric store.

When used properly, slipcovers can provide relatively inexpensive solutions to difficult decorating problems. A few years ago I had a client who hired me just after he had bought a full set of new dining-room furniture, including an eight-foot table and ten new dining chairs. While I could stomach the dining table with the help of a little Alka-Seltzer, I could not help but wish that the chairs would disappear into thin air. Rather than insult the client about his new purchase (which he was thrilled about), I suggested that we slipcover the chairs so that they would match the window treatment. He had some initial reservations, but after we showed him a few sketches of what his dining room could potentially become, he was quickly on board to let us disguise those dining chairs with slipcovers. Luckily for us,

The slipcover and bolster pillows help turn this daybed into seating. Floral throw pillows soften the crisp slipcover.

the chairs had a nice, rectilinear shape — which naturally lends itself to the tailored slipcovers we had made. Remember that the key to successful slipcovers is the type of fabric you use and the style that they are made in. I usually gravitate toward neatly tailored slipcovers rather than ones that are froufrou or cascading. Though there are probably many instances when these styles are appropriate, I find them high-maintenance and potentially messy. I also recommend making your slipcovers out of cotton or linen fabrics so that they can be washed or professionally dry-cleaned.

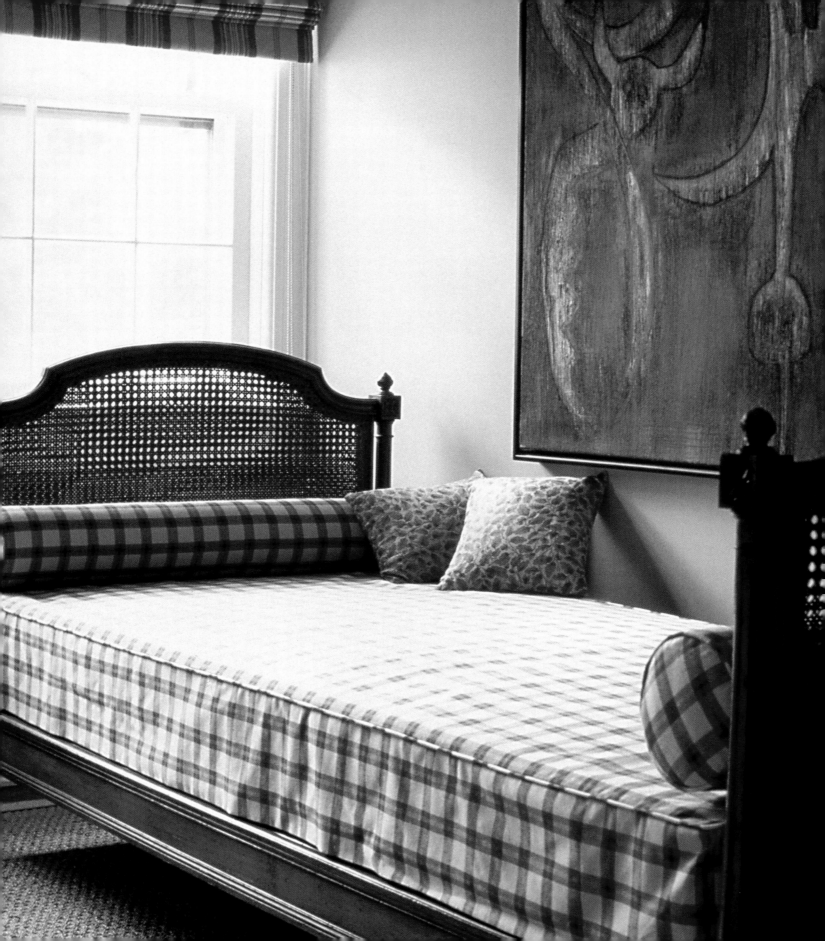

LEFT: The ample storage we designed in this client's bathroom makes this vanity cabinet as practical as it is beautiful. OPPOSITE: This client couple wanted their bathroom to have the look and feel of a spa. What could be more relaxing than taking a bath with a roaring fire in the background?

Closets, Cabinets, and Storage

Apparently, closets aren't just for skeletons, gay men, and your average criminal-in-hiding anymore. They have become such an integral part of our homes that we never really think about them unless we don't have enough of them. Everyone needs closets. Imelda Marcos needed a place for all those shoes. For Monica Lewinsky, a closet was a place to hang that infamous stained blue dress. Whatever your individual needs are, closets are essential to modern-day living. I have a

neighbor who couldn't get a mortgage for his new home until he built closets. Sounds absurd, but it's true. Our closets should be able to accommodate most of the stuff" we need to live and to support our lifestyles. All closets need organization to make them work properly. Coat closets, linen closets, and closets with bikes, clothes, tennis racquets, hats, and umbrellas. Even our unfinished projects live and breathe in our closets: that set of prints needing to go to the framer at some point during this millennium, that bag of dirty laundry that still hasn't made its way downstairs to the washer and

dryer. How many more rainy days do you think you need to convince yourself that you will probably never get around to that "rainy day" project?

I'm not sure what the world would be like if we didn't have any cabinets, but I have to imagine that it wouldn't be terribly pretty. I have visited the homes of many potential clients who give the impression that they are the most organized people in the world — CDs alphabetized, bills filed, recipes and photographs coded à la Martha Stewart. Only later, after I start working with them, do I discover that they have shoved

everything short of their firstborn into their cabinets. Although excavating such closets can be a little like opening Pandora's box, it is a necessary part of the organizational process. And I must admit that I can attack a closet or cabinet with the same level of vengeance as that great white shark in *Jaws.* Sorting and dismantling an accumulation of stuff involves asking a lot of questions. Do you really think you will ever use the boxes that your answering machine, computer, or stereo came in? Doubtful. Do you actually believe that at some point you will use that pink Samsonite

luggage you've had since 1972? Highly unlikely. Is it really necessary to hang on to that poster of Michael Jackson pre–plastic surgery? Since most of us continually operate at a disadvantage when it comes to closet or storage space in our homes, we need to break the habit of hoarding. We hoard stuff in the garage, the attic, our basements, under our beds, in the tops of cabinets, and closets. Most of these places are not easily reachable and generally pretty inconvenient. Over the years we continue to accumulate more and more stuff. It's as though stuff breeds and reproduces more stuff while the doors are closed and we aren't looking. Boxes of junk and bags of old clothes giving birth to more boxes of junk and bags of old clothes. At some point, it is worth taking time to sort through the things you own. You will probably find that there are many things that you don't really use anymore taking up a lot of room. I promise you that forgetting where you put that pair of brown shoes has less to do with Alzheimer's setting in and more to do with having too much stuff not properly organized in your closets.

Lose it, chuck it, toss it — call it what you like, but just get rid of it. Besides, it can be intensely satisfying to get rid of stuff. It can be even more satisfying if the things that you are getting rid of are going somewhere they will be appreciated. There are many organizations that will gladly accept your clothing and furniture donations as long as they are in good shape. And many of these donations are considered tax-deductible — places like the Salvation Army, Goodwill, Furnish a Future, just to name a few. Check the phone book for the various organizations in your area that will accept donations. Since most of us are probably less inclined to give things away if it involves schlepping bags and boxes somewhere, don't forget to ask the various organizations whether they make pickups. Many are willing to come and pick up the items directly from your home. There may also be some items that you should consider selling on consignment. Many places will actually sell your used furniture or clothing and give you a healthy percentage. I do this regularly with old clothes that I think I spent too much on to simply give them away.

Although cleaning out your coat closet, basement, garage, or attic is a great way to start, there is a lot more that is required if you truly want to live more elegantly and efficiently. To the extent that you can begin to incorporate a sense of organization in your life that allows you to live more efficiently, you will be that much closer to your goal. Only we can determine what exactly we need to make our homes efficiently organized and keep them that way.

I used an antique mirror from the flea market to replace the new one that came with my store-bought medicine cabinet.

Bathrooms require special attention when it comes to organization. Mr. Bubble, Q-Tips, cotton balls, towels, aspirin, creams, lotions, gels, combs, and brushes — the list continues. All these things seem so essential to our hygienic rituals and indulgences that there ought to be individual places for all of them. While there may not be an opportunity to redesign your bathroom, there are a few things you can do to make it organized and essentially more functional.

If you don't already have a medicine cabinet, buy one. Although most houses and apartments come with medicine cabinets nowadays, the standard ones can be frightfully unattractive. My least favorite are rectangular

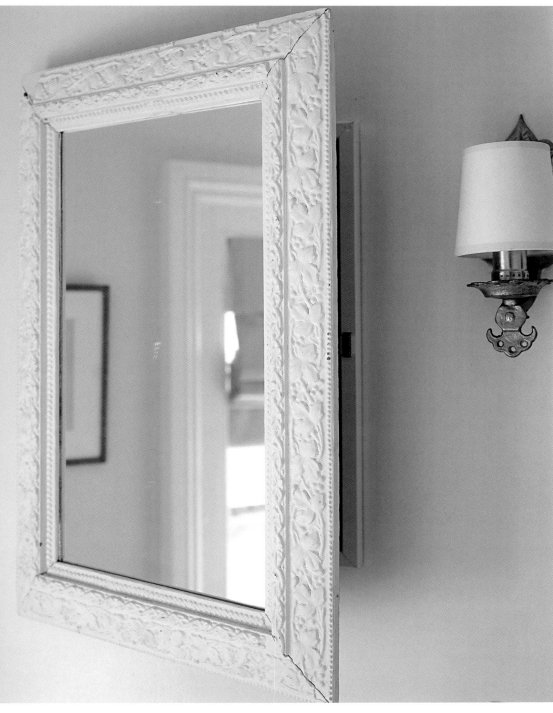

door of the medicine cabinet off and use an antique framed mirror in its place. A simple piano hinge will do the trick. And if the glass looks too old and is discolored or damaged, simply replace it with new glass.

While I love pedestal sinks, I prefer to use them in powder rooms or guest rooms, where it isn't essential to have a lot of storage. I prefer vanity cabinets simply because of the storage they provide. Vanity cabinets are great for the big items that won't fit in your medicine cabinet. Blow dryers, toilet paper, curling irons, bathroom cleaners, and even the ever-popular yellow rubber ducky. If you don't have room for a vanity cabinet, buy storage bins for your things. There is quite an assortment of stylish and affordable options to choose from. Storage bins and baskets are available in metal, straw, or wood. Some are stationary, and some even have wheels so that you can literally roll yourself toward organization and comfort!

with multiple mirrored doors and a row of frosted bulbs reminiscent of Ping-Pong balls. It is easy to replace these cabinets with something a little more tasteful. If you are planning on installing a recessed medicine cabinet, or already have one in your bathroom, take the

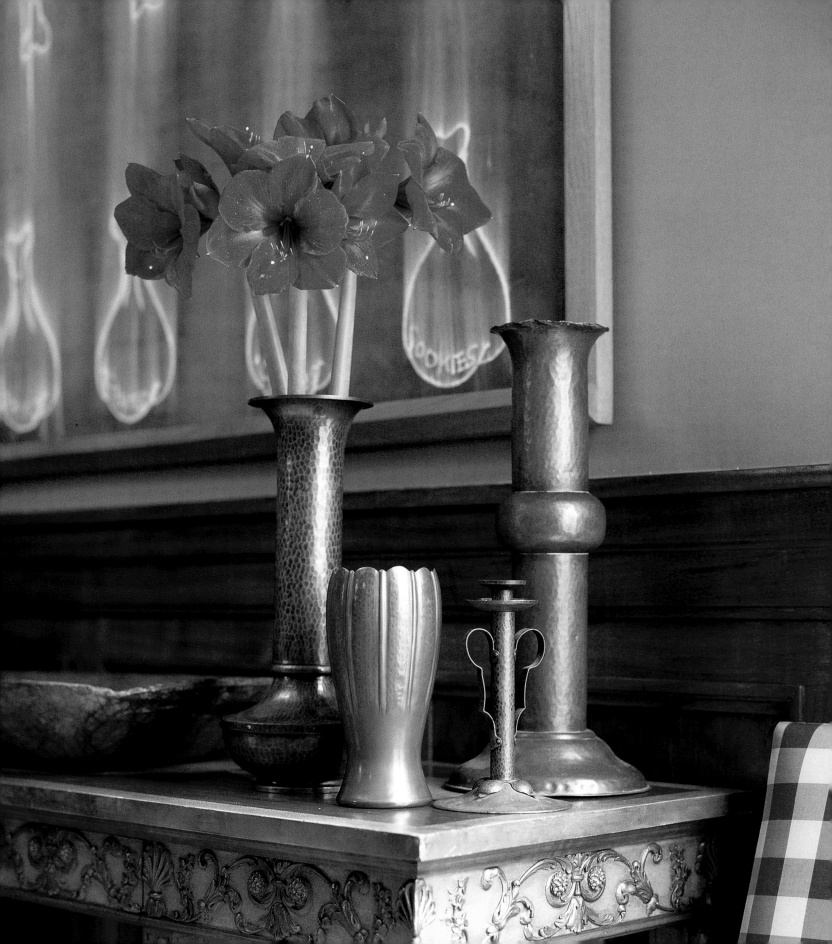

"There comes a time in a man's life when to get where he has to go—if there are no doors or windows—he walks through a wall."

—BERNARD MALAMUD

if your walls and windows could talk
I HAVE TO BELIEVE THAT THEY WOULD

have quite a lot to say, and probably not all of it we would want to hear. What you choose to put on your walls says as much as what you choose not to put on your walls. A beautiful oil painting, family photographs, a mirror, a sconce — the choices are as endless as the days are long. Thoughtfully combine decorative objects, artifacts, and art in ways that satisfy you visually. You should feel as though your walls are pleasing enough to look at without needing to wear sunglasses inside your home. And if you have to squint to look at what you've chosen to hang on your walls, you should probably take everything down and start from scratch. While it can be slightly intimidating to drive that first nail into your freshly painted bedroom wall, you have to start somewhere. It's kind of like jumping off the high dive at your local pool. The first time is pretty frightening, but each jump gets easier from that point forward. In general you should have some

idea of what you want to put where, before you start hammering away and making your walls look like Swiss cheese in the process. Hang the larger pieces first. Organize the other items on the floor before you put them up on the walls. Though I am by no means a pro at hanging art, I have learned a lot from clients, artists, curators, and art handlers about some of the general rules of thumb when putting up complicated works of art. I am fortunate enough to have some clients that are art collectors. Recently I watched a complicated art installation at a client's home in New York City. The artwork consisted of a group of photographs, all in different sizes and framed in different and unusual ways. I watched as one of the curators and professional art handlers laid out the pieces onto a large piece of cardboard on the floor to figure out how much space should exist between them before they went on the wall.

It's easy to make templates by tracing your framed pictures or photographs onto colored pieces of kraft paper or poster board. Cut them out, then tape the templates to the walls where you think you want to put the actual pieces. You may find that some things work in the intended wall spaces and that others don't. Live with the pieces of kraft paper taped to your walls for a day or two. Play around with the paper templates. Move them. Try them in a row. Try them more abstractly. Walk around the room a few times. Sit in a chair. Lay on the sofa. Different points of view are important to take into consideration when hanging anything. One piece may look good when you are sitting but looks terrible when you are standing. Once you've decided where things will go, trace along the top corners of the templates

with a pencil so that you know exactly where to hang the pieces themselves.

Keep in mind that framed pictures, paintings, and decorative objects do not exist statically on your walls. They should harmoniously play against the furniture and other decorative objects in the room. Your bookcase, sofa, and desk have a lot to do with how good or bad that framed pencil drawing looks on the east wall of your study. Be as unconventional as you want to be. Hang a picture in your bedroom closet. It happens to be one of the places that you mindlessly open every day. Wouldn't it be nice to see a pleasing photograph every time you reached inside to grab a shirt or pair of pants? Because of the humidity and the potential for damage, don't hang valu-

PAGE 138: Framed pictures don't have to be museum quality for you to enjoy them. OPPOSITE: Contrary to what many people think, contemporary spaces do not have to be cold or uninviting. Hang big and bold art to make peaceful statements.

able pieces in your bathroom. Powder rooms are fine. Hang some inexpensive prints or posters in your bathroom if you want art on the walls. Don't hang valuable pieces in direct sunlight, because the sun's strong rays can destroy them. Since most of us don't have uniform lighting like that in museums and galleries, be conscious of shadows that may be cast on your pictures from table and floor lamps. Consider using easels to display framed paintings or photographs. Not only is this method of display noninvasive to your walls, but it also provides an interesting alternative to traditional methods of hanging. Prop works of art or decorative objects on mantels, window ledges, and other unpre-

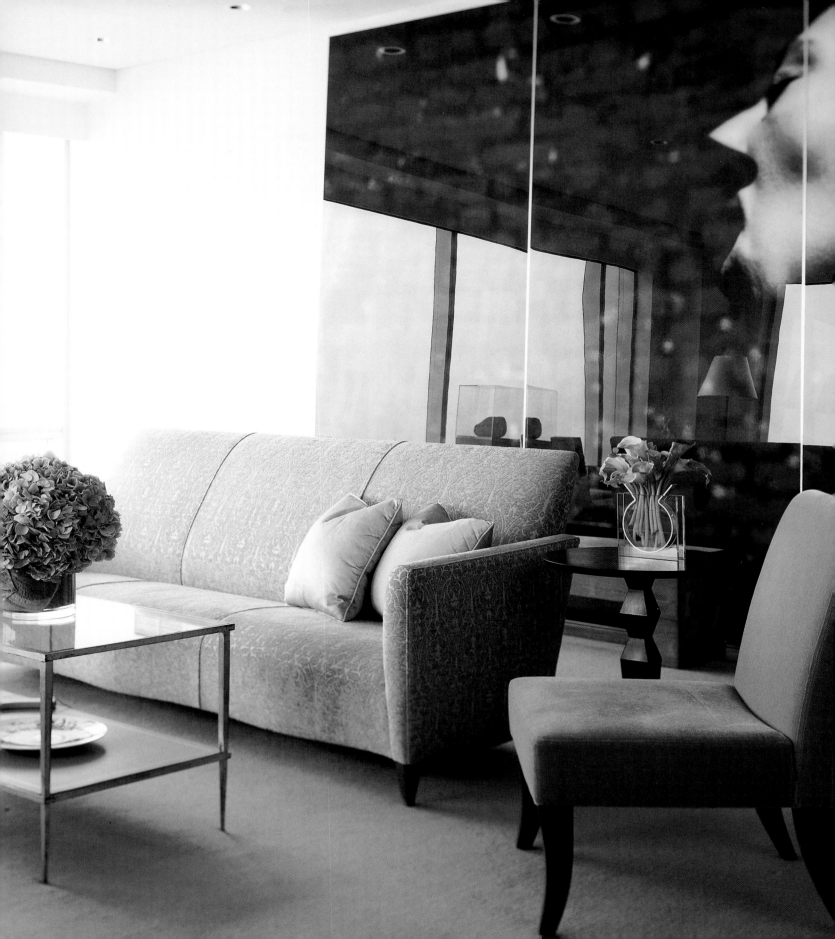

dictable places throughout your home. Place things on the shelves in your bookcases to break up the monotony of endless rows of books. Use architectural salvage, such as a piece of a dentil molding or a capital of a column, to create interesting contrasts. Even postcards can be interestingly displayed in ways that are truly complementary to your decorating scheme.

Note that while your great-grandmother's formal portrait may look better hung by itself and centered between two windows, those family photographs may look better grouped together. Most people's homes aren't galleries and museums. Though these places help set the standards, don't let them constrain or restrict you from doing something you feel inspired to do. Remember that a little nonconformity can be good. Since things don't have to make sense to anyone but you, hang pieces for your own personal enjoyment and pleasure. Whether it is a porcelain plate or a family photograph that you absolutely love, hang it across from your bed so that it is the first thing you see when you open your eyes in the morning. Sometimes things look better when hung in ways that seem less predictable. Despite what most people might think, walls and floors are almost never exactly straight. My friend Thelma Golden, chief curator of the Studio Museum in Harlem, says that "looks straight is straighter than is straight" when it comes to hanging art. Trust your

LEFT: Lean your favorite postcards on a ledge above a desk. OPPOSITE: Pictures of the same size and subject matter can be grouped together to create an interesting visual display.

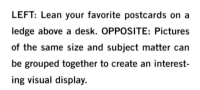

eyes. Or if you don't trust your own, trust your spouse's or your neighbor's.

Most people think that it costs a lot of money to frame things properly. Admittedly, custom framing can be very expensive. But the recent availability of low-cost quality frames has made framing easier and a lot more affordable. One way to make your photos or pictures look significantly better is to have things professionally matted to premade frame sizes like 20 x 24 inches or 30 x 32 inches. You will find that doing so will not only make your art look more impressive but will save you a lot of money. You can find standard frames anywhere — at the flea market, your local housewares store, and many mail-order catalogs like Exposures or Pottery Barn. Mix old frames with new ones. If the cost of using regular glass is prohibitive, use Plexiglas.

So now that you've figured out how to frame the thing and which wall you want it to go on, how high should it be hung? While many people suggest that you hang pieces at eye level (roughly five feet six inches or sixty inches A.F.F. — above finished floor), you should really use your own personal comfort zone when making the determination as to how high or how low something should be hung. If you and your spouse are both four foot ten, I think that it would make a lot of sense to deviate somewhat from the standard. Your mind may play tricks on you, but rarely will your eyes. If it looks better high, hang it high. If it looks better low, hang it low. If you have multiple pieces, pick a center point, then work up and down from that. Templates are good for hanging heavy pieces. If you have something that is particularly valuable, it might be worth the money to

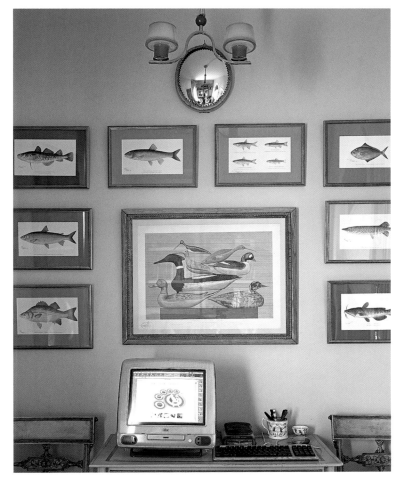

enlist the services of a professional picture hanger. We often hire art handlers and various other professionals to hang anything and everything clients want put up on their walls. Err on the conservative side when dealing with tricky shapes and sizes. Be careful when hanging anything that is fragile or that weighs more than twenty pounds. I recently had a mirror in my living room crash to the floor and break into a million pieces simply because I was too lazy to replace the wire on the back with something more substantial. I am reminded of this incident by the small shards of glass that still find their way into my foot every once in a while. Buy real picture hooks to hang your art rather than using any old nails that you happen to find in your house. They can help minimize the holes that you put in your walls. Again,

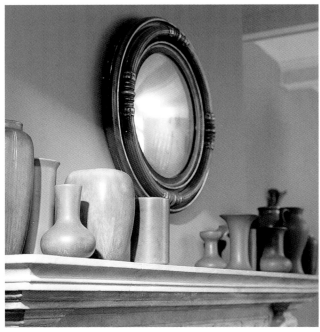

use both common sense and caution when hanging things. Use real wire as opposed to fishing line. And forget about substituting sewing thread or dental floss because you're too tired to go to the nearest hardware store.

There are many places where you can find art for your home. Check with your local chamber of commerce about art fairs and other upcoming art expos and events. Buy prints from museum shops. There are many great online art resources that have reasonably priced drawings, photographs, and prints. Check out Visualize.com, nextMonet.com, or artnet.com. You will be pleasantly surprised by how many terrific things they sell. Inquire at your nearest universities or art schools for exhibitions or shows featuring young and upcoming artists. You may be lucky enough to discover the next Romare Bearden or Salvador Dalí.

Take the time to look at and enjoy the private gallery that you have created for yourself in your home. It may consist of your children's drawings from school, a stuffed moose head, a photograph of last year's family reunion, or a set of ceramic plates. Remember, if nothing else, that art is a personal thing. One man's velvet Elvis is another man's van Gogh.

Mirrors

"Mirror, mirror, on the wall, who's the fairest of them all?" Thank God our mirrors don't talk to us the way that magical mirror did in *Snow White and the Seven Dwarfs.* Can you imagine what it would be like if your mirror commented every time you flossed your teeth or combed your hair? Even though we can practically dress and groom ourselves with our eyes closed, we all need that final checkpoint to make sure we don't walk out into the world looking ridiculous. Have you ever seen someone on the bus or the subway on your way to work and thought, Wow, she should have looked in the mirror before she left her house? The little old lady

whose eyebrows have been plucked off and then drawn back on crooked. Your work colleague who unknowingly makes an impressive sales presentation to the board of directors with an open fly. Or have you ever been on a dinner date and excused yourself to go to the rest room, only to discover that your date has been staring at the piece of spinach caught between your two front teeth? Mirrors help us visually put those things in check. But beyond the obvious and practical reasons for needing mirrors, I own them for reasons that have nothing to do with my appearance. I have a fascination with everything about them, especially if the glass in the mirror is original. Something about their reflectiveness and the way they look in natural sunlight, I find truly ethereal. I often strategically place them near sconces and candles because of the dazzling reflections captured when light falls upon them. Mahogany-framed, gilt, round, or square, mirrors are found in abundance in my own home and those of my clients. And in many instances where cost is not even an issue, mirrors can be more appropri-

ate than framed pictures or paintings. A gilt-wood, convex mirror above your mantel in your dining room may add a hint of elegance and formality to the space. A large rectangular mirror propped up against a darkly painted wall will contribute to the overall lightness and brightness of the room. Mirrors are the perfect complement to most walls when used in conjunction with art and other decorative furnishings.

OPPOSITE LEFT: Collections of vases or other favorite objects can make an interesting mantel display. OPPOSITE RIGHT: Don't be afraid to combine casual Arts and Crafts pieces with a more formal antique console table. The red amaryllis helps accentuate the red check fabric on the dining chairs. RIGHT: Sometimes things look better when hung in ways that are a bit unpredictable.

Window Treatments

Imagine what it would be like to live in a house without windows. Whether your windows face north, south, east, or west, windows help frame the world we see outside. Your view may be of a grassy backyard, the Eiffel Tower, or geese flying south for the winter. Whatever the view beyond your window, it is important to think about how to frame it properly. I've never been a huge fan of elaborate window treatments. And I'll most certainly pass on any window treatment that is described as being either lacy or racy. Although I know many decorators and designers who spend a lot of time focusing on ways to adorn their clients' windows, I have never been one of those people. While the choices are varied, I have always preferred window treatments that are very straightforward and simple. In most cases, I simply want to either frame the preexisting picture you see outside your window or hide it if necessary. Flat Roman shades and draperies are my favorites. I also like wooden blinds and simple solar shades or scrims. When thinking about buying window treatments, you have to think about practicality in addition to aesthetics. Decide what the objective is for wanting to install them in the first place. Maybe your apartment faces the street and you aren't looking to put on a peep show for your neighbors. In this case you might want to use blackout shades. Maybe you have a spectacular view of the Manhattan skyline and want everyone who visits to share in your incredible

architectural scenery. If you don't ever want the view to be blocked, install draperies at the sides of the windows as decorative accents instead.

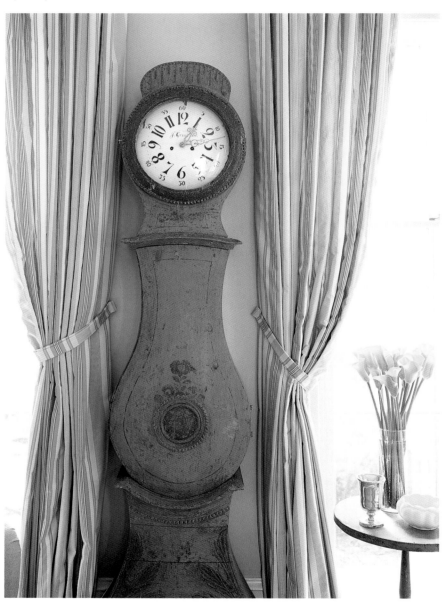

ABOVE: Choose window-treatment fabrics that pick up the same colors or tones of your important furniture pieces. OPPOSITE: Draperies can help soften the hard angles created by windows and walls.

Be conscious of the texture and weight of the fabrics you choose for your window treatments. Don't use fabrics that can't be washed or dry-cleaned. If you live in a

major city, the amount of dirt and soot that can accumulate on your window treatments is truly mind-boggling. Sheers are great if you are simply looking to diffuse the light. Heavier-weight fabrics are appropriate for draperies and any other styles that should block light. If you live in a cold climate like Boston or Buffalo, you should consider buying window treatments that are heavy enough to block drafts from entering and warm air from escaping. Lightweight cottons and linens work well for flat Romans or balloon shades. While it's fine to use silks for window treatments, they should always be lined to provide enough weight and add support. Lining also provides protection against the harsh effects of the sun, dust, soot, and rain so that your fabrics do not get damaged. Shades and draperies can be motorized or manually operated by chains and pulls. Obviously, if you have thirty-foot windows, motorized window treatments would probably make a lot more sense than manually operated pulls.

I typically use a lot of striped fabrics for my window treatments. Thin stripes or wide stripes — it doesn't matter since I'm equally passionate about both. The verticality of the stripes seems to help elongate windows, making them seem bigger and more substantial. Florals, prints, and other patterns can also work well, depending on the overall scheme of the room. Be careful when using plaid fabrics for shades because sometimes the grid pattern of the plaid can be "out of square." When this happens, your window shades can look crooked because the lines aren't straight. When decorating clients' homes, I usually try to tie the colors in the window treatments to something else in the

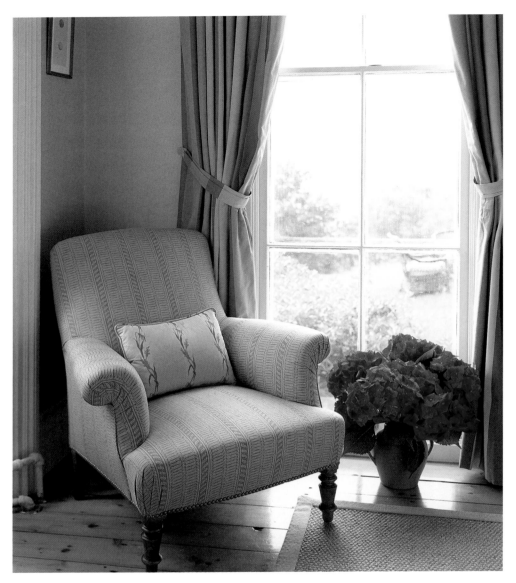

size windows, you can buy pre-made or premanufactured window treatments. These include blinds, curtains, and shades. But unfortunately most people's windows are not standard sizes, which means that treatments have to be custom-sized or fabricated. There are still many inexpensive options for people who can't afford to have window treatments made by pricey, custom workrooms. Try housewares stores and window-treatment catalogs like Smith + Noble (smith-andnoble.com). If you are looking for something fairly basic, you shouldn't have any trouble.

I have simple roller shades in my apartment. They are lightweight and crisp and clean looking. Luckily, my home is on the top floor of my apartment building, and I have windows

room. A blue and yellow floral looks great if there is something else in the room that is also blue and yellow. Maybe it's a bedspread or an upholstered chair. Maybe the color is exactly the same, but the pattern is completely different. Use anything that helps anchor the window treatments to the rest of room and unifies all of the decorative elements.

Maybe you want to provide your family with privacy, or maybe you are hoping to shut out some of the noise from the street below. Window treatments can help you do both. When you are lucky enough to have standard-

facing two directions. The windows on the west side of my apartment face a small park and other buildings at a substantial distance. It would be very hard to see me from across the street, unless of course my neighbors had a telescope or a very powerful pair of binoculars. While I have nothing against voyeurism, my neighbors would have to go to a significant amount of trouble to see me when I'm getting dressed. Rarely do I feel the need to pull down my window shades, and I continue to maintain a let-them-see-and-have-a-thrill attitude about the entire thing.

While I love the amount of light that my west windows provide, this same light can be problematic during the summer months, when the sun can be intense. My apartment often feels like a Betty Crocker oven when the shades have been up all day. While the window shades stay rolled up to the very top of the window frame during most months, they come down during July and August to keep my apartment cooler since I don't have air conditioning. The east side of my apartment is a very different story, however. The sun that enters this side of my apartment is rarely intense, but I closely face my neighbors on the courtyard side of my building. I have the same off-white roller shades, but they are usually kept at half-mast during the day and are completely down at night when my home would become completely visible to others.

My approach to window treatments at my country house is entirely different from my approach in the city. The windows in my living room and dining room are just shy of eight feet tall and frame a spectacu-

lar view of the Catskill mountain range and the Hudson River. While there is no question that the scenery is so beautiful that the windows could stand alone without drapes or shades, I use window treatments here for different reasons. My dining room has pipes that run alongside the windows, through the ceiling to radiators in the bedrooms above. In the ideal world I would have preferred to rework the heating system and gotten rid of the pipes entirely. But I did not have a budget that allowed me to spend money on that type of renovation.

OPPOSITE: These draperies not only adorn the windows but hide the radiator pipes that run alongside. RIGHT: Vertical stripes can help you elongate windows and make them look taller.

There were so many other things that needed to be fixed when I initially moved in that I had to prioritize. Ripping out pipes and radiators was very low on the priority totem pole. The temporary solution to the problem was the window treatment. I opted for floor-to-ceiling draperies, tied back alongside the windows. These draperies also help exaggerate the size of my rooms, mak-

ing them look bigger and more substantial. The blue, yellow, and green striped cotton fabric also gives me another opportunity to emphasize the atypical color scheme that I have chosen to live with. Because my window treatments are big and bold, I chose a style that was very conservative so that my draperies would not overwhelm the space.

While many designers like to repeat the same pattern in window treatments that they use on the furniture or the walls, I prefer to use different ones in an attempt to create spaces that are more dynamic and stimulating to the eye. When doing window treatments for more contemporary interiors, I usually stick with simple scrims and shades. These styles of window treatments are ideal because they do not compete with the clean lines and architectural elements common to these spaces.

Balance is one of the most important components to doing successful window treatments in your home. If you have an all-white bedroom, with white walls and furnishings, I wouldn't suggest putting up heavy red velvet draperies. Even if you want a little drama in your life, save it for the other areas of your home that are less predictable. While some degree of contrast is essential to help a room look terrifically pulled together, too much contrast can be distracting and off-putting. Many windows have substantial moldings and sills; others disappear and are hardly noticeable. Choose fabrics and colors that emphasize your rooms' architectural strengths, not highlight their weaknesses. Richly colored dark-wood blinds help evoke feelings of warmth and depth; light sheers can be somewhat whimsical and breezy. Like all of the other furnishings in your home, try to approach window treatments with the future in mind. Obviously, if you are renting an apartment for only a year and then plan on moving somewhere else, it probably doesn't make sense to invest in expensive or substantial window dressings. If you have already invested in window treatments and are forced to move, do plan to take your window treatments with you. They can often be modified to fit the windows of your new home, depending on their style and size.

LEFT AND OPPOSITE: Flat Roman shades like these are one of my favorite window treatments because they are practical and quietly elegant.

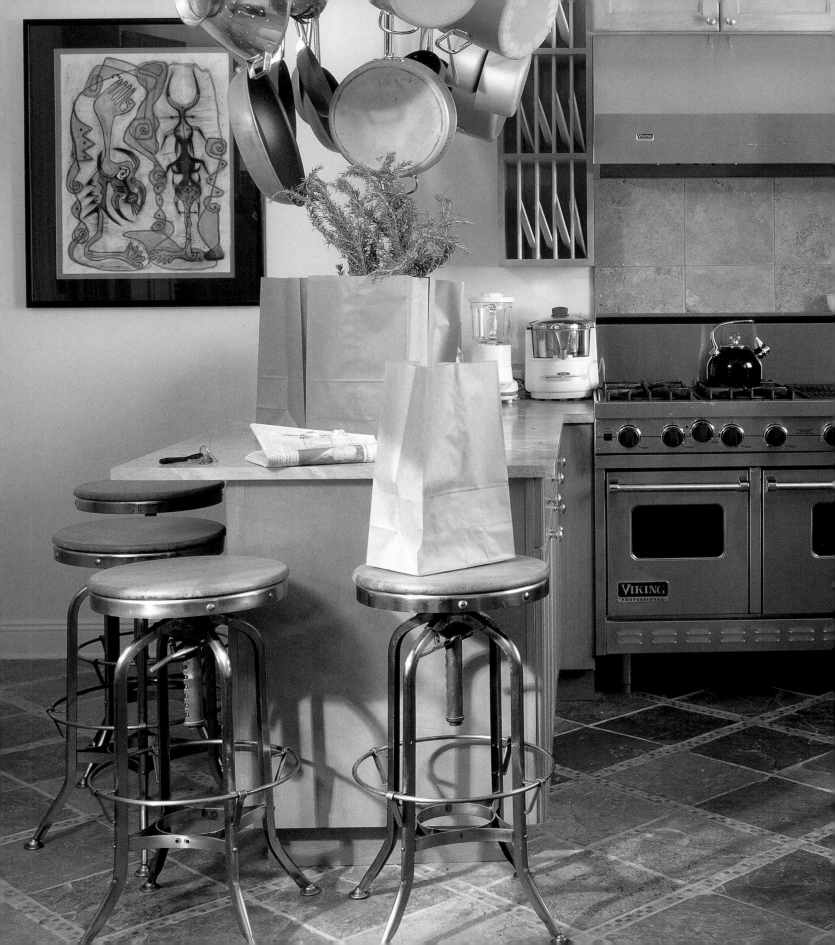

"Anything you can do, I can do better."

—IRVING BERLIN

getting help
and seeking
professional advice

AT WHAT POINT do you decide that it is time for you to seek professional help? For some people, it becomes evident very quickly. You don't need to be clairvoyant to see clearly into your home's future and tell that what you are doing will eventually make you suicidal. For others, it can take years to figure out. If you are really having a tough time figuring out how to decorate your place, and you think that you would prefer to have a designer or decorator assist you in your quest for a beautiful home, seriously consider hiring a professional. Being extremely talented in one area of life doesn't necessarily mean that you will excel at everything, or that you should even try. Whoever taught us that we should be completely proficient at everything we do was definitely smoking something other than cigarettes. Don't be fooled into thinking that just because you know

how to cut that perfect three-quarter-inch dado with your Craftsman saw from Sears, you will also be able to make a red and white toile fabric look good with a blue gingham check. Just because you can hack a computer and create a national computer virus doesn't mean that you know the difference between a kick pleat and a box pleat — or even if you know what they are that you will know which one looks better. No one should be ashamed of his or her inability to win the award for Decorator of the Year, especially since you probably haven't had the same type of training and experience that professional decorators and designers have had. As most people have a full-time job, it can be very chal-

lenging to juggle decorating with everything else they are expected to do in the course of the day.

Where to Find a Decorator or Designer

Though your fingers may do the walking through your local Yellow Pages in order to find a place to go snorkeling or sailing, I wouldn't say that this is the smartest way to go about finding an interior designer or decorator. Referral is probably one of the best methods for finding a designer you like. Ask your friends, colleagues, or neighbors. Have you recently been to a home that you love? Call the owners and find out who helped them decorate. There are all sorts of ways that people have been known to find the professionals they work with. Maybe you find yourself flipping through the latest *House Beautiful* magazine while grocery shopping and see a wonderful interior that you like. Look in the resource guide in the back of the magazine to find out who the designer is and call him or her up. Maybe you were sitting in your doctor's waiting room when you overheard a nurse discussing a decorator showhouse that she went to over the weekend. Find out where it is and buy a ticket for a worthy cause. Most showhouses are renovated houses that are full of rooms decorated

PAGE 154: This round mirror reflects another antique convex mirror in the backgound. LEFT: Mixing formal and informal pieces together in one room can make those spaces more interesting. OPPOSITE: Most designers will tell you that if you buy furniture that is well proportioned and classically shaped, it will never look dated or out of style.

by different designers or decorators in order to showcase their talents. The proceeds from these show-houses usually go to some type of charitable organization. Even if this does not help you hire a decorator, it will give you a great overview of the styles and furnishings available to you.

Feel free to check a designer's professional references if you think that it's necessary or makes you feel more comfortable. Only the extra-superfabulous celebrity-type designers will be offended if you ask for a list of client references. When you meet with designers, ask them to come to your home or the space you intend for them to work on. Most designers will have extensive phone conversations with you before they see your home. When they do, be prepared with a list of questions about fees, the time frame, how they

work, etc. Voice any special concerns or reservations that you may have and feel free to let them know that you are interviewing other designers as well. Before meeting with a designer for the first time, you should buy some design magazines such as *House Beautiful, Elle Decor, Architectural Digest, House & Garden,* and *Metropolitan Home.* Chances are, if you are thinking about hiring a designer, you probably already subscribe to some of these publications. Flip through the maga-

zines and tear out a few pages that illustrate what you like and, more important, the things you don't. As I mentioned earlier, it is often easier to identify what we don't like. Let's say you hate those hyperdecorated rooms done up to the nines in matching floral prints. The wallpaper, lampshades, and bedspreads all match and look as though they have been kidnapped by the flowers in your garden and are being held hostage. Or maybe you are passionate about colorful prints and pat-

terns, but cringe at the thought of living in a monochromatic and minimally furnished space with modern furniture. By identifying your likes and dislikes, and communicating them, you will help your designer know what to avoid while he or she is designing and decorating your home.

The Learning Curve

There is always a natural learning curve at the beginning of the design process. This is the initial phase of the project, when you have hired the design professional, signed a contract, and written a check. Now comes the hard part. At this point the designer will probably be doing everything short of a cartwheel and double somersault to get a sense of what you might like for your home. And you may find that during your first few meetings you don't really like what's being presented to you. The pink fabric feels nice, but the color is too bright and reminds you of Pepto-Bismol. The chair is the right color, but looks as if it's on steroids — it's way too large and the legs are too chunky for your taste. You want a chair in the same color, but much smaller in scale with simple, tapered legs. The key to this phase of the design process is *trust*. Trust that your designer is going to eventually start showing you things you like. Eventually like will graduate to love. If it doesn't, you may have hired the wrong designer.

Though your designer should give you a healthy assortment of things to choose from, don't expect to be presented with hundreds and hundreds of pictures, fabrics, or wallpapers on a daily basis. Remember that one of the reasons you hired a designer was to weed out all of the junk beforehand so that you are presented with only the best and most appropriate options available. Would you really feel better about having forty-five chandeliers to choose from rather than four? Try to keep in mind that it's about seeing quality, not quantity. Although clients often complain that their designers are not giving them enough things to choose from, it has been my professional experience that the more choices clients have, the more conflicted and confused they become about what they want. Let your designer select things that he or she thinks would be the best solution to your specific design-related problem. If you still want to see more options, simply speak up and ask.

The Renovation

If your home is to undergo any major sort of renovation, be prepared for the migraine headaches that come along with the renovation process. And, unfortunately, most of them are inevitable. While they come in both human and nonhuman forms, I guarantee that both types will test your patience and try your nerves. They include dust, debris, mistakes, contractors, subcontractors, change orders, the local utility companies, money and more money, noise, foreign and unpleasant odors, the building department, your complaining neighbor, the co-op board, and that inevitable delay that always seems to happen to everyone who has ever renovated a home. While the experience can most certainly build character, it can also cause you to lose

Candles, flowers, and symmetrically arranged accessories create a calming and attractive mantel display.

your mind. A significant renovation can become your worst nightmare come true if you aren't prepared mentally and financially.

the most disruptive and difficult things to live through. It is inconvenient on every level. But if you live through it, the results are usually well worth the brief period of pain. The only reasonable advice I can give to anyone who is renovating a home is to *have patience.* This should be your mantra throughout renovation, recanted daily in the lotus position. And the only final words of encouragement I can give are these: It always gets worse before it gets better.

Fees

Different design professionals use varying methods to charge for their services. While some designers charge hourly rates and flat fees, most designers (including me) charge a percentage on top of the wholesale or net cost of an item or service. The percentage that is charged can range significantly, but most designers generally charge somewhere between 30 and 35 percent. Some design professionals feel justified to charge more; others may charge less. The fee is determined by a number of factors. These may include but certainly aren't limited to the location of the project (is it local, or does your decorator have to fly to London each week?), whether it involves construction, the time frame, the size and scope of the

I always suggest to my clients that whenever possible, they stay somewhere else during the renovation process. An extensive home renovation is usually one of work to be completed, and the complexity and duration of the project. No matter what method or fee structure your designer uses to charge for his or her services, it is

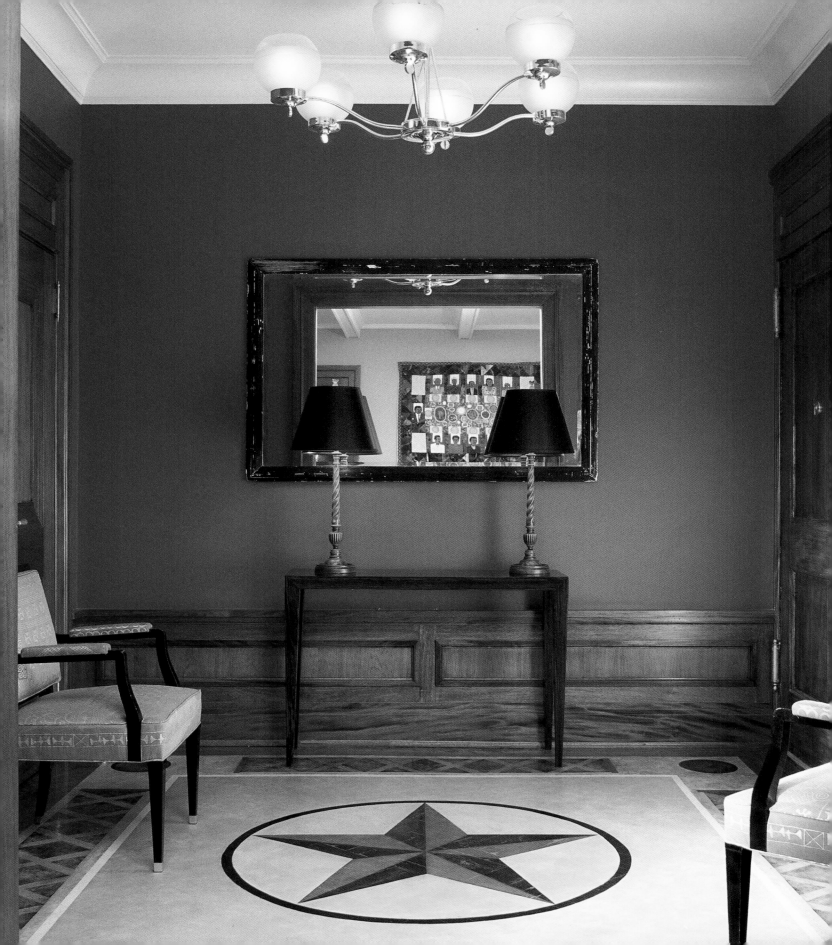

important to remember that your designer is in business. And if your designer wants to stay in business, it is necessary to secure a net profit that will sustain the designer and the organization that he or she is associated with. Presumably you've hired a designer or decorator for his or her knowledge, resources, experience, and training. If so, you should expect to pay for that professional expertise. In addition to fees, you can also expect to open your wallet for sales taxes and delivery, freight, and installation charges. Most design professionals will expect you to reimburse them for transportation and travel, messenger and courier services, postage, long-distance phone calls, and any other miscellaneous expenses incurred on behalf of your project. Once you have a conversation with a designer about your home and the fees that would be charged for his or her services, you will be in a better position to determine whether you can afford to hire a design professional.

We incorporated the colors of the walls, furniture, and fabrics into this custom-designed painted floor in order to create a bit of drama.

If you decide that you might like to hire a design professional to do your home, there are some important questions you should be prepared to ask the person you're thinking of hiring. The first usually is "Are you a designer or decorator?" "What's the difference?" I'm often asked. Some people care to make the distinction, others don't. The term *decorator* often conjures up images of white-haired ladies wearing cultured pearls and gay men in drag. Rarely do decorators look like Barbara Bush or RuPaul, and even more rarely do they sashay and shop all day for pretty fabrics and furniture, carelessly spending other people's hard-earned money.

Many decorators *are* self-appointed arbiters of good taste, but rarely will you see them rolling through your house with a shopping cart, picking up all the things that are in "bad taste" or "tacky" and ridding your house of them. These types of decorators do exist, and hiring them can be hazardous to your health and bad for your self-esteem. If you can't identify these superficial divas because of their physical appearance, you can at least identify them because they have their own unique vocabulary and language. They use phrases like "it's not called a couch, dear, it's a sofa" and "curtains are for the theater, draperies are for windows." They use superlatives like "must," "it's sooo baroque," and "it's absolutely fabulous." They correct you. They talk about the way you live. Somehow you feel lower than your coffee table, less significant than your blender or microwave oven. The goal is *not* to feel disheartened or disenfranchised. The goal is *not* to feel uncomfortable in your own home. If you have to bribe your golden retriever with a Milk-Bone for him to let you move into his doghouse for a while, find a new decorator.

Whereas most decorators focus solely on decorative elements like fabrics, window treatments, and upholstery, designers usually have an academic degree from an accredited design school or university. Most designers know how to draft and draw and usually like to *design* things for your home, including furniture, built-ins, etc. Most designers know a lot about space planning, lighting, and color, as well as a thing or two about construction and renovation.

The bottom line is to find a design professional whom you feel comfortable with. If you do hire a designer, don't expect them to manage your expectations. If I

hired a broker or money manager to manage my portfolio of stocks, bonds, and mutual funds, I would obviously have opinions about how my money is being invested. But I would also have to be clear about my expectations. Do I expect to make a 15 percent return on my investments or a 40 percent return? Obviously, if I expect 40 percent in a bear market, I'm probably going to be pretty disappointed at the end of the year. And if I am disappointed, is it my fault for having such unrealistic expectations, or my broker's fault for not managing them? If you hire a designer the day after Thanksgiving, don't expect to have your home completely transformed by the time Santa and his reindeer show up for Christmas dinner. And while the tendency to micromanage might be overwhelming at times, try to restrain yourself. If necessary, drive to your local police precinct and ask them to handcuff you and take you into custody. Do anything it takes to stop yourself from becoming an unreasonable client. Let people have enough room to do their jobs. It's one thing to make suggestions and recommendations, it's entirely another to constantly question everything your designers do, especially if you have hired them for their professional expertise.

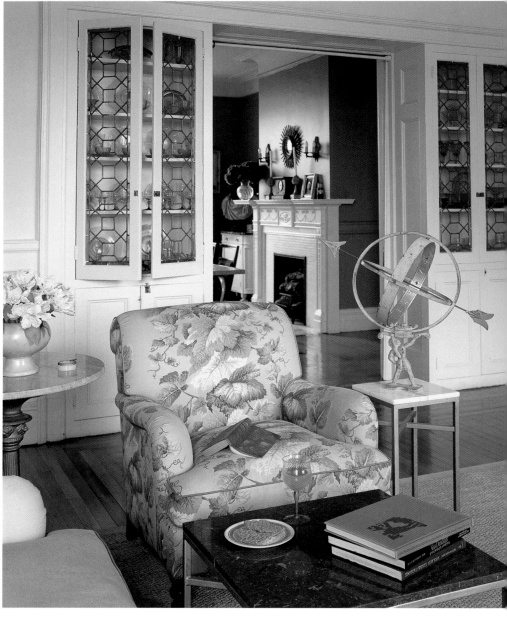

I'd like to believe that most of the homes I decorate don't look particularly decorated. Hopefully, that's why my clients hire me. Most of my clients are people who want to live in spaces that are as comfortable as they are elegant and beautiful — without looking overly decorated. I have never been hired to do a "period" inte-

rior. I have never been hired to do an interior that required chintzes and lots of froufrou things. Hire someone who has a style that is similar to your own or whose work exhibits an aesthetic you would like to have in your home. People often ask me, "Do people just let you go in and decorate and then call them when it's finished?" I always try to explain that it's far more complicated than that. There are designers and decorators who establish themselves firmly in a style and are hired to do just that. For many years Mario Buatta has been called the Prince of Chintz. Obviously, if you wanted a very minimalist and Zen-like interior, the Prince of Chintz probably wouldn't be the first person you would think about hiring.

A good designer should be versatile. One of the advantages that you have at your disposal when working with interior designers is that they usually employ entire staffs who focus on nothing other than space planning, design, furniture, fabrics, flooring, lighting, and color. While you are writing a brief, teaching a class, or doing a colonoscopy, we are thinking about interiors. Which carpenter can we use to strip that Federal mantel for your library fireplace? Which workroom can take measurements of your windows for flat Roman shades? Your interior designer can bid at that furniture auction you can't attend because you are in Seattle on business. Aside from all the design-related tasks we handle, we also take care of the hellish logistics and nonstop headaches that come along with those tasks. We get through all the intricately painful minutia

Shop at different places like flea markets, antique stores, and estate sales where furniture prices are negotiable.

that you don't have time for. Our goal should be to make you more comfortable and ultimately happier in your home.

A good designer should be able to do a contemporary interior or one that is traditional. But there are various designers who are better at one thing than another. Consider that before you hire them. Ask them about their strengths and weaknesses when it comes to furniture. They should have a working knowledge of furniture styles and be conversant in color and fabrics. A good designer should always be willing to take most of your personal idiosyncrasies into account. You may insist on having a bidet in your bathroom even though you don't know what it's used for. You may want to have drawers designed and built in your bedroom closet for your belts and neckties. Maybe you require blackout shades in addition to blinds, curtains, and shutters because the slightest detection of light bothers you when you sleep at night. Whatever it is that you think you want, don't be afraid to ask your designer how you can go about getting it.

Good designers are great listeners. They listen to what their clients want, and try to give it to them in ways that are inspiring and innovative. When designers do impose their taste on clients, the clients usually become disenchanted with the entire design process and look for ways to bail out. In certain respects, your relationship with your interior designer is no different from the other personal and professional relationships in your life. Sometimes the unions are harmonious, sometimes they aren't. Obviously, most people don't enter into marriage with the intention of getting divorced. Otherwise, they wouldn't get married in the first place, right?

Sometimes the reason the relationship isn't working out doesn't have anything to do with how much you like your designer or the services that he or she has been providing. I recently had a contract terminated by a client because I would not sign a confidentiality agreement. These situations are no different from any others that may arise in your professional life. Maybe you decide that you want to retain an attorney who is more specialized than your current one. Maybe your company is growing rapidly and you decide that you have outgrown your current CPA. If the relationship simply isn't working, the best advice I can give is to get out. Chances are that if it isn't working for you as a client, it isn't working for the design professional, either.

There are some important things to keep in mind about your designer. Despite your inclination to lay down on your new chaise and share all your problems with your decorator, your design professional is not your psychiatrist. While most designers care about their clients' basic well-being, we're highly unqualified to advise you on personal matters or be in charge of your mental health. And please don't make us the executor of your estate or nominate us to run for political office. Try to remember that your designer is not your maid, handyman, hairdresser, baby-sitter, or personal assistant. I have gone to clients' homes and had to feed their starving children. I have made clients' beds and been known to throw a dirty load or two in the washer for them. There are some things that most designers will be willing to do — even if you don't ask — all in the spirit of the project and to make your home look terrific. But try not to push us over the edge. My friend Eric Cohler, who is an interior designer in New York, gives this advice to people thinking about hiring a designer: "Don't make us your best friend. Keep it objective." I agree. Though I have very friendly professional relationships with my clients, those relationships are professional relationships nonetheless. It is important to realize the difference. If both parties understand the parameters at the outset, everyone be will less likely to be disappointed in the event that the relationship doesn't work out.

You will probably notice that designers and decorators ask a lot of questions. Some of them seem reasonable and some of them don't. If you don't want to answer, at least explain why. We need to know everything — your likes and dislikes, your daughter's birthday, your shoe size, your favorite flavor of ice cream, and your mother's maiden name. Designers don't ask questions because we are nosy by nature. Asking questions usually helps us get to know you better. The more questions we ask you, the more likely it is that we will figure out how you want to live and what we can do to help you reach that goal. A good designer should be candid in his or her assessment of your home and what will have to be done to improve it. The suggestions, while honest, should not be so brutal that you feel as though you've spent three rounds in the ring with Mike Tyson. You'll know that you've hired the right designer if your sanity and sense of humor are still intact after the project has been finished. Finally, when you invite your friends over to see your newly decorated home, it shouldn't scream, "I've been decorated!" If it does, your designer has done you a terrible disservice.

Try to keep knickknacks and tchotchkes to a healthy minimum.

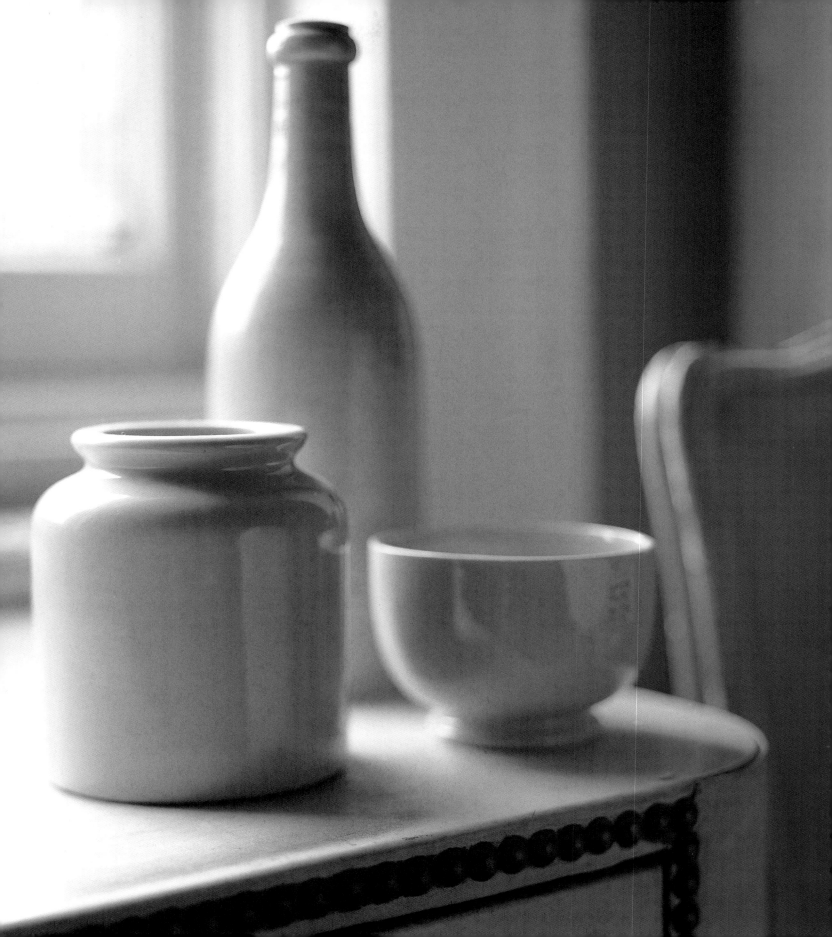

"What you see is what you get."

—ANONYMOUS

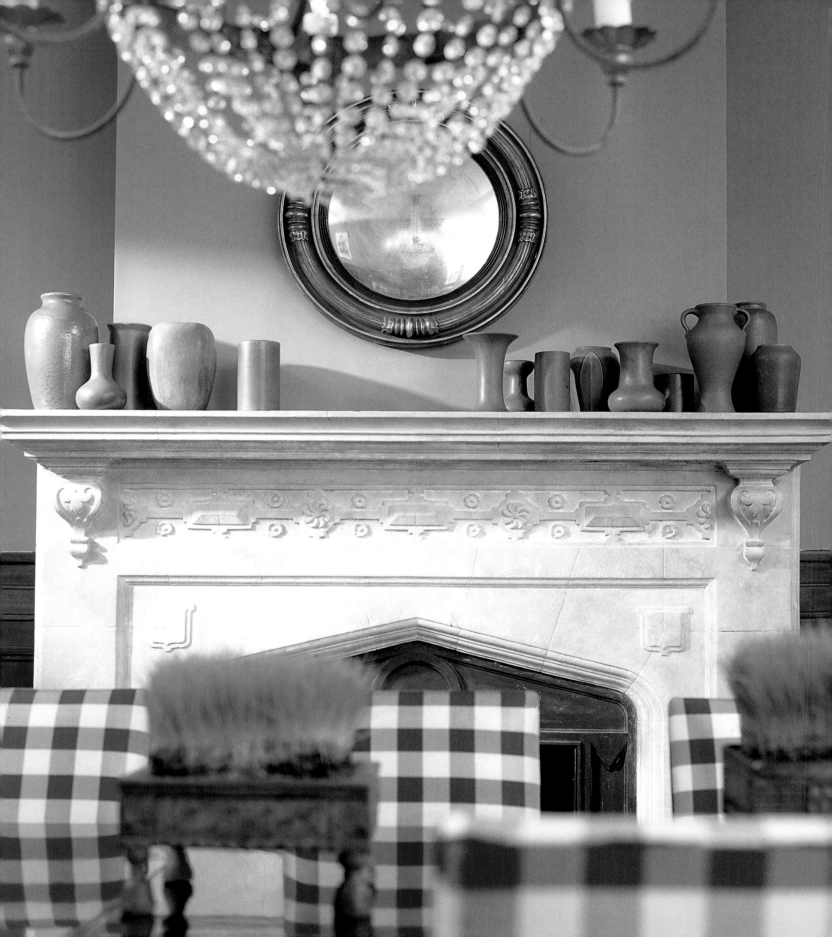

furniture
disorientation:
WHERE AND HOW TO SHOP

Most people could probably use a healthy dose of Viagra to get them motivated and up and out to shop for furniture. For whatever reason, many of us inexplicably become paralyzed when the time comes to think about buying furniture for our homes. There are always a million and one excuses as to why you are still living with that busted sofa with the springs and stuffing popping out. Even though it looks ridiculous and is painful to sit on, you can't find the impetus to replace it. Maybe it's because you don't have the time or the money. You'd rather buy a new sea kayak instead. Maybe it's because you are busy. You barely have time to make it to the dry cleaners on Saturday, and the last thing you want to do is spend your weekend shopping for a new bureau. Or maybe the problem is more deeply rooted in your psyche. For some people, it does have something to do with embracing adulthood and the perceived responsibility that accompanies it. This may be

behind your attempt to convince yourself (and your girl-friend) that your makeshift milk-crate coffee table from college will be coming back in style in 2004.

I guess in certain ways, some level of responsibility does come along with owning real furniture. While you don't have to walk it and feed it like the family dog, you do have to take care of it if you want it to last. Whether you live in Bethlehem or Birmingham, it's in your best interest to take care of your furniture. Fabrics fade when exposed to strong, direct sunlight for long periods of time. Wooden and upholstered furniture can begin to look like your great-great-grandfather if you put them too close to radiators or heaters. Buy a humidifier for your home. They are good not only for you but for your furniture as well. And don't be fooled by all those commercials suggesting that your wooden furniture is craving spray wax. If you need to clean wooden furniture, simply use a soft, damp cloth. Or if you decide to use wax to create more shine or luster, buy butcher's wax or tinted paste wax instead of spray wax.

I'm not a big fan of coasters or place mats, but have them on hand for parties or special occasions when children will be in attendance. If things do spill, wipe them up before stains move in and set up shop. Try to adhere to some type of reasonable schedule with respect to cleaning your home and the things in it. I'm not saying that your house always has to be spick-and-span clean or that you should be so preoccupied with cleanliness that you travel with Brillo pads in your purse. But if you find yourself having to tidy up your house *before* the house-keeper comes to clean, you probably ought to try to make cleaning more of a priority. Treat your furniture with a lit-tle respect. It will last longer, and a clean house says a lot about you and about how much you respect yourself.

Shopping for furniture is not exactly the same as shopping for a new blouse, a set of golf clubs, or a new bike. Some of these things you buy simply because you want to. You are not necessarily concerned about their shelf life. While you shouldn't be especially concerned about the life span of a new pair of running shoes, you ought to be concerned about the life span of the pair of night tables you are thinking about buying. Why not make conscious choices with the future in mind when you buy furniture rather than simply succumb to every impulse that strikes you? And while all of us have momentary lapses in judgment from time to time, I'd like to believe that good choices are impulses with infor-mation. Again, denial will get you nowhere fast. The key is in the approach and the attitude. That, com-

PAGE 168: I often use trays of wheat grass instead of flowers to brighten up interior spaces that need a fresh splash of natural color. OPPOSITE: Think about combining atypical colors and textures when you dec-orate.

bined with the knowledge of where to shop, will help ease the chest pains you might be experiencing when trying to furnish your home. Having a positive attitude will also go a long way. Try to shop for furniture with the idea of Furnishing Forward. Forward thinking hardly means that you should rush out to buy a baby crib and changing table because you think you may eventually have children. What it does mean is that you should think about buying things that you will own for a signifi-cant period of time. Will you outlive your furniture, or will it outlive you? Look at each piece of furniture with a critical eye. Do the legs wobble on that table? Does that

chair feel as if it's going to fall apart by the time you get it home from the store and into your study?

I have nothing against buying amusing collectibles or

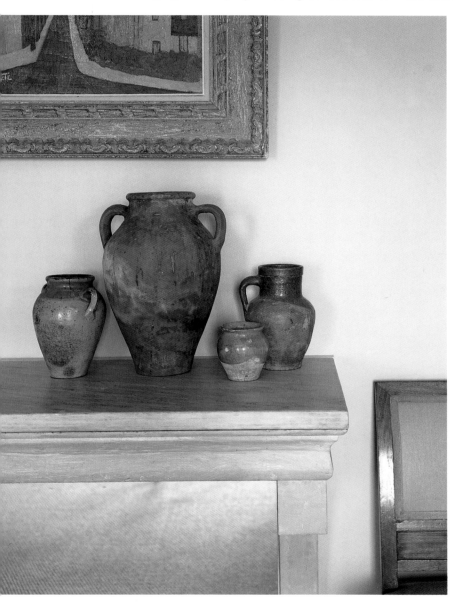

fun accessories for your home. There's something particularly satisfying about buying things that make you want to dance and your heart flutter. It's those whimsical and individual touches that help distinguish your home from everyone else's, making it truly your own. Remember, though, that those smaller-ticket items *are* different from the more expensive things like beds, tables, and sofas.

There's nothing wrong with spending forty bucks here and there on a ceramic vase, a scented candle, or that very special marquetry picture frame. But big-ticket items should be approached differently. When you think about pieces of furniture that you like, think of at least two places where they might work in your home. Great furniture should be versatile and interchangeable. That pair of green leather armchairs would look great next to the console table in the library, but they would also look great in the dining room next to the Swedish sideboard. That daybed will work well in my office for a while, but eventually I think I would like to use it in the guest room. If you buy pieces of furniture that are designed well, chances are you will be able to use them in numerous places in your home without getting tired of them. Furthermore, if they are well crafted and made of superior materials, they should certainly outlive the many life changes you will eventually go through. I often help clients buy furniture that ends up getting reupholstered later. Maybe they decide that they want their headboard to be apple green instead of Wedgwood blue. The important part about their decision is that they are not getting rid of the headboard itself. In 1990 I bought a set of four Victorian side chairs to use as breakfast chairs in my studio apartment. Twelve years later those same chairs flank my living-room mantel and fireplace. They were so well pro-

Buy furniture that has value. A well-made set of dining chairs and dining table is money well spent.

portioned and timeless in style that they still look great and are appropriate, even though my apartment is vastly different from the one I had twelve years ago.

If you buy furniture that is well proportioned and classically shaped, it will never look dated or go out of style. There are so many places for people to buy stylish, well-made furniture nowadays. You can try the traditional routes like furniture showrooms, department stores, and furniture specialty stores, or you can try to find the things you want in mail-order catalogs or on the Internet. Auctions, estate sales, and flea markets are still some of my favorite places to shop. I also like that the prices are almost always negotiable at these places. If you do not feel savvy enough to purchase from these types of places, try the more traditional stores, where there are salespeople who can help educate you or guide you in your selections.

Many people find shopping for furniture more confusing than the presidential election Florida recount. If you are in the market to buy new furniture, there are a few things you should know before you whip out that credit card.

Weight, Color, and Age

Don't be fooled by the weight of a piece of furniture. Just because that chair feels heavy doesn't mean that it's a better or more valuable piece of furniture than a chair that's lighter.

The same goes for color. Just because a wooden table is dark and more richly colored doesn't mean that it is of better quality than a wooden table with a lighter shade or

color. We often make associations that are not accurate. Darkly stained woods usually appear more formal than those that are lightly stained or have a clear finish. And newer doesn't necessarily mean stronger. That pine cupboard from the early part of the eighteenth century might actually be a lot more durable than that new cherry bookcase that has caught your eye. The fact that the pine cupboard has been around so long is a testament to its strength and longevity.

We need to get over the mind-set of associating new and shiny with better and superior. It is a trap that we have all fallen into before and that we still voluntarily pay money to fall into today. One of the reasons I encourage my clients to buy antiques is their inherent value. And since they only continue to get older, they really don't depreciate in value the way that new furniture can. Antiques are more frequently made of stronger materials and are often of superior quality than much of the furniture that has been manufactured in recent years. Like art, antiques can teach us a great deal about the time period in which they were made. What this means is that indirectly we get history lessons for free every time we sit in that old rocker on the porch or open the drawer of that antique dresser.

Finish

A lot of how wooden furniture looks has to do with the finish. Rarely do wood finishes look just okay. Most finishes look either really good or really bad, but rarely anywhere in between. What determines whether a finish can look good or not has to do with its application. Polyurethane finishes can sometimes look thick or almost like plastic. If

a finish is put on carefully and has sufficient time to dry or cure, the appearance will usually be a lot better than a finish that was rushed. I guess it's not that dissimilar to that manicure you ruined when you hurried out of the nail salon before it was completely dry. If you are thinking about buying a piece of wooden furniture that looks dull and appears to have no life, don't kid yourself into thinking that it will look better with time. Furniture restorer Stephen LoPiccolo sums it up this way: "A lousy finish is a lousy finish. It won't improve with age." That is why it is important to choose your finished furniture with care and attention. If your wooden furniture has a good finish, for the most part it should take care of itself. Better-quality finishes don't need to be refreshened for many years.

Before the twentieth century almost every piece of furniture was either solid wood or veneer on solid. Solid-wood furniture is generally one of the most expensive types of wooden furniture you can buy. Since more money has been put into the initial product to begin with, the construction of solid wood is usually of a superior quality as well.

It's better to have a dovetail joint than a screw holding those two pieces of wood together in your dresser. And you can't make a dovetail joint out of plywood, even if you wanted to. Again, the very nature of a higher-quality product (such as solid wood) is that you usually get higher-quality construction. After the twentieth century, plywood, chipboard, particleboard, and pressboard came into fashion. These man-made creations were inspired by the carpenters and furniture makers who figured out a way to utilize every product in the furniture-making process. (Hey, Jim, see that pile of sawdust left over from that cabinet we just made? Let's mix it with glue or some other binder and press it together and call it particleboard.) Whether you are purchasing man-made or solid-wood products, try to buy the things that you really like and can reasonably afford.

Veneer is a thin slice of wood that is taken off a tree. Veneers enable us to use the most beautiful part of a log and affix it to something far less beautiful or expensive. Since furniture is less frequently made out of solid wood nowadays, furniture with veneer can offer a

LEFT: Sometimes fruit works better than flowers. Use fresh lemons to add a touch of color and texture on top of a wooden table display. OPPOSITE: "Cut" light-colored walls with dark or ebonized woods and gilt mirrors or decorative accessories.

great opportunity to buy something that looks great but is not as expensive. Veneers can range in style and pattern, and it is really a matter of personal taste as to which veneers you find yourself being attracted to. Personally I like very straight and linear wood veneers without a significant amount of activity or pattern.

Repairs and Joinery

Solid woods are easier to repair than man-made products like fiberboard. A cheap piece of furniture that was poorly made is not a bargain in the end. It costs as much to repair a thousand-dollar chair as it does to repair a ten-dollar chair. In fact, the ten-dollar chair might actually cost you more to repair. If you nick or scratch your wooden furniture, don't despair. You can hide small

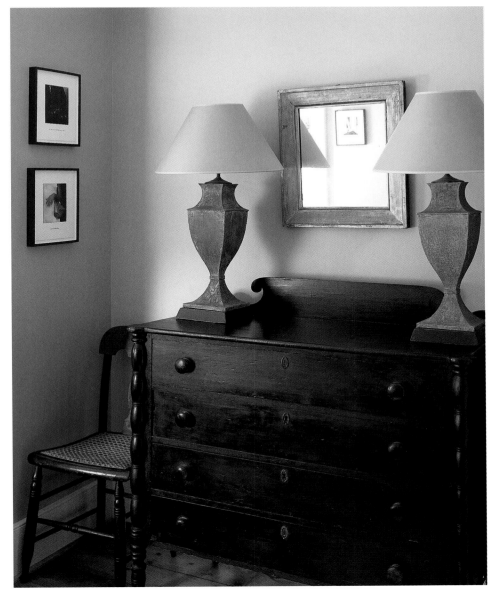

nicks and scratches with brown or black shoe wax (not to be confused with liquid shoe polish). And if you are going to touch up scratches yourself, err on the lighter side to begin with. It's always easier to make those marks darker than it is to lighten them.

While books can help you gain some insight into wood construction and joinery methods, you will gain the most knowledge by really looking at and learning from actual furniture. Don't be afraid to turn over a chair or open a drawer to see how it is made and how pieces of wood are

joined together. Looking at a joint is no different from looking at a seam inside a suit jacket or pair of pants. Joints (like seams) will tell you a lot about the quality of the workmanship. When I was in design school in New York, I had a professor who loved to take us to various auction houses to look at antique furniture. She was fascinated by the joinery methods used on chairs and cupboards, bureaus, tables, and high chests. She used to carry a flashlight and on occasion would unabashedly crawl under the furniture to look at the way it was constructed.

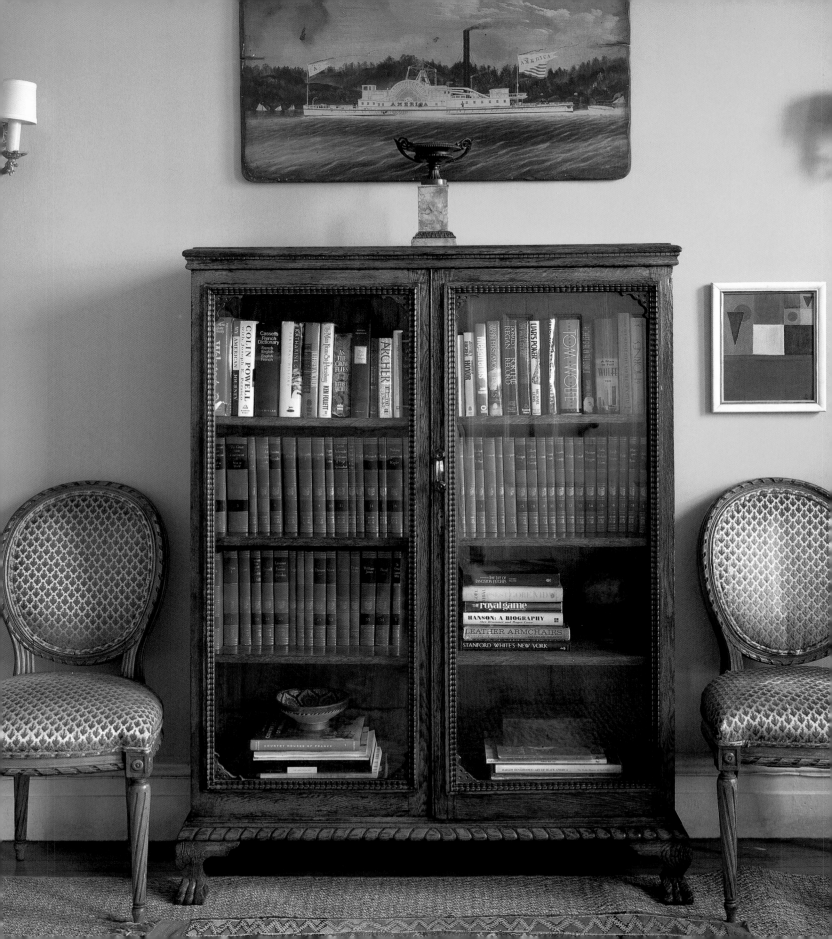

Auctions and Shopping

Auctions are great places to learn about furniture. They are also fun to watch and participate in. Go to a Saturday furniture auction. You don't have to bid on anything, but I guarantee that by the time it is over, you will wish you had. Watch how the process works, the energy and excitement that people display when they come close to getting the piece of furniture that they want. You will learn a lot not only about bidding procedures but, more important, about the furniture for sale and the prices they sell for. If you visit auctions that sell a diverse range of furniture styles from different periods, you will start to recognize prices, pieces, and periods. There aren't too many other places that you can get a free education about furniture in general and antiques in particular. One of the best publications I can recommend that lists furniture auctions and estate sales is a weekly newspaper called *Antiques and the Arts Weekly*. It lists furniture auctions and antique shows throughout the country. Whether you live in New Jersey or New Orleans, it'll have something listed that will pique your interest.

Most designers will tell you that you will never go wrong if you arrange furniture with symmetry in mind. Pairing sconces and chairs in this library helps achieve a symmetrical balance.

If you are going to hit the stores, be prepared to shop like a pro. Bring a Polaroid camera, a pad, pen, and, of course, the ever-essential tool of the trade — a tape measure. If you don't own a Polaroid, try a disposable camera with a flash. You'd be surprised how good the images are when they are developed. Before you leave the house for your shopping excursion, make a list. Windex, paper towels, wheat flour, maraschino cherries, coffee, toilet paper, a sofa and a club chair. Measure important walls beforehand. It is helpful if you know ahead of time whether you a need a six-foot sofa or a seven-foot sofa. Be sure to write down your widths and heights of doors, windows, and stairwells. There is nothing more anticlimactic than getting that wing chair home only to find out that you will have to unscrew the legs before getting it through the door and up the stairs to your bedroom.

Don't be afraid to ask questions about the furniture, especially if the person selling it claims that the piece is an "antique." Beware of the word *style* if it is included in the description of the item for sale. The difference between Louis XVI and Louis XVI style is about 225 years. Ask questions. Where is it from? What period? How old is it? Do you know anything about the piece? The more you ask, the more information you will have at your disposal when it comes time to decide whether to purchase something. Find out about delivery and return policies before you open your wallet or checkbook, just in case you get that pea green ottoman home and decide that it doesn't work. Bring your paint colors either stapled or taped to a piece of paper for reference. You may think that you will remember the exact color orange you painted your breakfast room but find that you get confused when there are actually thirty shades of orange being shown at the store. And finally, don't ever shop when you are sleepy, hungry, hungover, or otherwise in a bad mood. All can lead to disasters bigger than Chernobyl. Keep thinking about Furnishing Forward. You are trying to furnish for the future.

Not fare well, But fare forward, voyagers.
— *T. S. Eliot*

the do's and don'ts of
design and decoration

DON'T: Overdo it. Too much of a good thing can be a bad thing. The right amount of giltwood or gold leaf can look amazing. The wrong amount can make you look like you have the King Midas touch.

DO: Mix metals. Use platinum or copper sinks instead of traditional porcelain or stainless steel. Use chrome or nickel hardware and bathroom fittings rather than traditional brass.

DON'T: Buy cheap, contemporary black lacquer or black leather furniture or any combination thereof. These items seem to be very popular among bachelors in their twenties and thirties.

DO: Buy Chinese or Japanese lacquered furniture such as cabinets or screens.

DON'T: Follow every furniture trend you see in a magazine. Go with your gut. If it seems ridiculous to hang a chandelier in the middle of your garage, it probably is.

DO: Think about the pros and cons of certain materials before installing them in your home; while a cool, marble floor may feel great under your feet in the summertime, the same floor feels unpleasantly frigid in the dead of winter (unless you have radiant floors).

DO: Buy any piece of furniture that you think has great lines or that you think you may own for the rest of your life. You may tire of the fabric that it's upholstered in, but you will never get tired of its shape and silhouette.

DO: Buy fresh flowers from a florist, a farmer's market, or even your local grocery. They can immediately uplift your spirits.

DO: Bring the outdoors inside by buying plants and trays of grass, stones, and shells for the interior of your home.

DO: Use folding screens to help delineate different areas and spaces in your home.

DO: Buy furniture that complements the art in your home rather than competes with it.

DON'T: Forget to focus on the details. Smart decorative accessories like interesting wall sconces, table linens, dishware, and glassware can make a big difference.

DO: Provide your houseguests with aromatherapy bath salts, scented soaps, and candles during their stay at your home.

DO: Realize that the same principles apply to furniture as to makeup and jewelry. Wearing one exquisite piece of jewelry can be much more impressive and elegant than wearing a necklace with matching earrings and bracelet.

DO: Buy anything that helps evoke a feeling of calm and serenity — comfortable and functional furniture, natural floor coverings, and fabrics like cotton, linen, and raw silk.

DO: Surround yourself with interesting art and intriguing people.

DO: Use patterns in ways that complement the space rather than complicate it. For example, do mix stripes with florals or other patterns. A floral print on an upholstered sofa can easily complement striped wallpaper if the overall color scheme is similar.

DON'T: Feel as though every color in a room has to match perfectly. Save paint-by-numbers for your children.

DON'T: Be militant in your pursuit of perfection.

DON'T: Make a fool of yourself. While it is fine to have photos of yourself in your home, don't create shrines or temples on your own behalf. If walls could talk, I'm sure they would have something to say about this sort of display of ego.

resources
TO HELP STEER YOU IN THE RIGHT DIRECTION

CHILDREN'S FURNITURE RESOURCES

Kids can have stylish stuff, too. Try these places for colorful and practical furniture for your children.

Pottery Barn Kids
800.430.7373

Children's Furniture Co.
800-697-3408
www.childrens-furniture.com

Maine Cottage
PO Box 935
Yarmouth, ME 04096
207.846.1430
www.mainecottage.com

IKEA
800.434.IKEA (4532)
www.ikea.com

FURNITURE DONATIONS

The following places will accept donations of furniture and other household items. Many will also accept your clothing donations. Call to find locations close to you.

Furnish A Future
20 Jay Street
Brooklyn, NY 11201
718.875.5353

Salvation Army
800.SAL.ARMY (725.2769)
www.salvationarmyusa.org

Housing Works Thrift Shop
143 West 17th Street
New York, NY 10011
212.366.0820

Goodwill Industries
for locations throughout the country
800.664.6577
www.goodwill.org

The Furniture Bank
(Metro Atlanta) 404.355.8530

The Furniture Bank
(Houston) 713.970.7486

EBAY

Buy, sell, or trade used furniture at this online auction house.
www.ebay.com

AUCTIONS

Don't be afraid to consider auctions as a reasonable shopping alternative to stores. Even if you don't buy anything, use the opportunity to learn something about furniture. It doesn't cost anything to browse and get ideas.

Tepper Galleries
110 East 25th Street
New York, NY 10010
212.677.5300
www.teppergalleries.com

William Doyle Galleries
175 East 87th Street
New York, NY 10128
212.427.2730
www.doylenewyork.com

Phillips
406 East 79th Street
New York, NY 10021
212.570.4830
www.phillips-auctions.com

Christie's East
219 East 67th Street
New York, NY 10021
212.606.0400
www.christies.com

Sothebys
1334 York Avenue
New York, NY 10021
212.606.7000
www.sothebys.com
www.sothebys.amazon.com

FURNITURE AND THINGS

The following places sell all sorts of things for the home. Many carry furniture that is very reasonably priced and in stock.

Crate & Barrel
800.323.5461 phone number for store locations
www.crateandbarrel.com

Lampa
977 Main Road
Aquebogue, NY 11931
631.722.9450
www.lampa.com

Fishs Eddy
889 Broadway
New York, NY 10003
877.347.4733
www.fishseddy.com

LIGHTING

Try these resources for different types of lighting.

Akari
32–37 Vernon Boulevard
Long Island City, NY 11106
718.721.2308
www.store.yahoo.net/akaristore

Urban Archaeology
143 Franklin Street
New York, NY 10013
212.431.4646
www.urbanarchaeology.com

Artemide
1980 New Highway
Farmingdale, NY 11735
800.359.7040
www.artemide.com

PICTURE FRAMES, PHOTO BOXES, AND OTHER MISCELLANEOUS STUFF

Exposures
800.222.4947 phone orders
www.exposuresonline.com

Pearl Paint
800.221.6845 x2297
www.pearlpaint.com

Light Impressions
PO Box 22708
Rochester, NY 14692
800.828.6216
www.lightimpressionsdirect.com

Target
800.800.8800
www.targetstores.com

PAINT

You've got to start with a good paint job.

Benjamin Moore
800.826.2623
www.benjaminmoore.com

The Home Depot
800.430.3376
www.homedepot.com

Farrow & Ball
845.361.4912
www.farrow-ball.com

BOX SPRINGS AND MATTRESSES

Remember the story of the Princess and the Pea? Even if you don't, buy yourself a good mattress and boxspring.

Dial a Mattress
800.mattres (leave off the extra s for savings) (800.628.8737)
www.dialamattress.com

EVERYTHING YOU NEED TO MAKE A GREAT BED

Sheets, blankets, duvet covers, pillows, matelasse covers, and bedspreads.

Down Inc (to the trade only)
800.552.9231

Chambers
800.334.9790 phone orders

Garnet Hill
231 Main Street
Franconia, NH 03580
800.870.3513
www.garnethill.com

Eddie Bauer Home
800.789.1386 for catalogs
800.552.8943 for store locations
www.eddiebauerhome.com
www.eddiebaueroutlet.com

SISAL AND SEA GRASS RUGS

No home is complete without one!

Sisal Rugs Direct
888.613.1335
www.sisalrugs.com

THINGS FOR THE KITCHEN

Even if you don't know how to boil water.

Williams-Sonoma
800.541.2233
www.williams-sonoma.com

Sur La Table
1765 Sixth Avenue South
Seattle, WA 98134
800.243.0852
www.surlatable.com

Chef's
PO Box 620048
Dallas, TX 75262
800.338.3232 for catalogs
www.chefscatalog.com

WINDOW TREATMENT

Try these mail-order catalogs for reasonably priced custom window treatments.

Smith+Noble
800.248.8888
www.smithandnoble.com

Great Windows
12011 Guilford Road
Annapolis Junction, MD 20701
800.556.6632
www.greatwindows.com

BATHROOMS

Everyone should have an attractive and functional bathroom in their home. Check out these places, sites, stores, etc., for tile and accessories.

Waterworks
800.998.2284
www.waterworks.com

Portico Bed & Bath
888.759.5616

Restoration Hardware
15 Koch Road, Suite J
Corte Madera, CA 94925
800.762.1005
www.restorationhardware.com

Pottery Barn Bed + Bath
888.799.5176 phone orders
www.potterybarn.com

Ad Hoc Softwares
136 Wooster Street
New York, NY 10012
888.748.4852
www.adhocny.com

NEWSPAPERS

The New York Times
Thursday House & Home section
www.nytimes.com

Antiques and the Arts Weekly
5 Church Road
Newton, CT 06470
203.426.8036
www.thebee.com

STRAIGHTENING UP AND ORGANIZING YOUR WORLD

Baskets, filing cabinets, storage bins, hangers, etc.

Hold Everything
800.421.2264

California Closets
1625 York Avenue
New York, NY 10028
800.339.2567
www.calclosets.com

Poliform (U.S. headquarters)
150 East 58th Street
New York, NY 10155
888.POLIFORM
www.poliformusa.com

GARDENING STUFF

Bulbs, tools, plants, flowers, seeds. No home is complete without a garden, no matter how small it is.

Gardeners Eden
800.822.9600
www.garden.com
800.466.8142

www.gardenweb.com

www.gardenbazaar.com

www.myseasons.com

FLEA MARKETS

MASSACHUSETTS
Brimfield Antiques Show
www.brimfieldshow.com
www.brimfield.com
NEW YORK CITY
The Annex 26th Street Flea Market
26th Street and Avenue of the Americas
212.243.5343
Every Saturday and Sunday
9 A.M.–5 P.M.

PASADENA
1001 Rose Bowl Drive
30 minute drive from LA
626.577.3100
www.rosebowlstadium.com
Every second Sunday of the month

SAN JOSE
San Jose Flea Market
1590 Berryessa Road
800.BIG.FLEA (800.244.3532)
www.sjfm.com
Wednesday–Sunday, dawn to dusk

ILLINOIS
The Kane County Flea Market
(St. Charles, west of Chicago)
630.377.2252
First weekend of the month from May to December

PLACES TO BUY ART

Visit the following web sites for a great selection of affordable art:

www.nextmonet.com

www.visualize.com

www.artnet.com

INTERIOR DESIGNER REFERRALS

Need to hire a designer? These organizations might help refer you to one.

ASID
(American Society of Interior Designers)
608 Massachusetts Avenue, NE
Washington, D.C. 20002-6006
202.546.3480
www.asid.org

OBD
(Organization of Black Designers)
300 M Street, SW
Suite N110
Washington, D.C. 20024
202.659.3918
www.core77.com/obd

Allied Board of Trade
(Publishers of the *National Directory of Professional Interior Designers and Decorators*)
200 Business Park Drive
Armonk, NY 10504
914.273.2333

IIDA
(International Interior Design Association national headquarters)
341 Merchandise Mart
Chicago, IL 60654
888.799.IIDA (4432)
www.iida.com

The Franklin Report
506 Lexington Avenue
Suite 1E
New York, NY 10021
212.639.9100
www.franklinreport.com